Photography for the Naturalist

Photography for the Naturalist

Photography for the Naturalist

Mark Lucock

GUILD OF MASTER CRAFTSMAN PUBLICATIONS LTD

First published 2002 by
Guild of Master Craftsman Publications Ltd
166 High Street, Lewes, East Sussex, BN7 1XU

Text and photographs © copyright Mark Lucock
Copyright in the Work © Guild of Master Craftsman Publications Ltd

ISBN 1 86108 290 8

British Cataloguing in Publication Data.
A catalogue record for this book is available from the British Library.

Cover design by Fineline Studios
Book design Geoff Francis, Francis & Partners

Colour separation by Viscan Graphics Pte Ltd (Singapore)
Printed by and bound by Kyodo (Singapore) under the supervision of
MRM Graphics, Winslow, Buckinghamshire, UK

Acknowledgements
I wish to thank my family who have given me encouragement and
support in this project and, more importantly, who have provided
genial companionship on so many of my travels and wildlife
encounters.
I also wish to express my gratitude to Stephanie Horner who did the
most remarkable job of editing this book.

To my family
– Jill and Rebecca –
whom I cherish
above all else

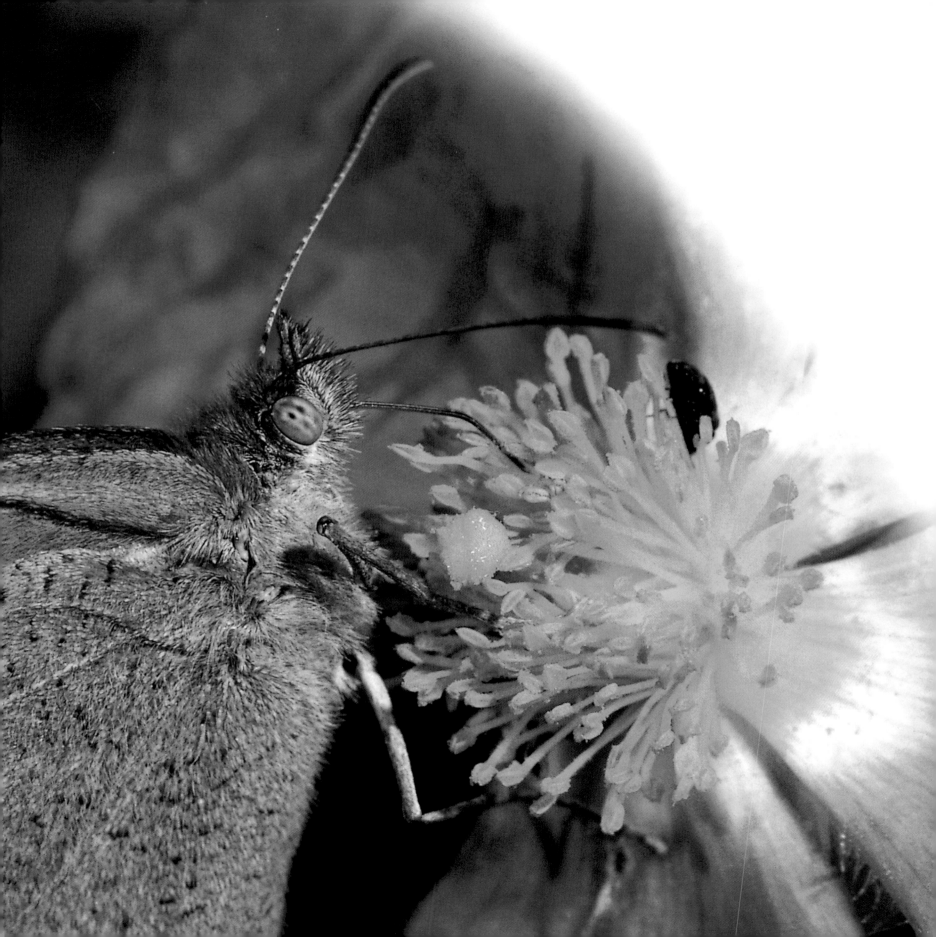

Contents

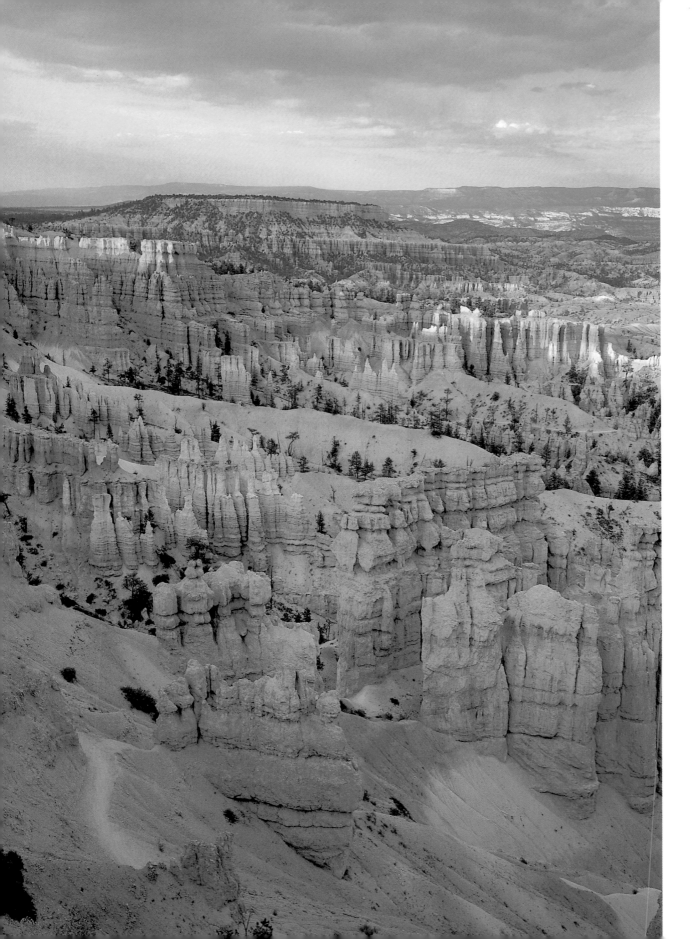

Sunset Point, Bryce Canyon, Utah. Mamiya 7ii + 65mm wideangle lens, f/16, 1/2sec, Velvia, tripod.

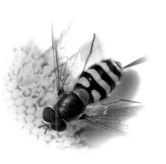

Introduction

An enormous number of us share a passion for the natural world. Some of us also have an interest in photography. I set out to write this book with the purpose of combining these two interests in the context of a modestly priced national or international holiday. The book is not about professional wildlife photography and truly exotic locations. Forget 600mm f4 lenses and photographic safaris – all you need is a careful selection of reasonably priced camera equipment and the background knowledge of what to look for, whatever your destination.

Photography as a popular pursuit started a long time ago; access to distant areas of wilderness for ordinary people is more recent, as is the visual tapestry of outstanding natural images which meets the eye on our screens, in magazines and in books. In fact, over 150 years now separate the pioneering images of William Henry Fox Talbot from the visually arresting nature photography of such contemporary artists as Stephen Dalton and John Brackenbury in the UK, whose critically sharp images of creatures in flight set the highest standards in wildlife photography.

Over this period, a number of famous names emerged, among them Eric Hosking for his bird photography, John Fielder, David Muench and Jack Dykinga for their large-format American landscapes, and Frans Lanting for his unique perspective on wildlife portraiture. In Britain several first-class, all-round photographer-naturalists including Heather Angel have also become household names. Initially, camera technology advanced slowly until in the past few years when it exploded as electronics became integrated into cameras at ever-increasing levels of sophistication. The very best of modern

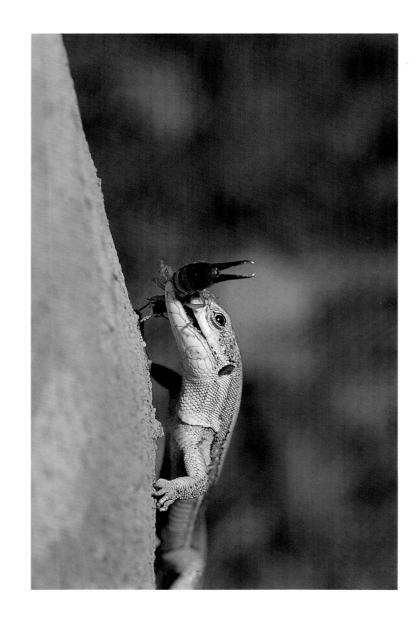

Troodos lizard with earwig, Cyprus. Pentax MZ5n + 100mm macro lens, AF280T flash, f11.5 on Velvia.

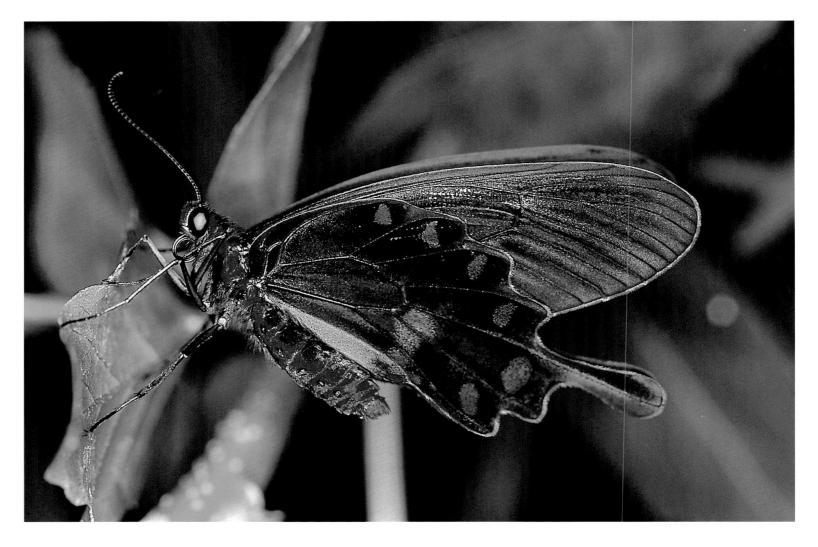

I shot this pink rose butterfly with fairly basic equipment: a 35mm SLR, an independent lens manufacturer's 90mm macro lens and an inexpensive manual ring flash unit. It demonstrates that good technique, not expensive equipment, makes for good images.

cameras represent an amazing synthesis of engineering, electronics and ergonomics. However, generally speaking, good wildlife photography of all forms can be achieved without a plethora of flashing LEDs, squeaks, beeps and autofocus lenses. In fact, as a functional tool the SLR (single lens reflex) camera probably reached its acme several years ago, and what really ensures success – in nature photography at least – is a critical blend of human attributes that transcends technology, namely, a special empathy with and a real understanding of the subject, matched with absolute rigour in the application of the art.

I anticipate that the majority of readers will purchase this book because, like me, they have a deep passion for the natural world and wish to record on film its many remarkable facets. After all, this pursuit is in itself extremely enjoyable, but it can also be profitable to the individual and valuable to the conservation of wildlife and landscape. In a small way, by producing good photographs of the natural world and marketing them through various outlets, you can instil a sympathy for, and understanding of, nature's intricate and beautiful web. More important, you will be garnering future support for the responsible guardianship of our verdant planet.

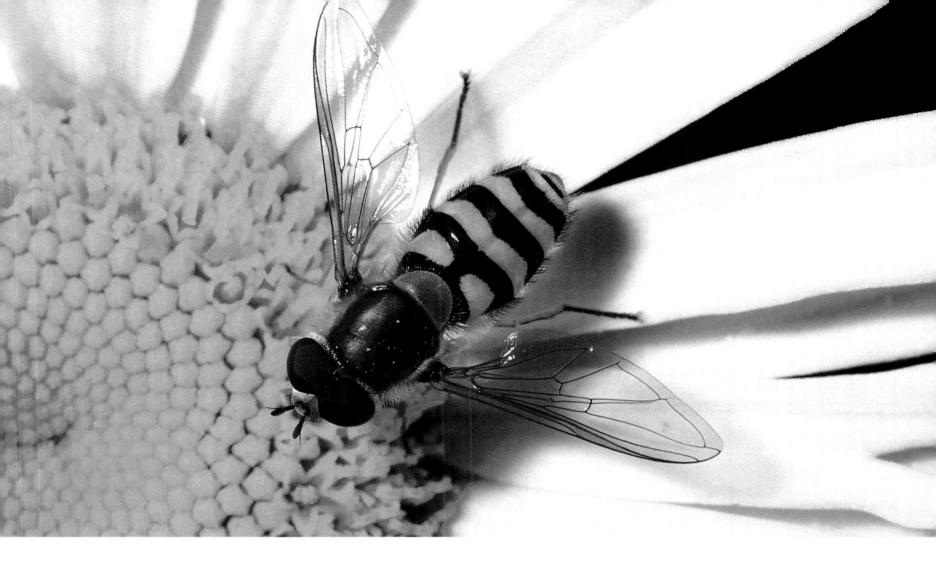

Visually arresting images can be achieved easily and with a minimum of equipment. This shot of a hoverfly was taken in my back garden, and shows you don't need to travel far to take great pictures. 75mm extension tubing on 50mm standard lens to give $1^{1}/_{2}$ x life-size magnification.

As far back as I can remember I have been obsessed with the natural world; gathering caterpillars in shoe boxes at the age of 6, twitching (bird-watching) at 12 and studying the life sciences at university as a young adult. Once I introduced photography into the equation I felt I had consummated a life-long craze. My primary objective in writing this book is to provide fellow nature-lovers with a similar desire to explore a diversity of habitats and enjoy the tremendously rewarding pursuit of natural history photography.

Not everyone can afford state of the art equipment or to travel to exotic destinations. I have found that such indulgences are by no means essential for achieving success in photographing and selling images of nature. The scope of photogenic material to be found within a small radius of where any one of us lives is limited only by our imagination. Once you have learned to 'see', it is difficult to exhaust the photographic opportunities afforded by even a modest garden or local park. Consider, for instance, close-up photography. This opens up a whole new inner world where you focus on an increasingly detailed microcosm. Photomacrography techniques make it possible to capture the intricate perfection in even the most insignificant and diminutive of organisms – the hoverfly, for instance – providing a unique reflection of the infinitely complex beauty of nature. Put

simply: the back of a derelict inner-city factory can offer as much photographic potential as an area of pristine wilderness in a distant national park – and it's within easier reach.

Thanks to the medium of photography, the natural world is no longer the esoteric frontier that it once was. Keen amateurs and ardent professionals alike are producing excellent material, although it is a sad fact that a substantial amount of technically poor natural history material is still published. I hope this book will help to put you in a position to make a real contribution to how others perceive the world by giving you the skills and confidence to build up and market your own portfolio of superb images.

There is no lack of photography books on the market. I have tried to address the shortcomings I perceive in the plethora of published material by adopting a tested organizational approach to my own book, which extends from the essential technical basics to selecting camera equipment and fully understanding how to use it before getting out in the field. I describe the natural history of the main groups of organisms and key aspects of life cycles where relevant to the photographer. After all, you are more likely to take great shots if you know what to look for, when and where. I have included first-hand accounts of my experiences of various unusual and interesting habitats close to home and abroad and I have also included a section on selling photographs, because if you are going to take up nature photography seriously, you must acquire the business acumen to market your work.

Capturing wildlife on film, more than any other branch of photography, requires as thorough a background knowledge of your subject as possible. For instance, seasonal abundance is dictated by life cycles, geographical ranges vary, and habitat requirements differ. As an example, in British woodlands brimstone butterflies are on the wing at the very first signs of spring. If you want to photograph this species early in the year, you need to be out and about with your camera before you have shaken off your winter blues. During this period brimstones are frantically looking for a mate and then for their favoured egg-laying sites. Even when you feel sure you know which species will be where and at what time of the year or even day, the weather can have the last say, or you find you have misjudged the most appropriate lens for recording the event. You may be more certain of success if you have a special

Subjects for the nature photographer are not exclusively in rural contexts. I took this shot of magpies over the centre of Leeds, my local city. 80–210 zoom on Pentax LX. Hand-held.

interest in a particular group of organisms, or at least carry a good reference guide (see the Bibliography). That said, half the pleasure is discovering a plant or creature you know nothing about, or photographing the unexpected.

As your skills develop and slide numbers build up you will learn to become hypercritical of your own work – optimizing exposures for composition and design by using your newly acquired technical expertise. Once you begin to obtain good results, you may wish to seek to publish your work. Financial reward apart, it is very exciting to see your first nature picture in a glossy magazine. However, although I have included advice on how to market pictures, it would be a pity to lose sight of what first attracted you to this absorbing and magical craft. Don't be tempted to snap away without stopping to observe and marvel (unassisted by a viewfinder) at the fragile beauty yet omnipotent presence of nature. It would be a pity to reach the point where your photography bores you or where earning money from transparencies takes precedence over the pleasure of taking the picture itself. And enjoy the buzz from experiencing the real thing, as well as the thrill of anticipating the vibrant image captured on a frame of Velvia.

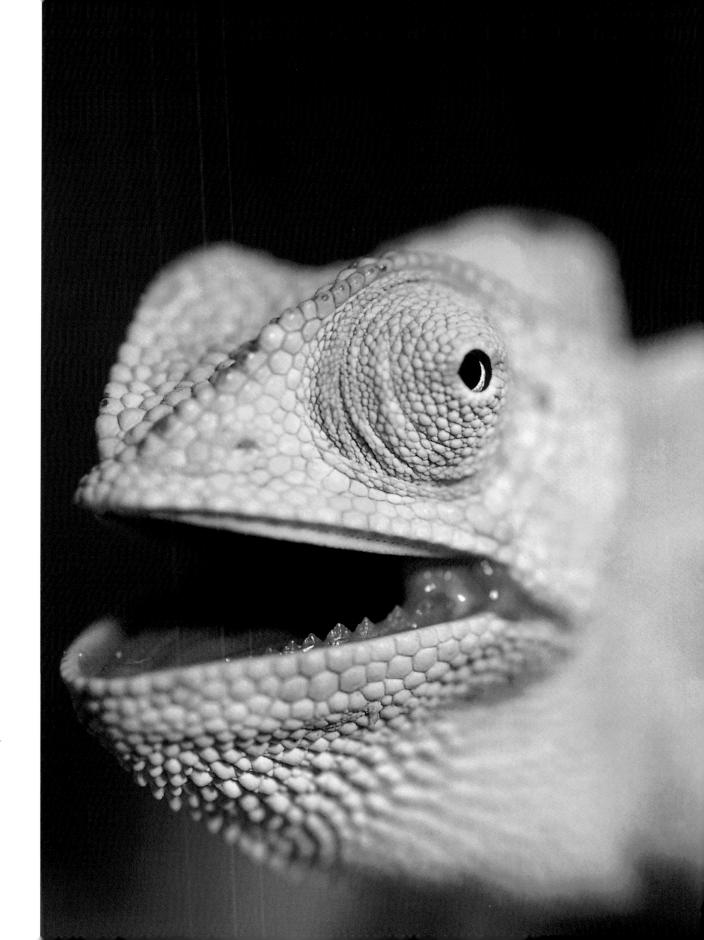

This European chameleon, like many others I shot on the Laona Plateau in Cyprus on a family holiday, was taken with a Pentax MZ5n + 100mm macro lens. However, to my mind, only this image, and the one on page 14, have real impact and thus good sales potential. AF280T flash, f/11 on Velvia.

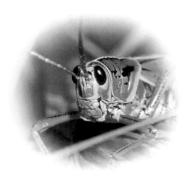

What are our subjects?

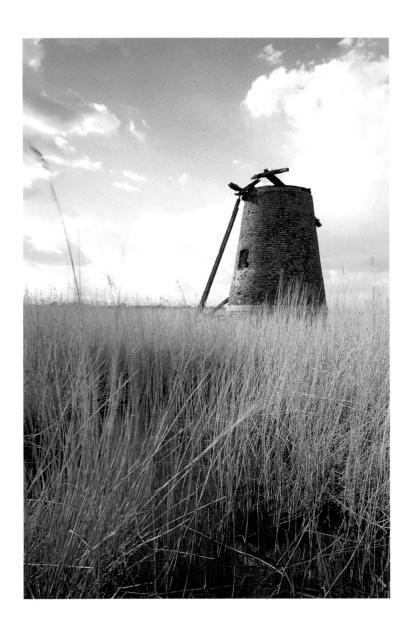

The answer to this question depends, of course, on our own vision. One person may simply wish to record accurately all the butterfly species native to a particular country or area – perhaps for a research project or simply to build a collection of species photographs just as a philatelist collects stamps. Another person may take a more artistic than scientific approach and strive to make a visually intriguing study that has all the hallmarks of a well-composed subject with strong elements of design. (For such a study, you will be more successful with plants or the environment since adroit insects, reptiles and the like seldom wait around for a photographer to set up his best composition.) Then there are people like myself, hybrids, perhaps, of the first two, whose scientific training and deep-rooted passion for nature mean that they are constantly developing their creative side while recording as much of nature's bounty on film as possible.

Human elements can sometimes provide a positive addition to the natural landscape.
This disused windpump on Dingle Marshes in Suffolk, England, exhibits a synergy with the surrounding reeds. Fuji GSW69iii, tripod, Velvia.

This Arizona desert millipede obligingly rolled up, permitting me to take a picture with a strong graphic tone. Pentax LX and 100mm macro lens.

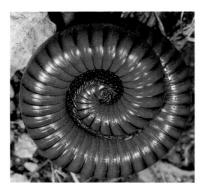

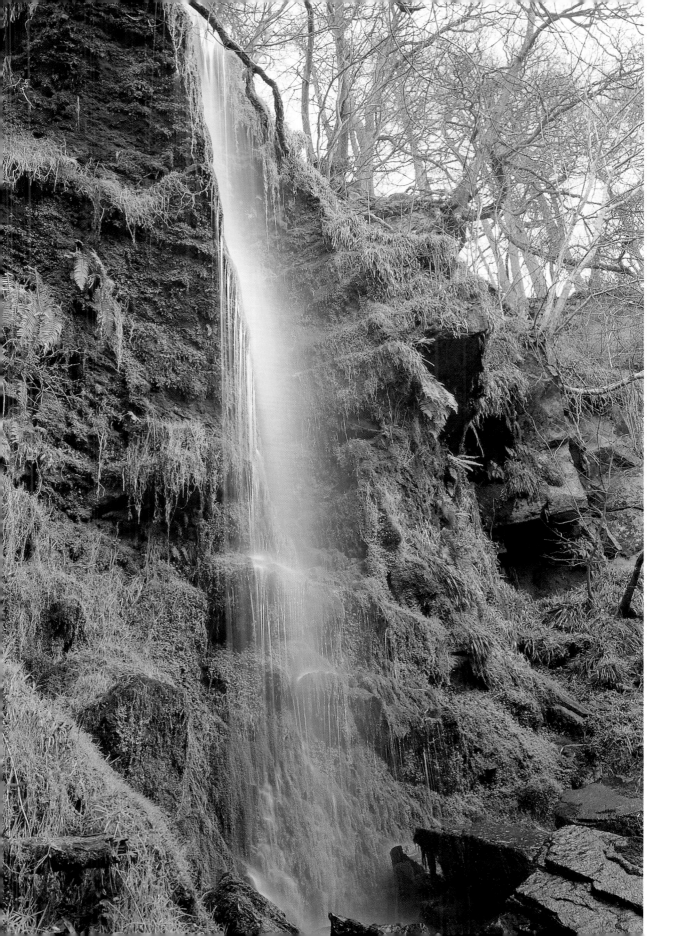

Mallyan Spout, North Yorkshire Moors, England. Mamiya 7ii + 65mm wideangle lens, f/22, 1sec, Velvia, tripod.

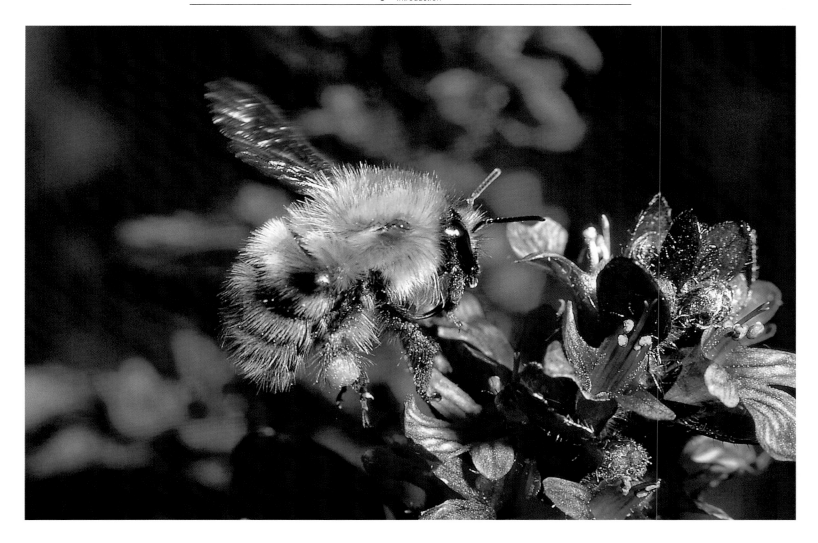

The carder bee is a common garden visitor. The bee's tardy
hovering makes it quite simple to obtain good flight shots.

For most keen natural history photographers, what we shoot depends
on where we are, and where we are is usually not far from home.
Dedicated professionals are considerably more proactive in their
wildlife and natural history photography. They identify a topical or
saleable theme in advance. This entails first a period of thorough
research, including potential outlets for the images, before a
judicious selection of the best equipment to take, and how to travel.
Professional photographers may invest a large sum of their own
money in what they believe to be a project with the potential for
financial reward. Often this means a news-worthy event, such as a
newly erupting volcano or the devastation caused by an offshore oil
spill. All the same, taking the professional approach does not always

guarantee picture sales, and in turn pictures shot on more humble
excursions can sometimes sell for a small fortune.

One of the main objects of this introductory section is to open the
amateur naturalist's mind to the everyday photo opportunities that are
all around us. I visit many natural beauty spots each year, where,
theoretically at least, people gather to wonder at nature. In reality
this is not always the case. One example in particular always sticks
in my mind. The vast sawgrass prairies (the so-called Pahayokee) of
the Everglades National Park in southern Florida are punctuated by
numerous jungle islands or 'hammocks', small, dense collections of
tropical trees where tall hardwoods dominate. The most famous of

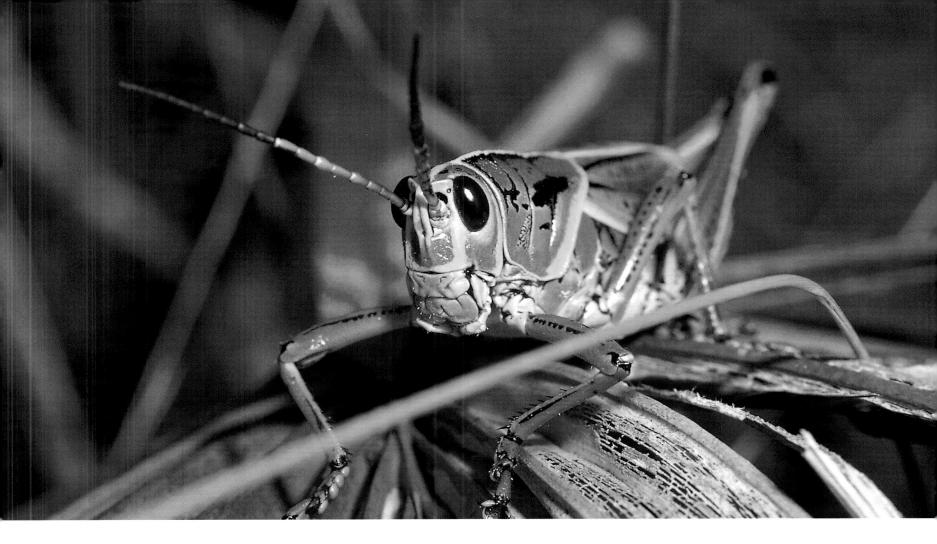

Southern lubber grasshopper, Mahogany Hammock,
Everglades National Park, Florida. Pentax LX + 90mm macro
lens, AF280T flash, f/11 on Kodachrome 64.

these, Mahogany Hammock, has a long circular boardwalk through the heart of this steamy semi-tropical ecosystem. On one slow, enjoyable circumnavigation, I managed to photograph large golden orb web spiders, green and Cuban brown anoles, blue-tailed skinks, rare liguus tree snails, warningly bright Heliconius butterflies and lubber grasshoppers. In addition, I gathered numerous artistic images of saw palmetto leaves, gumbo-limbo bark and a myriad of other tropical plants. During this amble, I was passed by groups of other visiting tourists from Europe, as well as Americans, so preoccupied with themselves that they were oblivious to the secrets of their magical surroundings. Most were adorned with expensive, even professional-quality camera gear, but none saw the photographic opportunities beyond and within the dark entanglement they were

traversing. In fact, many were positively rushing along at a pace quite unsuited to observation and more importantly, the climate. I equate this with a certain human characteristic in that many people seem more concerned with destination than journey. To the nature photographer, it is the journey, and the many observations en route, that matter. I doubt whether any of those tourists were aware of even the grandest of the photogenic airplants which so colourfully embellished many of the proud hammock trees.

So the answer to our question 'what are our subjects' is either that they are what forethought and planning dictates them to be, or, more likely, they are what observation and curiosity discover – irrespective of where on the globe we happen to be.

Photographing the natural world
for pleasure and profit

We should begin by cutting through the enticing propaganda of glossy magazine adverts. For a start, the hallmark of every good landscape photographer is an ability to recognize that it is the light and not an alluringly advertised camera that defines the quality of a photograph. The interplay of light can mutate the ordinary into the extraordinary, providing a host of emotional connotations. Unfortunately, however, catching good natural light is very much down to chance. It often means a long, sometimes uncomfortable, wait. Experienced landscape photographers know that good light usually means bad weather, although this generalization is by no means hard and fast. The first lesson to learn is that a camera in itself cannot create the conditions for a great photograph. Neither can it find suitable material to record. These are down to you – and, sometimes, to sheer luck. For landscape photography at least, if you do your job well, the type of 35mm camera you use is almost irrelevant; a point and shoot compact can often turn in results indistinguishable from those taken with an SLR. Of course, by investing in medium-format equipment the potential to take and sell quality landscape images can take a significant leap. (I discuss medium format as the choice for landscape photography in chapter 18 – see page 136.) Yet despite this accepted dogma, many photographers, myself included, still sell more 35mm than 120 roll film slides.

One of the most photographed rock formations at Bryce Canyon, Utah, has to be Thor's Hammer. It seems to appear whenever an editorial feature includes Bryce. This means it is a highly saleable subject, and should definitely be photographed by anyone with a camera at hand. Look at the postcards of a tourist attraction to see what the local photographic icons are for an area, and try to shoot them in both standard and novel ways.

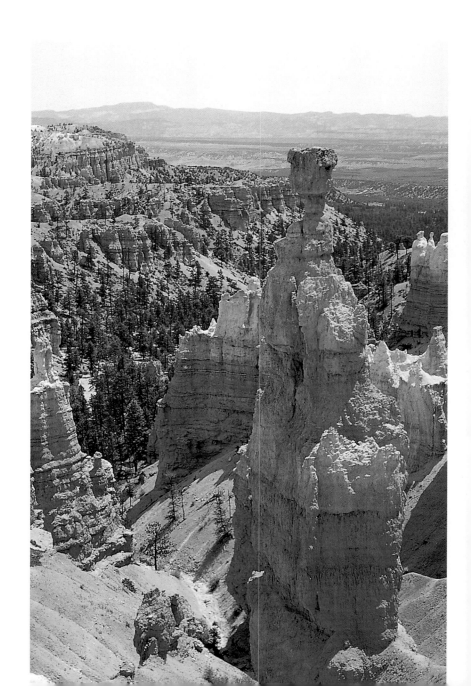

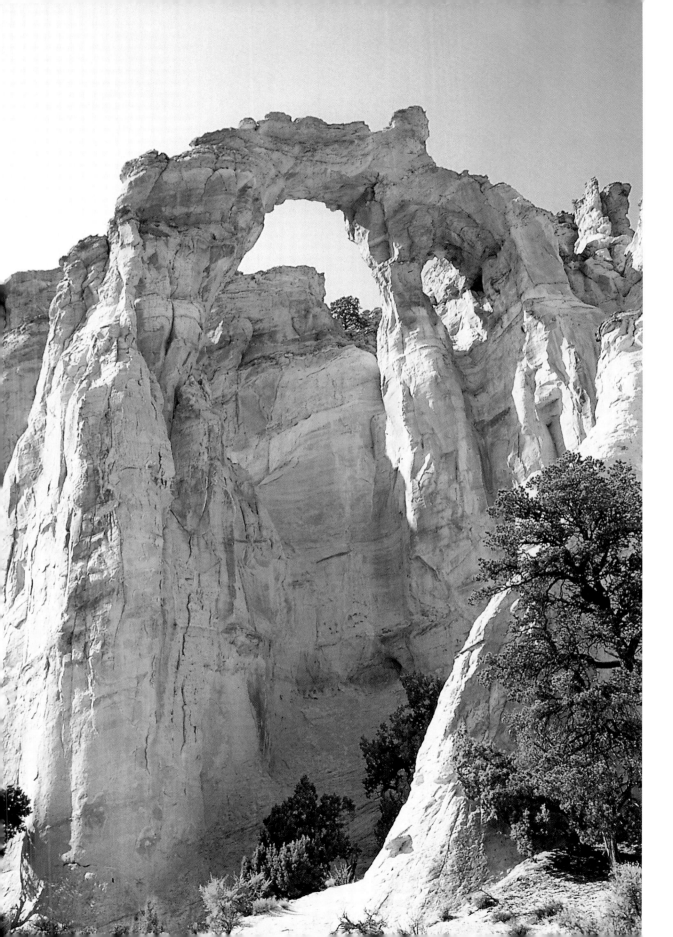

Grosvenor Arch, Grand Staircase Escalante National Monument, Utah. A hot day indeed – 120 degrees. I gave this shot +0.5EV to compensate for a fierce sun. Pentax MZ5n, standard zoom lens.

Photography is all about looking for a different angle or perspective on a shot. The view from a derelict building in the Cypriot ghost town of Theletra. Pentax MZ5n + 28mm lens. Exposures were bracketed on Velvia.

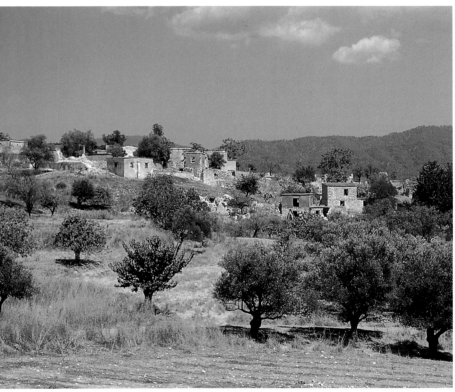

The ghost town of Kio in Cyprus is a former Turkish village now left to nature. Pentax MZ5 + 28–70mm lens, f8.5 on Velvia.

Wildlife photography differs from landscape photography in many respects. Most obviously, animals are usually either too far distant or too close for easy photography. Furthermore, they can have this irritating habit of constantly moving around, often quite rapidly. This means that neither the limited lens range of 35mm compact cameras nor the bulky, slow to use medium-format cameras are practical. But it isn't so difficult to produce remarkable and highly saleable results, given the right tools for the job and a little skill and experience. One of my holiday hikes illustrates that all you need is the ability to recognize, and to seize, photographic opportunities wherever they occur. It shows just how you can make the most of a situation and collect enough good images plus a story line that has the potential to sell to any typical travel magazine. Indeed, this is exactly what I managed to do.

Many of us visit the Mediterranean each year. Over the past 20 years I can only guess how many miles I have hiked through Mediterranean landscapes. My family and I have followed convoluted trails, sometimes unmapped, but never untrod, through endless olive and citrus groves, maquis and garrigue. Strung together, our forays probably span Gibralter to Athens. One recurrent theme to nearly all our walks, be they in Lycian Turkey, the Ionian or Aegean islands or Cyprus, is the ghost town: a small settlement stripped of its human element through war, landslip or earthquake. Only by taking the time to explore the crumbling piles of concrete and stone can you reveal the soul and hidden nature of the typical ghost town. This particular exploration proved to be a photographic argosy, fitting even for *National Geographic Magazine.*

During a family holiday to Cyprus, I spent a few days trekking around the island's ghost towns in search of wildlife. Before my arrival I was especially looking forward to visiting the wild and officially protected Akamas peninsula, hoping to photograph much wildlife and enjoy several tranquil walks. Forget it, the whole peninsula was heaving with activity, and any wildlife had moved well away from the well-beaten tracks. The tide of tourists had attracted several tacky souvenir shops and there was talk about further development to attract even more tourists to the Akamas. In truth, I found more solitude, wildlife and pleasure walking around the decrepit buildings and surrounding orange groves of Theletra, a ghost town on the Laona plateau on the west of the island, than I ever did on the Akamas.

Agamas are the largest lizards found in derelict Mediterranean towns and ruins. Pentax 100mm lens.

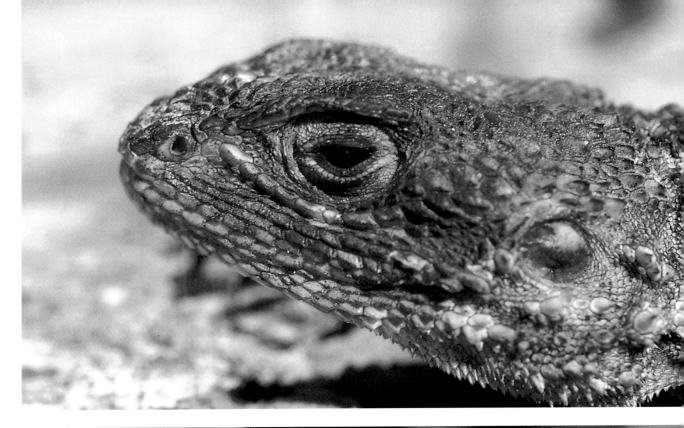

Asian tree frogs can be found in derelict ghost towns on Cyprus (and next to hotel swimming pools where they find refuge from the cutting sun). Pentax MZ5n + 100mm macro lens, AF280T flash, f/16 on Kodachrome 64.

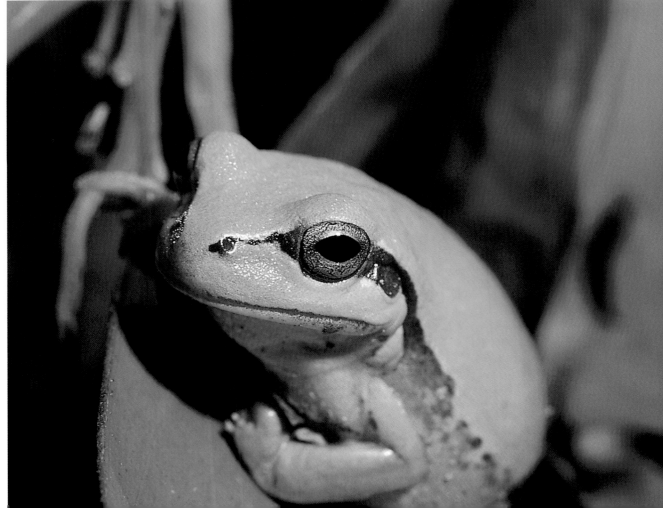

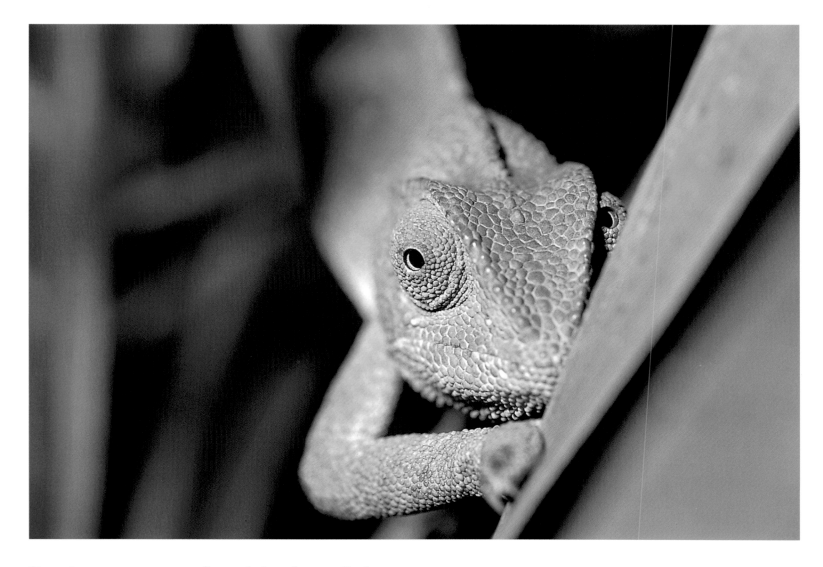

Chameleons are common on Cyprus but rarely seen. Pentax
MZ5n + 100mm macro lens, AF280T flash, f/16 on Velvia.

A spring walk in virtually any rural part of the Mediterranean is a heady experience. Floral sights and smells are evocative, conjuring up mellow visions along the lines of a Cézanne painting. However, open your eyes and there is far more life to see than you could possibly imagine. Searching out the biology and hidden photographic gems of the Mediterranean gives you so much more to do than merely walking to reach an arbitrary destination – which in fact is often no more than the point you started from. The ghost town of Theletra provided an added dimension to our walks and proved to be an environment rich in opportunities for wildlife photography.

As I took my first steps into Theletra, now the mere carcass of a once bristling Cypriot village, the unnervingly still aura of this ghost town hit me. The dangers of rockfall and landslide sounded the death knell for Theletra. Neighbouring Kio and other Cypriot ghost towns were dealt a lethal blow in 1974 when Turkey invaded Cyprus. These tumbledown villages are now, on the face of it, no more than containment for the local goats.

Tourists and goats, however, are not the only inhabitants of the decaying concrete labyrinths of Theletra. The stillness of the main

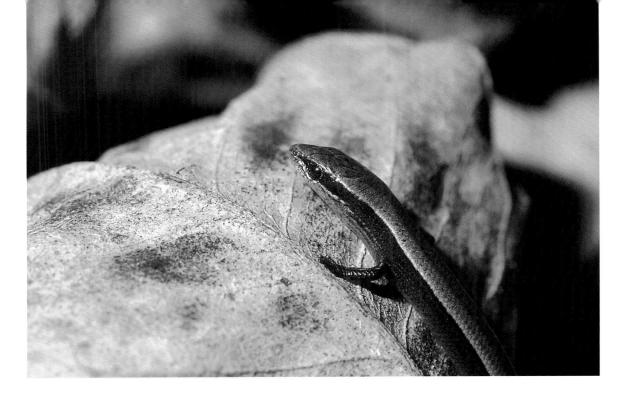

Snake-eyed skink taking a break from swimming through leaf litter. This fellow was only about 3cm (1¹/₂in) long. Pentax MZ5n + 100mm macro lens, AF280T flash. f/5.6 on Provia.

street contrasted with the manic activity of a thousand and one reptiles darting for cover along the narrow side streets. During the day Theletra's bulkiest pedestrians are the large and cryptically coloured agamas – the nearest thing the eastern Mediterranean now has to dinosaurs. I can't help but think of them as the Schwarzenegger of lizards. Their head-bobbing skittish nature is surpassed only by the frenetic dashing of the more diminutive Troodos and snake-eyed lizards. As the sun rose to its balmy zenith, these lizards plopped, rustled and scuttled away from my every footstep at a distinctly jaunty pace. Not so the most interesting of all Mediterranean reptiles. The overgrown and entangled figs and grape vines that embellish so many of the crumbling buildings provide perfect camouflage for bulbous-eyed, sloth-like creatures with a prehensile tail – chameleons. The only time you will see one of these elusive creatures is when they either lose their purchase and drop to the ground or when they decide to cross the road – as they often do. Photographically, darting agamas can be difficult subjects, but as you might imagine, chameleons are very easy ones – providing you can spot them in the first place.

Strange as the chameleon is, a stranger reptile can be found in the leaf litter surrounding the trees in the enclosed gardens and citrus groves. This organism's oddity arises through behaviour rather than appearance. Snake-eyed skinks swim through the leaf litter as dolphins skim the waves, writhing through the interface between

ground and air with supreme alacrity. These fascinating creatures, no longer than your thumb, bridge the evolutionary gap between lizard and snake and have little in the way of legs. They often reside in small groups – just like a pod of dolphins – and are mesmerizing to watch, but frustrating to photograph. I took two rolls to get a couple of useable images.

The chameleon is not the only organism to live in a hidden, shadowy world of subterfuge. As I searched through abandoned grassy courtyards, I turned up other secretive animals that blend into their surroundings with a consummate ease that never fails to amaze me. Praying and empusid mantids are so grass-like that their predatory bodies were lost from view at every blink of my eye. Diminutive tree frogs are equally well camouflaged. Placed on the end of my finger, I wondered how a backboned animal so small can exist in such a large world. Like chameleons, tree frogs can rapidly change their colour – from vivid lime green to drab olive. Although the common tree frog is found all over the Mediterranean islands and mainland Europe, it is the Asian tree frog that resides in Cyprus. It seems to have found a perfect home in the haunting isolation of another nearby desolate village, Evetrou, now totally decrepit and empty. This Turkish village nestles beside a large reservoir which provides a perfect watery habitat for all manner of life, frogs and stripe neck terrapins included. Theletra has no reservoir, but there is an endless supply of water in tanks used to irrigate the surrounding citrus trees.

Clouded yellows never seem to stop for breath as they ply the Mediterranean landscape. They are one of the hardest butterflies to photograph. Pentax LX + 100mm macro lens, TTL flash.

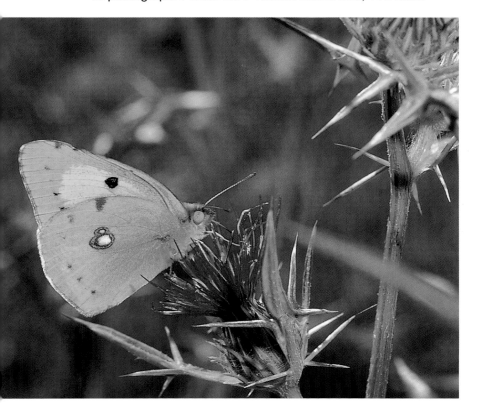

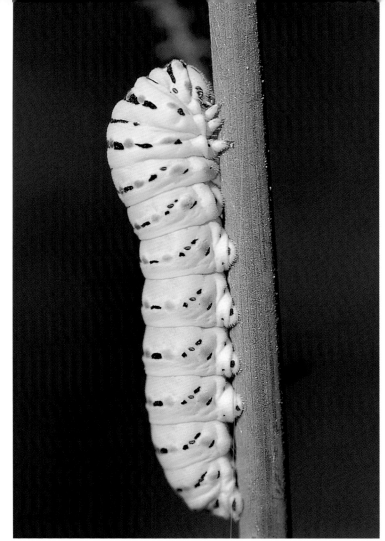

Swallowtail butterfly caterpillar, Laona Plateau, Cyprus, in August. Pentax MZ5n + 100mm macro lens, TTL flash.

Although my footsteps along Thelatra's 'main street' were lost in the emptiness and isolation of this ghost town, they were enough to scare pigeons into flight. Waves of them shot out in front of me with a noisy flap of feathers. The Hitchcock-like appearance of these birds from within the gloom of decaying buildings was the antithesis of spring butterflies dancing in the dappled sunlight. Butterflies flutter from blossom to blossom between but never through the buildings. From February sulphur-coloured cleopatras dominate, giving way to migratory clouded yellows and painted ladies which busily dart and dance along alleyways. Later the blues, hairstreaks and fritillaries embellish the tumbledown walls and overgrown wild garden of herbs and grasses until the searing heat of the mid-summer sun prohibits all but the odd swallowtail or lattice brown.

The only wild plants in flower during my visit in August were fennel and globe thistle. Fennel is ubiquitous around the ruins and provides a delicious meal for the psychedelic caterpillars of the swallowtail which relish its lanky umbel stems. I spent several minutes waving my camera lens in focused tandem with the gentle sway of a fennel stalk that carried a beautiful swallowtail caterpillar. My efforts were rewarded.

As summer bites, the ghost town's crumbling mortar provides shady respite from the desiccating heat. It is at night that Theletra comes to life. Lizards give way to a sinister crowd of dwellers. Top of the pecking order (excluding cats and owls) is the blunt-nosed viper (sometimes referred to as the Levant viper). In Europe this is the most feared and

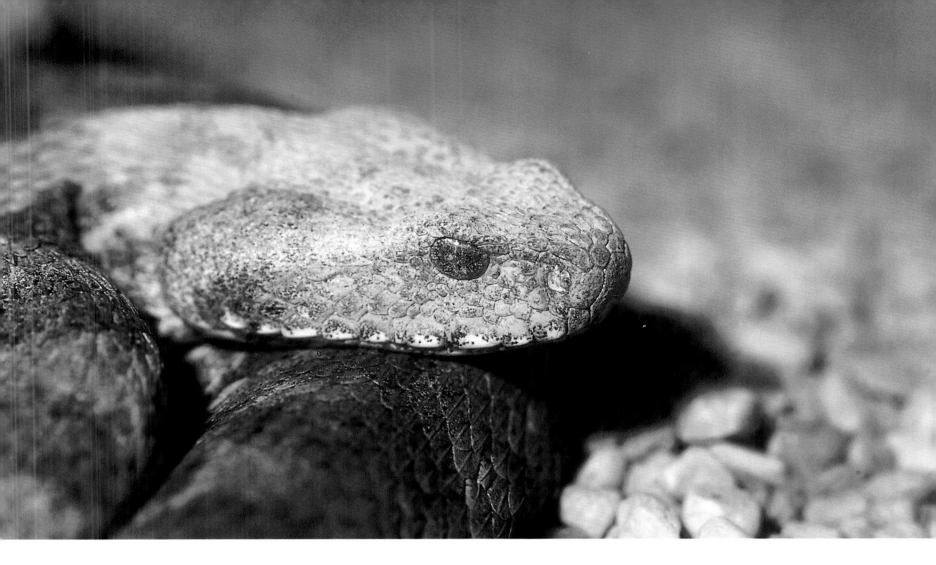

Deadly blunt-nosed viper – Europe's most dangerous snake and a Cypriot ghost town resident. I don't recommend photographing this animal since it will strike at you several times before your finger can release the shutter. Pentax MZ5n + 200mm lens with Nikon 3T dioptre. Kodachrome 64.

deadliest snake. I knew that vipers lie in wait for their prey and strike out at any potential meal that passes within a foot or so of them – relying solely on the rapidity of their strike for survival. However, having seen only staged and fairly unimpressive video footage of rattlesnakes striking, I was dumbfounded when I witnessed first-hand a blunt-nosed viper attack. It can make repeated strikes, four times in one second, injecting fatal haemotoxic venom. Its face has the mean look of its pit viper relative – the western diamond back rattlesnake which occupies a similar niche in the ubiquitous western ghost town.

You need to look twice to see this young blunt-nosed viper. Pentax M25n + 100mm macro lens and TTL flash.

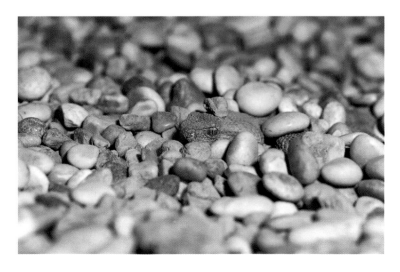

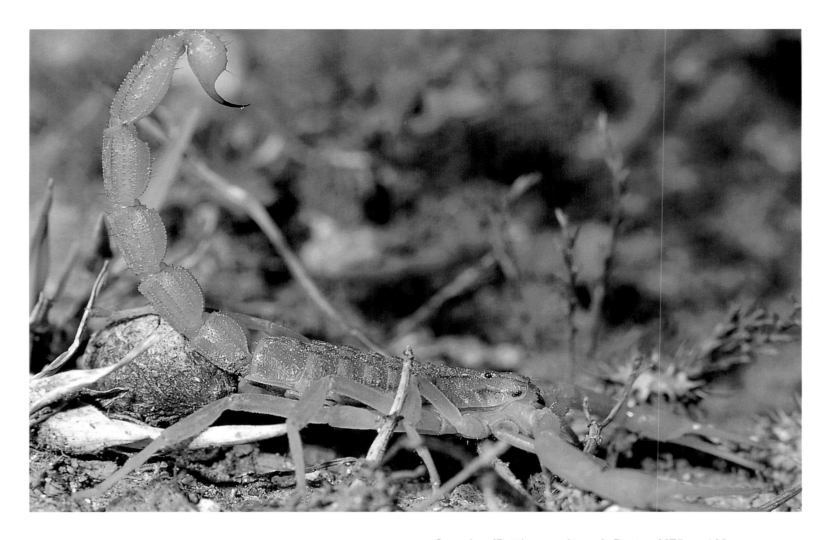

Scorpion (*Butthus occitanus*). Pentax MZ5n + 100mm macro lens, AF280T flash. f/11–16 on Velvia.

Within seconds of entering Theletra on my first hike there the twilight had lit up a young Montpellier snake literally flying across a collapsed concrete floor. This is another poisonous snake found throughout the Mediterranean but as it is back-fanged, I knew it presented no threat to anything larger than a tree frog or snake-eyed skink.

Turning over a splattering of small stones, as I have an irritating habit of doing, I revealed all manner of mini-beasts: small to very large butthus scorpions whose sting is more painful than dangerous; the European tarantula (*Lycosa narbonensis*); and, ugliest of all, scolopendra centipedes. These last are usually finger-length but I

have seen specimens bigger than the span of my hand (nobody believes me, but it's true), a writhing mass of legs and poison fangs. These mini creatures all hide from the blistering heat of the day but emerge at night, parading through the streets eking out their existence. I kept a look out for rarer, but fascinating worm snakes and malevolent, ugly wind scorpions. This latter creature is 99.9% jaw. It isn't poisonous but it can give a vicious bite. It is so ugly that as I photographed it, the hairs stood up on the back of my neck.

Life in the ghost towns of Cyprus is tenuous. Theletra may have lost its human inhabitants, and at first sight engender visions of the

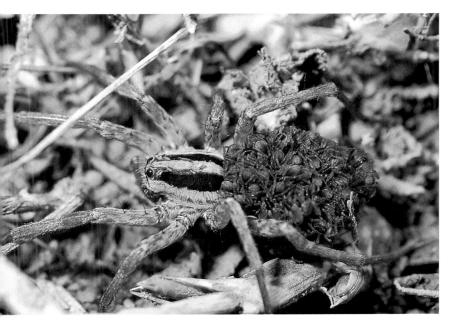

The European tarantula, *Lycosa narbonensis*, is found all over the Mediterranean – just turn over the odd stone. This one is ferrying her newly hatched young away from my camera. Pentax LX + 100mm macro lens, AF280T flash, f/16 on Kodachrome 25.

The wind scorpion is one of the ugliest inhabitants of arid environments. This large specimen certainly moved like the wind before I managed to creep up on it. Pentax LX and 100mm macro lens.

afterlife, but, along with other abandoned villages, it is indisputably still living. Take the trouble to seek out what there is to photograph, and you will discover that in fact there is abundant life, all of it fascinating and sometimes extremely dangerous.

I have included this account precisely because it does not focus on any protected area or parkland. Rather, it shows what marvellous things can be found in the most unlikely places. Indeed, it does no harm to eulogize about nature outside of protected havens, since it may make some small contribution to redressing the loss of the ever-diminishing natural world. There is a strange contradiction in the creation and use of beauty spots and areas designated as being of natural or scenic interest. Once a biologically valuable area of land is categorized as such, it immediately becomes a magnet for coachloads of tourists, jeep safaris as well as bona fide naturalists. This plethora of people not only has a direct impact on the nature, it despoils the special ambience that wild, once isolated places have. Worse still, designated areas become a target for local and international entrepreneurs – particularly hotel developers. In this way, natural places become the victim of their own beauty, which can lead to their eventual destruction. Cyprus provides a typical example of this paradox.

It seems that limiting not expanding visitors is the only way to offer real protection to nature. It is a sad fact that naturalists sometimes have to leave so-called 'protected' areas and beauty spots in favour of quieter tracks and trails suitable for nature photography.

If a photographic hike through forgotten places attracts you, the applied section (pages 72–147) show you how to tackle a variety of interesting subjects. Wildlife subjects and hiking in the Mediterranean are at their best in early spring. Time your visit carefully, and you will likely be rewarded with a profusion of colourful flowers and heady scents. Later, in the full heat of summer, hiking can lose its appeal, and you will be forced to take a hat and to carry water no matter how short your planned walk. At this time, too, many organisms go into a period of suspended animation to avoid the desiccating sun. Autumn, however, is again a very pleasant time for amateur naturalists as many native bulbs will be in flower. Who knows what you may be lucky enough to see, and what better way to leave a place than with a haunting memory and some great shots that will one day draw you back.

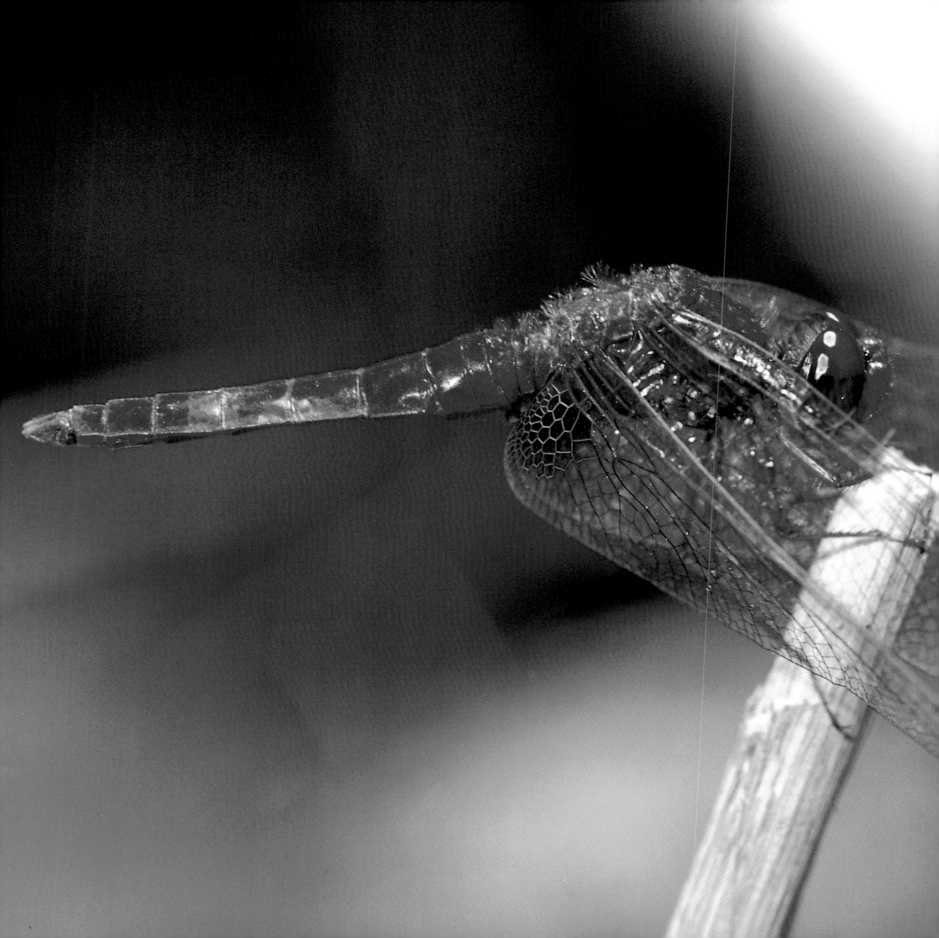

The Basics

This section considers the mechanics of photography. Throughout, my strategies have a slight bias towards shooting the myriad of small- to medium-sized organisms you are likely to encounter in many habitats worldwide. By this definition I mean insects, reptiles, birds, smaller mammals and plants. In later chapters I look at the broader aspects of nature photography and at organisms on a group-by-group basis, as well as the immensely popular pursuit of landscape photography. However, whatever your interest, the first consideration is the scale at which you are going to approach your subjects.

Photographic scale
4

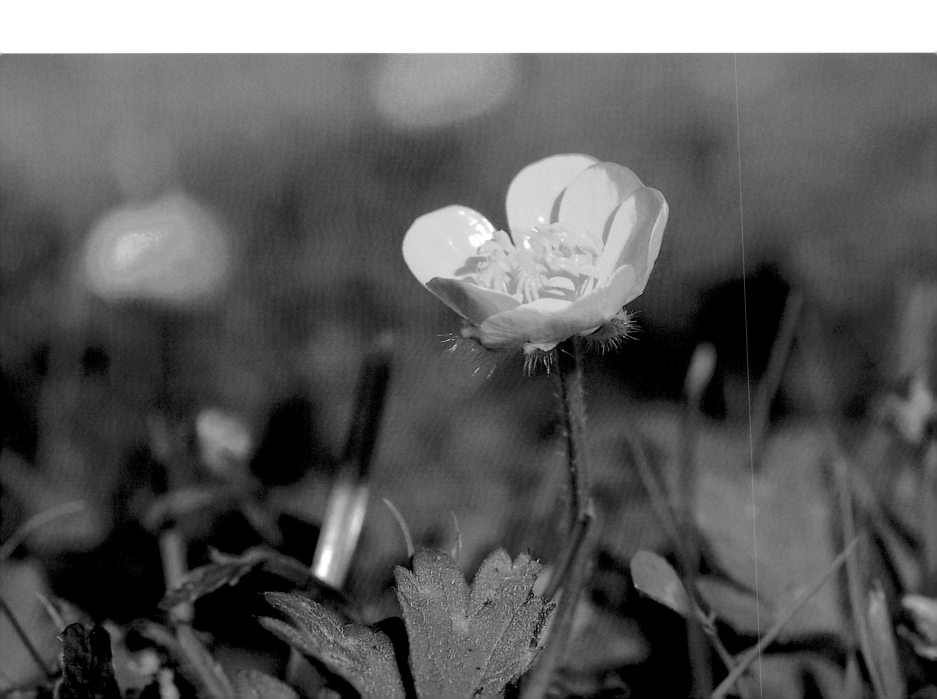

Defining photographic scale with respect to magnification range is often a bit of a foible among photographers. The more authoritative workers go as far as recognizing three or four distinct magnification ranges, namely, normal, close-up, photomacrographic and photomicrographic. However, this can be very confusing if you compare the terminology adopted by leading manufactures: Nikon, for instance manufactures a *micro* (for small) lens and Pentax has a *macro* (for large) one. Both are essentially identical in that their resolving power is optimized for *close-up* work over the same magnification range. I suggest that we forget any such definitions – this is a book about the real-life situation of photographing nature in the field as close up as necessary for the subject. It is not an academic exercise in developing a new vocabulary or redefining an old one.

How close?

I find it most useful to consider the degree of 'closeness' as the ratio between the actual size of the image reproduced on either the negative or transparency film, and the size of the subject being photographed. The usual convention is to describe this magnification rate as a fraction where unity is equivalent to life-size reproduction i.e. the image on film is the same size as the subject being photographed. Hence 1/4 x, 1/2 x, 1 x, and 2 x span a range where the photographic image appearing on the film varies from one quarter to twice life size. (Some authorities express this as a ratio; so 1/2 x becomes 1:2 and twice life size is 2:1. I find this confusing and advocate the system where magnification rate is expressed as a fraction or integer.)

In out and about photography you will never actually need to know the exact magnification rate. However, understanding the principle is important for a number of reasons, not least because it provides a fundamental unit of measurement to quantify apparent closeness or magnification, irrespective of the technique in use. So, for a 35mm SLR camera, the format most commonly described throughout this book, and the one preferred for close-up photography in the field, a wide range of magnification rates is possible.

Many of the more common subjects for the nature photographer are small and require a real understanding of the principles of close-up photography. Pentax MZ5n + 100mm macro lens, TTL flash.

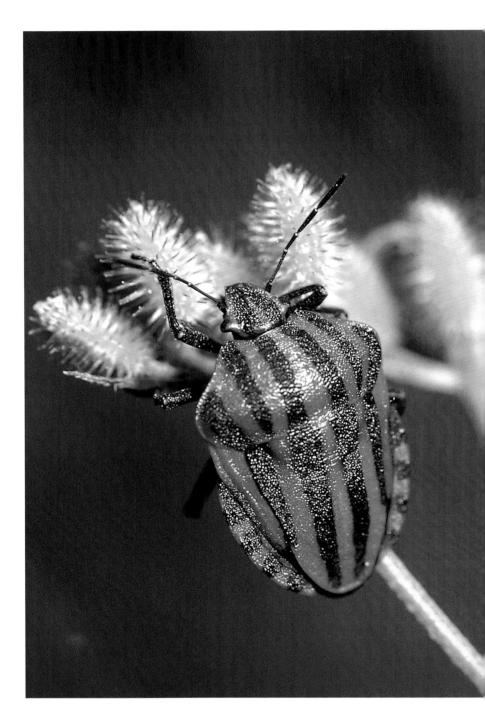

Harlequin bug. In the Mediterranean heat haze, colour is all around at the macro level. Pentax SFXn + 50mm macro lens. Manual flash.

Until recently most amateur photographers purchased their camera in combination with a 50mm standard lens which on its own is capable of a magnification rate typically 1/6 x–1/10 x life size. For practical purposes this is not particularly useful, although you could use it for larger reptiles. An adult Mediterranean tortoise, for instance, would fill a substantial part of the film's frame with a 50mm standard lens. At this rate of magnification we are not stretching photography outside its normal limits.

Manufacturers of many zoom lenses qualify the focal length range with the word 'macro'. This is a misnomer: don't be misled. What it generally means is the lens can achieve magnification rates of 1/4 x–1/3 x life size. These rates are not in the true macro range and the image quality is generally poor by comparison with a prime macro lens. A lecture I once gave on techniques in wildlife photography began with a picture of a dragonfly taken with an 80–210mm 'macro' zoom lens. The point I was making was that this was not the best way to create such a picture, and subsequent examples of dragonflies taken using three other techniques demonstrated this quite nicely.

To achieve close-up images in a magnification range which is useful for most natural subjects in the field, you need a true macro lens which can focus down to a magnification rate of 1 x without the need for bolt-on extras. Expensive, although high-quality prime macro lenses are available in the 50–200mm range. However, there are more economic techniques available for achieving the same useful magnification rates without recourse to a true macro lens and these are discussed in some detail in subsequent chapters.

Ask yourself at this point if your subjects are going to be so small that you need to extend your magnification rate beyond 1 x; I suspect the answer is no. In fact, beyond life-size magnification you enter a realm which requires special techniques and ultimately a microscope. These photomicroscopy techniques are outside the remit of this book, since they are clearly not field techniques suitable for photographing wildlife in their natural habitats.

For out and about photography of the many small creatures that you might encounter in different habitats, it is best to work in the range 1/8 x–1 x magnification. The chapters in part two, Applied Nature Photography, are weighted with examples in this range. However, clearly, no one definition can be used for all possible subjects.

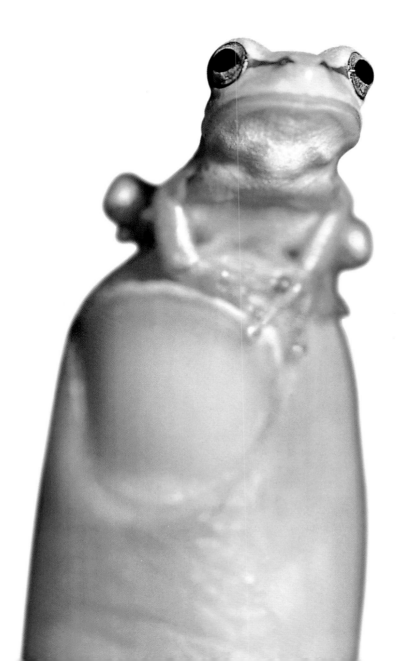

Insects are not the only creatures that require some degree of magnification. This tree frog is extremely small. The scale, however, is only obvious by comparing the size of the frog to that of my wife's finger. Pentax MZ5n + 100mm macro lens.

What controls the exposure?

Mastering exposure is central to the whole image-making process. Many readers may already understand the rudiments of exposure. None the less, this chapter provides the foundation of all that follows, and its importance cannot be understated.

Exposure is dependent upon three variables:

Shutter speed refers to the duration that the camera shutter is open during the actual picture-taking process. The longer the period of opening, the more light reaches the film.

Aperture is defined in f stops and is a measure of the size of the lens opening. Small f numbers, say f/2.8, represent large apertures and large f numbers, f/22 for instance, represent small apertures. As f numbers are reduced, progressively more light reaches the film.

By balancing shutter speed and aperture according to need you control the amount of light hitting the film emulsion. This equilibrium is modulated by the characteristics of the film being used (i.e. film speed).

Film speed/sensitivity slow films require a greater intensity of light than fast ones in order to record an image. Films are marketed with an ISO (formerly ASA) number. A low ISO number means a slow film and vice versa. For example: ISO 25 is slow, and suited to bright ambient conditions or flash, whereas a fast film, say ISO 400, can maintain the same exposure (shutter speed and aperture) under much duller conditions.

This winter shot needed a 4sec exposure at f/16–22. West Beck, North Yorkshire Moors, England. Mamiya 7ii + 65mm wideangle lens, Velvia, tripod.

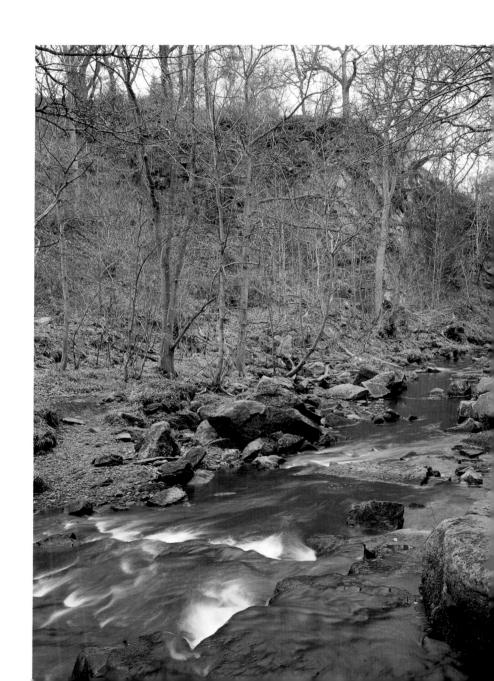

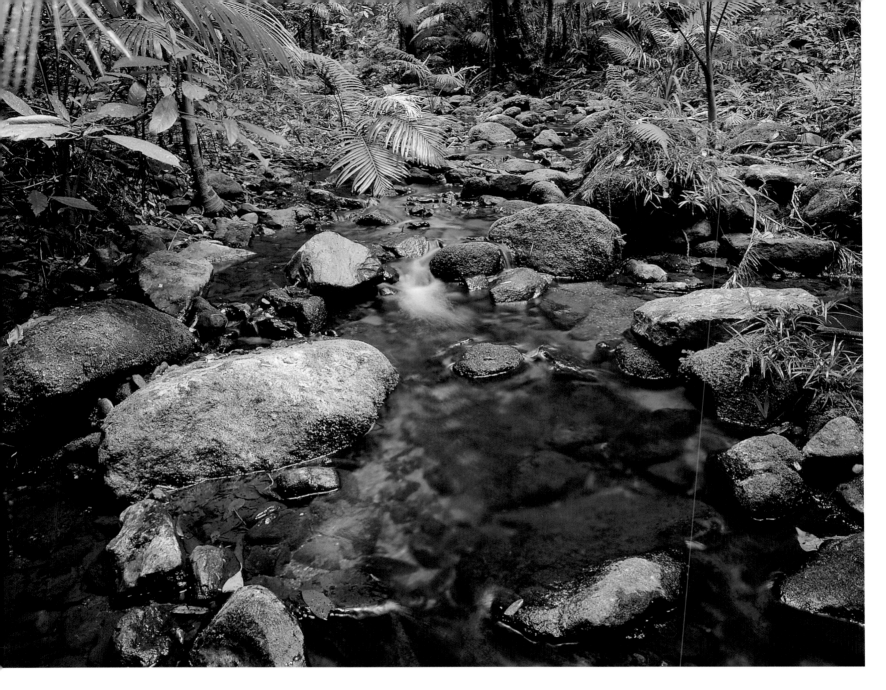

In order to communicate the various aspects of exposure theory effectively, I propose we talk in exposure value (EV) stops. An EV stop is either double or half any value. For instance, shutter speeds range from many seconds down to, in modern cameras, 1/8000 of a second. A typical sequence would be: 2, 1, 1/2, 1/4, 1/8, 1/15, 1/30, 1/60, 1/125, 1/250 x, 1/500, 1/1000 and 1/2000 (with x being maximum speed of flash synchronization). You will note that this sequence represents a series in which each shutter speed is half the preceding value and twice the subsequent one. Each doubling or

Creek in Mossman Gorge section of Daintree National Park, Queensland, Australia. I exposed this watercourse with a small aperture (f/22) to retain the best depth of field possible. Good depth is essential to the success of this picture. A small aperture and a very low light level required an extremely slow shutter speed (8sec) to get the exposure spot-on. Slow shutter speeds are always desirable with such shots as they help the water to 'flow'. For images like this to work you definitely need a tripod and a stop watch. Mamiya 7ii + 43mm ultrawide lens.

halving of shutter speed represents one EV stop; for instance, 1/125sec to 1/250sec is a one-stop decrease in exposure. Shutter speed is used first to balance the amount of light reaching the film emulsion and second to control motion. The slower the shutter speed the more likelihood of blur.

The f numbers that define aperture are also a progression of one-stop changes in which the amount of light admitted through the lens is either doubled or halved. However, the arithmetic change is not obviously reflected in numbers of the typical f-stop series: f/1.4, f/2, f/2.8, f/4, f/5.6, f/8, f/11, f/16, f/22 and f/32. (Apertures can be even smaller in large format lenses.) Nevertheless, f/4 lets in twice as much light as f/5.6 and represents a one-EV stop increase in exposure, as does opening the aperture from f/16 to f/11. Your f number dictates depth of field, or the extent of the zone of apparent sharpness. I explain this more fully on pages 36–7.

The two variables of shutter speed and aperture have a reciprocal relationship: if you halve the shutter speed and open the aperture by one stop you are providing the film with the same quanta of light as if you had doubled the shutter speed and closed the aperture by one stop. Although the amount of light reaching the film is equal in each case, the effect in terms of depth of field and action-freezing potential will vary.

So, it is now possible to communicate in EV stops. Take one example: 1/30sec at f/16 provides the correct exposure for a flower. However, a slight breeze dictates that we use a faster shutter speed. A two-stop change of shutter speed to 1/125sec freezes the flower's motion as required, but to maintain the correct exposure we must also open the aperture by a corresponding two stops to f/8 – an aperture that we decide provides sufficient depth of field for this subject – and we can now take the picture.

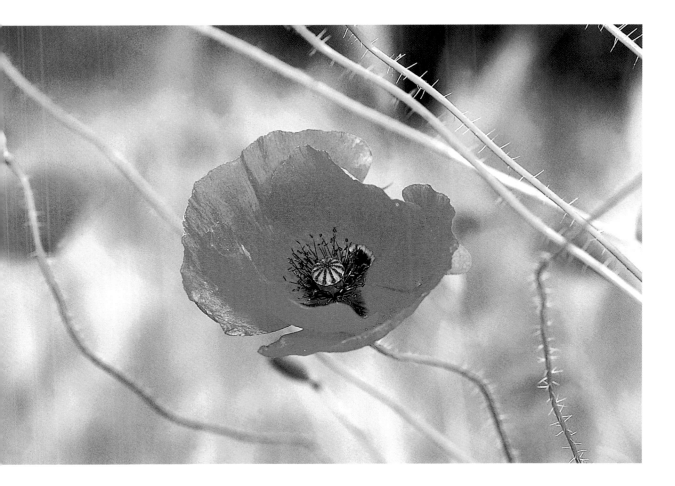

A slight breeze meant I used 1/125sec at f/8 to freeze the movement of this poppy.

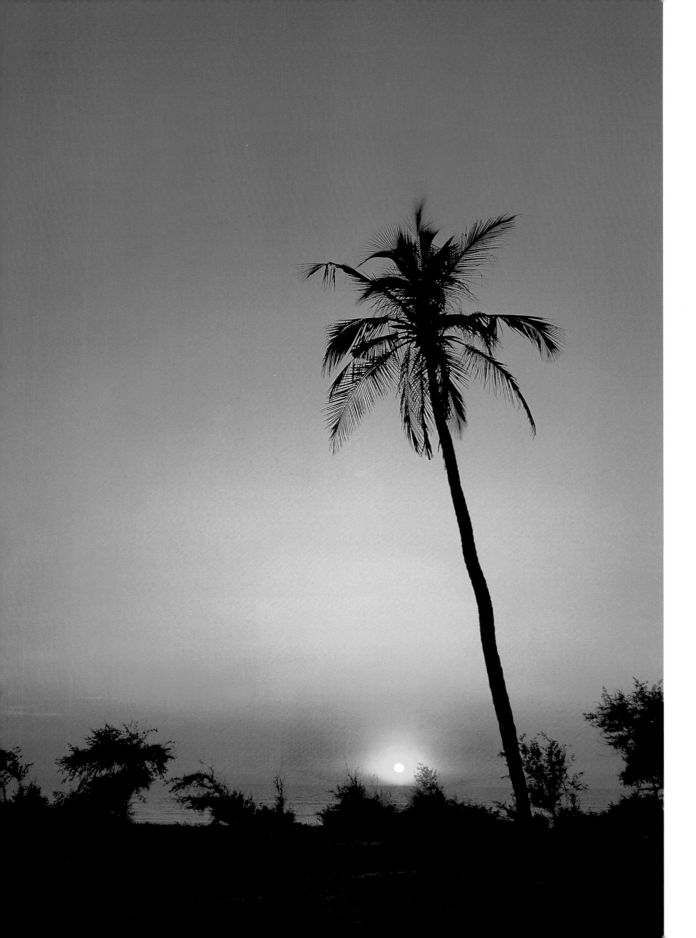

Photography of the natural world should be a pleasurable hobby, yet there is no reason why it can't also be a profitable pastime. This is particularly true if you keep your eyes peeled for icon-type imagery. For instance, I shot this coconut palm silhouette on a beach in India as the sun set. Although it could grace any travel brochure cover, the truth is that during the day this was the most moth-eaten palm on the beach, and most definitely not at all photogenic. What is more, the red sunset was probably a result of bad air pollution due to traffic emissions. I might add that the spot where I placed my tripod to take this picture at the beginning of my stay, was a field with grazing water buffalo. Within two weeks, half a hotel stood on the same site. Fuji GA 645Wi, f/22.5, 1sec, Velvia, tripod.

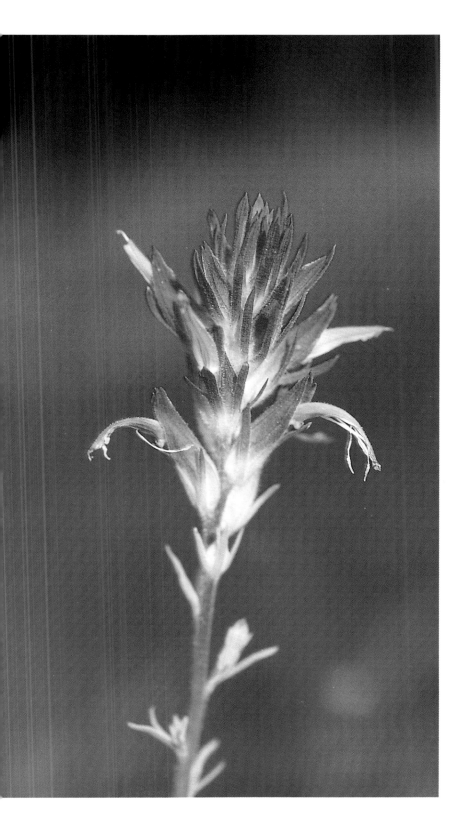

The sensitivity of the film in use also plays a role in determining the correct exposure. Film speeds are the same as f numbers and shutter speeds in that they also work in stops, in this case, though, represented by a halving or doubling of their ISO number. Examples of film with a slow speed include Kodachrome 25 and Velvia 50. Popular medium-speed films include Kodachrome 64 and Provia 100F, while among the moderately fast films are Kodachrome 200 and Fujichrome 400. Super-fast films are now also available with a speed of ISO 1600. As we decrease the ISO number by halving it, thus ISO 400 to ISO 200, ISO 200 to ISO 100, ISO 100 to ISO 50, ISO 50 to ISO 25 we are, each time, increasing the exposure need by one EV stop.

To return to our flower which required an exposure of 1/125sec at f/8 to freeze its motion in a slight breeze, assume now that the breeze has become a gale and we need to maintain the original exposure but use a faster film to facilitate a shutter speed which has greater action-freezing potential. Assuming your original film was ISO 25 and working in EV stops, what is the shutter speed/aperture combination needed for an ISO 100 film? Simple enough, Provia 100 F is two EV stops faster than Kodachrome ISO 25, so change the Kodachrome's exposure by two EV stops to 1/500 sec at f/8. This combination will have the desired effect of freezing the gale-blown flower but it represents only one of several ways in which an ISO 25 exposure of 1/125 sec at f/8 could be changed by the two stops necessary to provide equivalent exposure on an ISO 100 film: 1/500 at f/8, 1/250 at f/11, 1/125 at f/16 and 1/60 at f/22 are all possibilities. However, since action-freezing potential is paramount, we opt for the fastest shutter speed option.

Indian Paintbrush, Arizona, one of the many red flowers that accent arid environments. 1/125sec was just sufficient to stop movement and camera shake for this hand-held shot – but only just. 1/125sec at f/5.6.

Controlling TTL metering

The difference between you, the enthusiast, and the average snap shooter, is one of attitude. Presumably you have purchased this book because you really want to gain some expertise in nature photography. The snap shooter's first likely question would be: why do I need to learn all this brain-stretching theory and work in EV stops when my through the lens (TTL) metering can work out all my exposures for me. TTL metering is certainly a tremendous and probably the most significant asset to your wildlife photography, but you cannot rely on it completely. There are four good reasons why you and not the meter must have the final say in exposure determinations:

- not every subject or scene that you photograph is going to be mid-toned, although this, at least in theory, is what your camera has been calibrated to.

- the creative element in you will, at times, wish to force the camera to greatly over- or underexpose the image.

- different films exhibit differing properties and often, through personal preference, you will consistently choose to under- or overexpose a particular type of film by say 1/3 of a stop. Perhaps this treatment provides better saturation of colours or imbues the image with some other purely subjective quality.

- exposure compensation is often necessary in tricky lighting conditions where there is heavy contrast.

All TTL meters measure light reflected from the subject (as opposed to an incident meter, which measures light falling on the subject). Providing the subject you are metering is mid-toned, your exposed slide of the subject will also be mid-toned. What, however, if your subject does not have average tonality? The commonest solution here would be to meter an 18% reflectance grey card in the same ambient light as your subject and to use that exposure reading to shoot your subject.

Ultimately, however, colour fidelity is less important than realizing your mental picture of the subject in the final exposed image. This could be a photograph in which mood has been enhanced through gross over- or underexposure. In such a case this is the correct exposure for that particular subject, even though it is very different from the camera's optimum exposure determination based on the subject's average tonality.

Staying in control

Transparency film has an exposure range of nearly $2^1/2$ EV stops either side of optimum: i.e. minus $2^1/2$ EV stops you have a black featureless image; plus $2^1/2$ stops you end up with complete bleach out. If you are going to inject a creative element and successfully realize your intended vision, you need to predict consistently how a mid-toned subject will change as you increase or decrease stops. Take, for instance, a speckled wood butterfly of average tonal range. The butterfly completely occupies the crucial viewfinder-metering zone and becomes a mid-toned brown image on film. My preference would be to underexpose by 1/3 of an EV stop in order to provide a more saturated rendition of its russet-coloured wings. This gives the image more impact and saleability. (Editors tend to favour slight underexposure when selecting transparencies for publication because the underexposed image generally retains more detail which can be brought out in the colour separation process used in printing.) If I were to underexpose by one stop, colours would no longer be true to

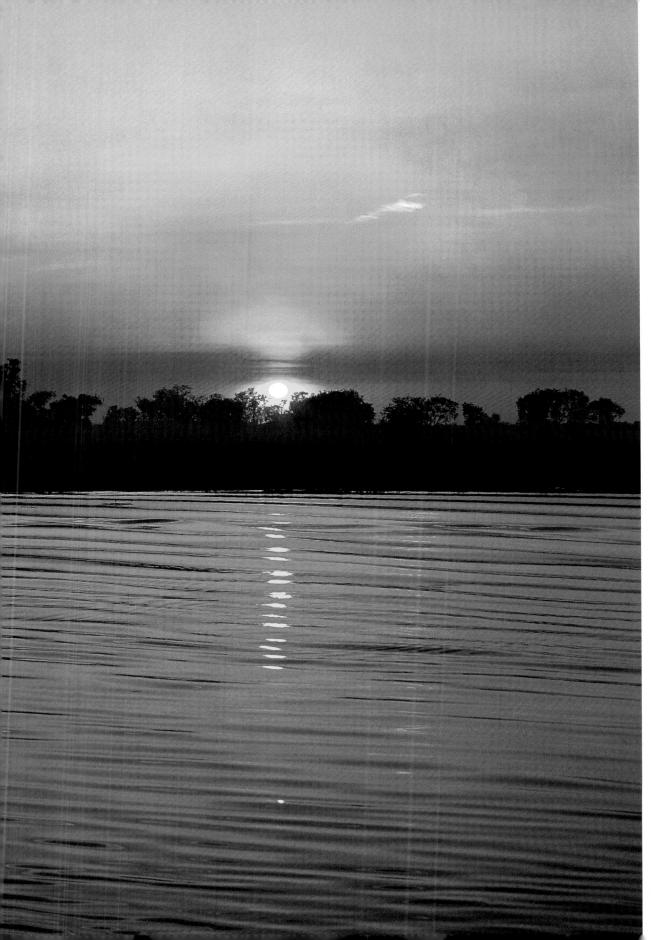

Sunset over Yellow Waters, Kakadu National Park, Northern Territory, Australia. The intense brightness of the sun will always tend to underexpose slide film in this kind of shot. I would guess that even the best TTL meters would be fooled to some degree. Fortunately, I feel, with sunsets slight under-exposure is desirable since it dramatically enhances warm evening colours . No filtration was used here. Pentax MZ5n + 28–70mm lens, hand-held.

This small irridescent brown argus butterfly is very bright and fools the camera's TTL metering into slight underexposure. In this case it actually improves the shot to have marginal underexposure and produce a mid-tone image.

life; at $1^1/2$ stops underexposure it looks like dusk has fallen; and at two stops down it would be like viewing the original butterfly through sunglasses at night.

On the other hand, if my subject were a clouded yellow butterfly, which is not mid-toned, my TTL meter would expose the extremely pale wings as mid-toned and this would result in underexposure. While I would probably consider this desirable in this particular instance, it is essential that you remain in control and can recognize what are mid-tones and what are not. If colour fidelity were important for my clouded yellow butterfly shot, I would have needed to provide up to a 1/2 stop extra exposure to that indicated by my TTL meter.

Similar compensation can be applied to difficult lighting situations. As a rule of thumb, if you don't have a grey card handy when shooting a subject heavily contrasted against a dominant bright background, avoid underexposure by increasing the exposure by x number of stops. Equally, a bright subject contrasted against a dark background will cause a TTL meter reading to overexpose the subject's detail, leading to a washed-out appearance. To compensate

for this, you must reduce the exposure by x number of stops. With experience x becomes a readily definable quantity – providing you always think in EV stops.

Armed with this knowledge you can now really begin to exert some control over the exposure-making process. Just as we all acquire our early mathematical skills the hard way, only later resorting to electronic calculators to assist us, it is only with a real understanding of exposure that I feel able to identify the various metering options available on modern cameras – matrix, spot, average, centre-weighted and multi-segment among them. Remember though, as yet none of these can completely replace your ability to determine subject tonality and tricky exposure issues – although they are definitely getting better at it.

As with the irridescent brown argus butterfly, this clouded yellow butterfly is so bright in the summer sun that exposures should also be bracketed to get it right. Pentax LX 100mm macro lens, TTL flash.

The relatively neutral colour of the southern form of the
speckled wood butterfly is unlikely to cause problems with a
TTL metering system.

Selecting an appropriate camera system

Despite the many impressive features of the modern camera body, it is still essentially no more than a black box to hold and expose film. When it comes to producing critically sharp images, the contribution made by the camera body pales into insignificance compared to that of high-quality optics and good technique. Much of the following discussion only applies to 35mm equipment, although some of it is relevant to the medium-format camera (see chapter 18).

To excel in the discipline of wildlife photography you must select a 35mm SLR camera from a system manufacturer, by which I mean one who can also supply a good range of quality prime lenses, particularly 50mm and 100mm macro lenses. Nikon, Pentax, Canon, Minolta, Contax, Leica, Sigma and Olympus all supply suitable gear. I prefer Pentax, although many professionals seem to favour Nikon or Canon.

If landscape photography is your forte, you should consider purchasing a medium-format camera. This shot of the Grand Canyon was taken at sunset from the North Rim using a Fuji GSW69iii which produces super large 6 x 9cm transparencies (half the size of a 5 x 4in large-format camera).

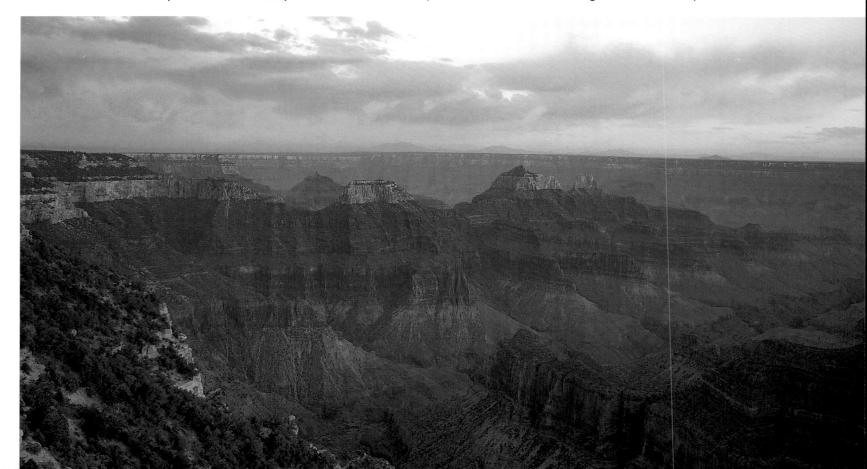

It would be wrong to compare individual cameras since the pace of development means that any comparison would soon be one of redundant models. I will leave the test reports to the magazines and focus on particular features not cameras, though for the record I favour the professional standard Pentax LX and Z1-P which I used for most of my work until Pentax brought out their MZ series of cameras. Little compares with the MZ5n – an amazing amateur camera capable of matching and exceeding results obtainable by many professional ones.

Essential features

When you set out to buy your camera, you should be looking for a reliable and rugged yet flexible tool. If you are at all serious about succeeding in this sphere of photography you really do need to ensure your camera has at least the following features:

- manual exposure
- through the lens (TTL) flash control
- wide range of high-class lenses
- remote release facility

- aperture priority exposure
- manual and auto focus
- mirror lock up
- power cord socket
- depth of field preview

Both my Pentax LX and Z1-P have all these features, and the LX has a sealed construction to provide a degree of weather-proofing – important when you are shooting in the humid tropics or a dusty desert. Also, when the batteries fail in sub-zero temperatures, its normally electronic shutter will continue to operate as a mechanical-only shutter. However, the budget price of the MZ series means you might not be so reluctant to take one with you to extreme places where you would think twice about taking a more expensive camera.

Let's run through the primary features in more detail:

Manual exposure control

This facility allows you to vary your exposure either side of the camera's determined optimum. It can be achieved by altering either the shutter speed or the aperture (see page 25) or, as I frequently do, the exposure compensation dial. It is worth reiterating that cameras do not always make the best choice of how to expose film – they need your input to override their in-built settings for a tricky lighting situation or when you want to be creative. Manual exposure control can also be used when employing a manual flash gun for exposing subjects using a variety of flash techniques (see chapter 11).

Aperture priority exposure control

For rapid setting of exposure or for use with a remote camera release, this is the preferred exposure mode. Aperture selection dictates depth of field and therefore apparent sharpness. For this reason it is useful not only for macro work but also in landscape and habitat photography. I would recommend you only consider buying a camera that provides a viewfinder readout of the coupled shutter speed. This is important because at slower shutter speeds you need to employ either a flash or tripod in order to avoid camera shake.

TTL flash

Arguably this is the most useful feature on a modern camera and I wouldn't consider buying one without it. Photo-cells respond to the light actually received at the film plane. As soon as sufficient light has been delivered, the flash output is quenched. The technique is discussed at some length on pages 65-70, but for present purposes I would say it offers the photographer the most convenient and accurate mechanism to achieve exposure with electronic flash.

Manual focus

This is the only mode suitable for close-up work in the field. I have never used the autofocus facility on my Pentax lenses for any of the 10,000 close-up slides I have on file. However, autofocus, which is now an almost universal standard, is useful if not essential for virtually all other aspects of nature photography – including speedy shots of static landscapes.

These two photographs of a Cardinal require different exposures, owing to the differences in magnification and altered ambient lighting of each image. The best way to obtain good repeat exposures under different conditions is to use TTL flash control, as I did here. Both images were taken with Pentax LX + 100mm macro lens.

Mirror lock up

This option is exceedingly useful, but these days it is limited to the very best of the professional cameras: notably the Nikon FM2, F3, F4, F5, Pentax LX and Z1-P (in the guise of 2sec self-timer), Contax RTS 111 and Leica R6. Its main purpose is to avoid mirror 'slap' at slow shutter speeds where the vibration can degrade image quality. Fortunately damping is very good in many modern cameras and mirror slap has been reduced to a minimum. Nevertheless, I regularly use this feature of my Pentax LX and find it particularly useful for studio-based slide duplication.

Wide range of high-class lenses

It is vital to establish that the system your camera belongs to contains high-quality optics in the 24–300mm range. Refer to the photographic press which often features optical tests on a single class of lens from different stables. Whatever you choose, make sure 50mm and 100mm macro lenses are available, and that (even if you can't imagine buying them yet) the manufacturer should also supply both a 200mm macro lens and a 300mm lens with a fast maximum aperture of f/2.8. Under this heading I will include the need for a set of three automatic extension tubes – sizes 12mm, 19mm and 26mm and a range of ultra high-quality dual element dioptres, optically corrected for use with lenses in the 200mm range. Medium telephoto zooms are also invaluable for general nature photography when you want to travel light. My favourite in this category is the Pentax 28–70mm zoom with a Nikon 3T dioptre in my pocket should I need to focus really close.

Power cord socket

Depending on the camera's sophistication, this feature permits either manual or TTL electronic flash to be used off the camera (i.e. remote from the camera's hot shoe). It facilitates multi-flash setups or allows for judicious positioning of small flash units to deliver even illumination to tiny subjects which tend to move with great alacrity and require the high speed of flash to arrest their movement.

Remote release

As with a mirror lock up, a remote release helps to prevent vibration during the moment of exposure. It is particularly useful for exposures longer than 1/30sec where an unsteady or heavy-handed individual might cause camera movement. Releases come in two basic forms: a simple, mechanically operated cable which screws into the shutter-release button; or the far more expensive electronic cable release

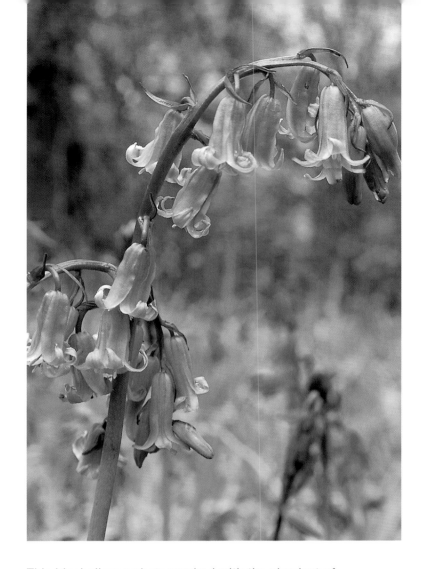

This bluebell was photographed with the simplest of equipment – a Pentax MZ series camera with a standard 28–70mm zoom lens. To achieve this shot I added a Nikon 3T dioptre and used a tripod. I focused manually and relied entirely on the camera's metering system for exposure.

which plugs into a dedicated socket. (Mine was second-hand and very cheap, and it works fine on all my electronic cameras which do not contain a screw-threaded shutter release.)

Depth of field preview

Depth of field is the zone of sharpness, which, in close-up photography, extends equally on either side of the exact point of focus (in normal photography the zone of sharpness extends two-thirds behind and one-third in front of the point of focus). The lore on depth of field states:

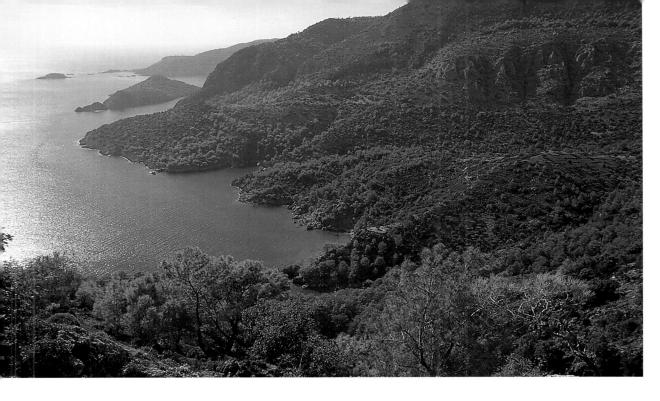

A straightforward shot of the Turkish coastline between Kaya and Ölu Deniz taken on aperture priority at f/16. Pentax LX with 28mm prime lens.

1 That the smaller the lens aperture, the greater the depth of field and vice versa

2 For a given lens aperture, depth of field decreases as the distance to the point of focus decreases

3 When the distance between film plane and point of focus is fixed, increasing the focal length of a lens will decrease the depth of field

and

4 For a given magnification rate, say 1 x, and a fixed aperture, lenses with a different focal length will yield an image with the same depth of field.

To illustrate some of these points I have included the following table, which shows how the magnification rate of either a 50mm or 100mm lens affects depth of field over a typical range of apertures.

Magnification rate	Depth of field in mm at				
	f/5.6	f/8	f/11	f/16	f/22
1/10 x	36.4	52.0	72.8	106.0	148.4
1 x	0.7	0.96	1.3	1.92	2.69

If you have absorbed all this I am sure you now appreciate the value of having a depth of field preview lever which manually stops the lens down to the selected aperture, giving an instant view of the depth over which the plane of sharpness extends. For instance, you may wish to lose the cluttered background of vegetation behind a butterfly freshly emerging from its chrysalis, or the grassy background concealing and distracting from a well-camouflaged praying mantis. In these situations you would open the lens aperture to obtain a narrower depth of field and thus achieve the necessary differential focus to make the subject 'pop' into vision. Alternatively, you may need to extend depth of field in order to render a fairly large beetle sharp over its entire width.

Several secondary features are useful if not quite as important as these primary features. First, autowinders and motordrives, whether built-in or discrete, are handy options, though they are less useful in close-up work than in other spheres of nature photography. You will certainly increase the repertoire of flash possibilities with 1/250sec flash synchronization, but it isn't a prerequisite to obtaining pin-sharp images of flighty insects where electronic flash has been balanced with ambient light. Likewise, multimode cameras with shutter priority exposure control, spot-, multi-segment- or matrix-metering are all useful but not essential. Their presence can augment your potential to take good wildlife photos, but not guarantee them. Finally, innovations such as red-eye reduction, 35mm (or APS) panoramic modes, and DX coding for film speed are more for the snap shot amateur market; I do not consider them to be features that should influence your purchasing decision.

Film selection

8

Two of the most amazing phenomena of our times are so commonplace that most people take them for granted. Manned flight and an ability to record images on film, are, in my opinion, among the greatest technological achievements, and I am always in awe of them. In particular I wonder at the almost magical act of recording an image on celluloid simply by aiming a lens and pressing a button. Of course magic has nothing to do with it, and a basic understanding of how a film works will help you to choose and use films to best advantage.

I will work on the premise that most readers will be interested in achieving the sharpest possible rendition of their subjects. For this reason you will need to select the slowest film speed that suits your prospective image – typically ISO 25–100. A slow film, Kodachrome 25 for instance, is virtually grain-free. However, as the ISO number increases, so a compromise is made between speed, grain and therefore sharpness. At ISO 400 and above you lose the ability to produce bitingly sharp images and I would suggest that unless you are after a specifically grainy image a fast film would simply compromise the effective use of an expensive high-quality lens. (ISO stands for International Standards Organization and is synonymous with ASA.)

Tropical rainforest, Western Ghats. Shots like this require one of two approaches; first, a fast film and hand-held camera yielding grainy, poorly defined images, or, second, a slow film in concert with a tripod and small apertures. I adopted the latter approach. Fuji GA 645Wi, 1.5–2sec, Velvia, tripod. If I had to reshoot this scene, I might go for Provia 100F: faster than Velvia but with a finer grain structure permitting excellent sharpness. The extra stop would allow a smaller aperture at 2sec (the longest auto exposure on this camera), to further improve depth of field.

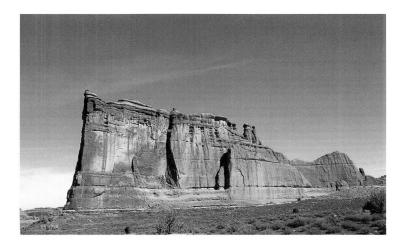

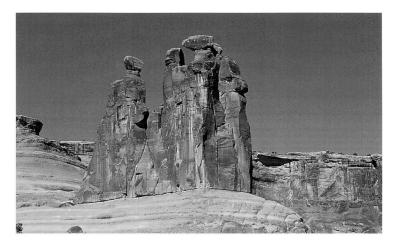

The bright conditions in Arches National Park, Utah, mean that you can safely use a slow film, say Velvia, and hand-hold your camera, even when applying small apertures. This is particularly true if you are using a lens in the 28–100mm range,

because under these conditions shutter speeds are generally above 1/30 or 1/60 sec. The rock formation on the left is the Organ; above is Three Gossips. Both shots were taken using 35mm SLR with standard zoom lens. Unilock tripod.

Transparency vs. print

If you have any aspirations to marketing your wildlife images you should only ever consider using slide film. Colour negative film (print film) is for the hobbyist, and without exception transparencies (slides) are the preferred medium for high-quality reproduction of colour pictures in magazines and books.

Transparencies have a number of advantages over prints. First, they are sharper because a print is just that: it has already been through the printing process once, and each time this is effected there is a loss of quality. Second, transparencies are returned from the lab exposed as intended, whereas colour printing machines automatically compensate for and adjust print exposure. Third, they are usually cheaper and finally, they are easier to store and retrieve in readily viewed filing systems.

Which brand?

It is easy to be objective about parameters such as film speed, grain and apparent sharpness; selecting a film brand is far more subjective. Professional nature photographers have tended to favour Kodachrome, although in recent years many appear to be switching to Fuji Velvia or Provia 100F (currently where my preference lies). Experiment with different brands and make up your own mind; if you like one, stick with it and learn to predict how it behaves under different conditions.

I have stuck fairly rigidly to Kodachrome 25, 64 and ISO 50 and 100 films by Fuji. I have no hesitation in indicating Kodachrome 64 and Fuji Velvia as my favourite slow films. I find it hard to distinguish between the sharpness of images taken on these films and Kodachrome 25, hence I usually select Kodachrome 64/Fuji Velvia for the extra stop in exposure that they give me.

Green frog species, face on. Pentax LX + 100mm macro lens, AF280T flash, f/11 on Kodachrome 64.

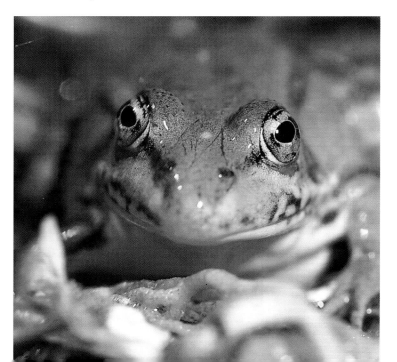

In addition to Kodak and Fuji, other film manufacturers include Agfa and Konica. Many films are sold under brand names which reflect high street supermarkets and chemist shops. These films are not manufactured by the high-street chains that market them, but by international manufacturing companies.

Many films are available in professional and amateur versions. For nature photography I would recommend the amateur since this version is more robust and has a longer shelf life – an important consideration if you are travelling to warmer parts of the world.

If you are aiming towards high resolution photography, you require the fine grain of ISO 25/50/64. However, if your subject is in conditions of limited illumination and you resort to a tripod and long exposure times as opposed to flash, you may encounter a problem known as 'reciprocity failure'. This will be enhanced where close-up work is achieved through extension with its attendant light loss.

Reciprocity failure might occur in autumnal oak woodland where the still intact canopy of leaves reduces the incident light falling on fungi fruiting among the leaf litter. If under these conditions your exposure time exceeds one second and you allow your camera to record the fungi on an auto setting your slide may be underexposed. This is because the normal reciprocal relationship between aperture and shutter speed falls apart at very long or very brief exposure times. The amount of extra light necessary to compensate for reciprocity failure varies from film to film. It is a simple matter, and one I'd encourage, to undertake a series of test shots to work out the compensation needed for your favourite film(s), although the following chart gives the recommended exposure compensation for some commonly used transparency films.

Velvia ISO 50; at 4sec open aperture by 1/3 of a stop (CCO5 magenta)
Kodachrome ISO 25; at 1sec open aperture by 1/2 stop (no filter)
Kodachrome ISO 64; at 1sec open aperture by 1 stop or as a rule of thumb double the exposure given beyond one second (CC10 red)
Sensia ISO 100; no compensation necessary
(The recommended filtration is given in brackets.)

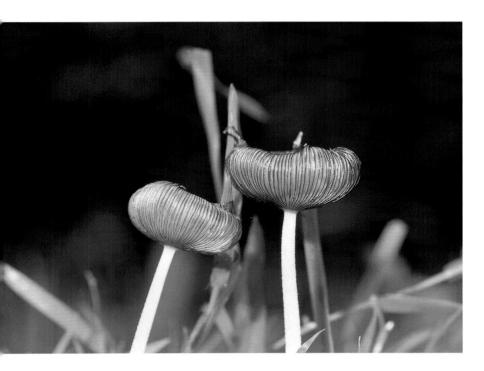

I came across these mini toadstools (*Tubaria furfuracea*) in an alpine wood in Austria. I relied on the ground's soft layer of vegetation to support the camera, but also used a burst of fill-in flash to add punch to the final image shot on Velvia.

Tips for the safe handling of your films

In very cold conditions avoid autowinding and rewinding – stick to manual operation if possible – because at low temperatures, film becomes brittle and the sprocket holes tear very easily.

In warm humid conditions maintain film in hermetically sealed containers, preferably containing activated (blue) silica gel. This is more important for exposed and fast films than slow and unexposed films.

Avoid contact with the following substances as they are likely to damage film emulsions: mothballs, paints, solvents (i.e. in cleaners and adhesives), car exhaust fumes, biocides (including anti-fungal agents) and foam insulation.

Process your films immediately – don't leave them lying around after exposure.

The effect of X-ray machines

Whether or not film is damaged by the use of X-ray machines as part of airport security is a regularly debated subject and one which remains largely unresolved. The value of lead bags is unclear and may simply cause the machine operator to boost the power to investigate the shielded bag. My advice is to ask for a hand search, particularly if you are making extensive use of domestic flights which means your films would otherwise incur a substantial cumulative dose of radiation. In the US a Federal Aviation Authority ruling entitles anybody to a hand search upon request. I can still remember the intimidating look on an official's face in Dubrovnik when I requested a hand search. His wordless grunt unmistakingly conveyed the message: put your film through the machine or else. I have never experienced any problems due to X-ray exposure and if I'm travelling within Europe I don't bother to request a hand search. Still, fast films above ISO 400 should not really be X-rayed: it has been reported that a single pass dose of 0.3 milliroentgens will damage ISO 400 film after 10 passes and ISO 100 film after 30 passes. However, be especially careful in Third World countries where X-ray machines may be old and not particularly 'film safe'.

Amphitheatre at Xanthos, Turkey. Pictures like this benefit from an off-centre subject providing a sense of scale. Kodachrome 64 on a Yashica T3 compact camera.

A more worrying trend in recent years has been the introduction of a new generation of super X-ray machines which are capable of scanning luggage for electronic devices that could be suspicious, and subsequently pumping up the X-ray power to search for explosives. These apparently do harm film, particularly APS film. At the time of writing, these machines only monitor luggage destined for the plane's hold, so what you take with you in the cabin should be spared. However, in the UK at least, hand searches are generally refused and health and safety regulations are now limiting the weight of hand luggage to around the measly 5kg (11lb) mark (marginally more on long-haul flights), so if you want to keep your film safe in your hand luggage, you need to cut down on your camera equipment. As an alternative, if you are travelling as part of a group or with family members, you may be able to distribute your kit among them to comply with the personal luggage allowance.

Camera supports

To photograph nature in the field you need a tripod. What you select will necessarily be a compromise in weight terms between what you can comfortably carry and how solidly it can anchor your camera and lens at lengthy shutter speeds. In my opinion you are unlikely to find such a combination for much less than the £150/$200 mark at today's prices.

You may ask: do I actually need a tripod? I'd say you do. Most pictures in this book were taken with either flash or a tripod (or some other support) or both. Very few images were taken hand held with ambient lighting alone. Any proficient nature photographer would recommend buying a good-quality tripod.

Sunset Point at dusk, Bryce Canyon, Utah. I took this image at that critical point between day and night where light is at its most precious. I was at an EV almost beyond the camera's auto exposure limits. However, since I had a sturdy Unilock tripod with me this presented no problem. I was the only person at Bryce on this evening with a tripod, yet there were hundreds of people with hand held cameras merrily clicking away, flashes automatically discharging willy nilly. I wonder what their images came out like. Not like this one, I suspect. Mamiya 7ii + 65mm wideangle lens, f/16, 3–4 sec, Velvia, tripod.

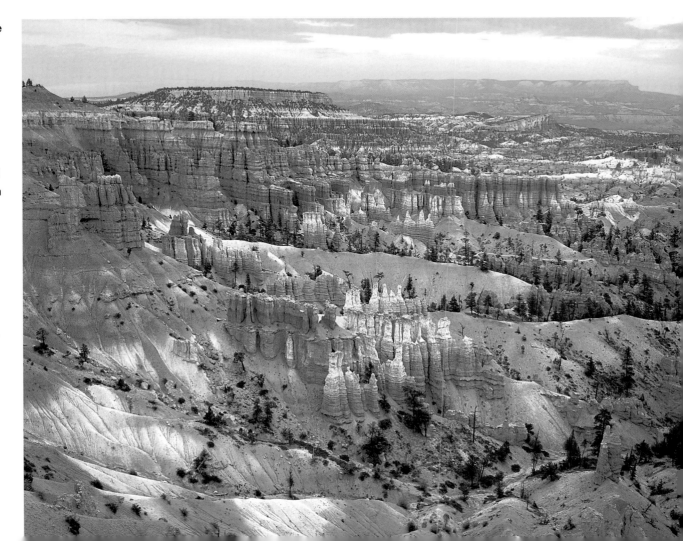

So the next question has to be: what do you look for in a good-quality tripod suitable for both general and close-up work? The perfect tripod would be too heavy to move; we need to be pragmatic here. I have compiled a list of tripod features ideal, if not essential, for landscape, close-up and general wildlife work:

- a solid, heavy-duty construction which can take knocks and withstand extreme conditions
- a mechanism which allows low-level work without recourse to reversing the centre column and/or attaching the camera from below

- spiked legs for extra grip
- sealed, water- and mudproof legs
- a large dynamic range between its minimum and maximum working height (without extending the centre column, which will compromise stability)
- fewest leg sections, since these are potential weak points
- potentially the most important feature of all: try to get a tripod with a carrying strap attached directly to it. This may seem a small point, but it can make the difference between taking your tripod with you on a trek or leaving it at home. A carry bag for your tripod is not the same thing
- a varied range of high-quality heads must be available to include a large ball and socket (don't consider the more common mini ball and socket heads), a quick-release head based on both a ball and socket and a pan and tilt head, and, finally, a good pan and tilt head (expect to pay half as much as the tripod for a good head).

While I look after my photographic kit and maintain it in pristine condition, you can't care for your tripod in the same way. It's too big and it will become battered pretty quickly if you use it properly and take it with you on your nature forays. However, despite a worn appearance, a good tripod should give you years of service.

I photographed this flowering fishhook cactus (*Mammilaria microcarpa*) in the Sonoran desert. The beauty of Unilock/Benbo style tripods is that they let you get really low on uneven terrain. Pentax MZ5n, 28–70 zoom with Nikon 3T dioptre. Ambient light.

Natural Bridge, Bryce Canyon National Park, Utah. Despite the vibrant lighting, a stiff wind was blowing when I took this picture. I held the centre arm of my Unilock tripod with all my weight to stabilize the Mamiya 7ii. The result is a tack-sharp picture. Sometimes I loop my gadget bag over the tripod to help steady it under breezy conditions.

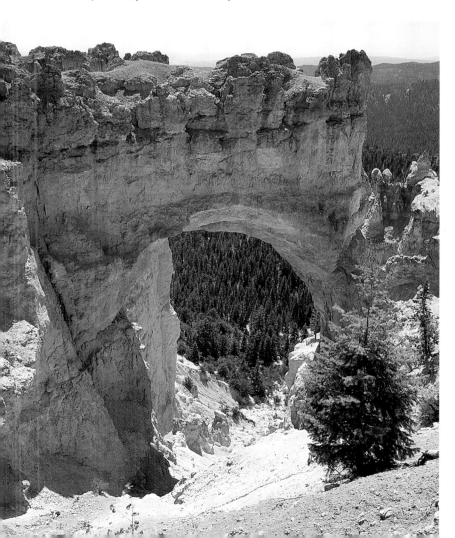

My own preference is for a design first used several decades ago to support theodolites. At the time of writing, the design is marketed by two companies: Benbo (from 'bent bolt') and Unilock. I strongly recommend the Benbo Mark I and Unilock Model 1600 tripods – I have one of each. These days the Mark I gets regular use in my slide duplication procedure while the Unilock gets all the hammer out in the field. The reason for this is simple: my Unilock has the one carry strap I possess attached. That apart, there appears to be no difference between models and both tripods fulfil the above criteria. They extend to about 1.6m (5ft), weigh 3.4kg (7$\frac{1}{2}$lb) and both are based on a unique yet simple design in which the three legs are connected by means of a bent bolt and, along with the centre column, can be locked in place by twisting a single lever. This means the legs move independently and can be placed in any position on any terrain, from flat out horizontal for close-up work to one leg down, two up for leaning against a tree or rock face. With this design the centre column can be twisted around from the vertical to the horizontal for excellent low level work. There are other commendable designs, among them the Manfrotto Triminor and certain Slik and Gitzo models, which also make low level close-up work possible. The solid 2.65kg (nearly 6lb)

Arizona barrel cactus in flower. This was also shot using a Unilock tripod, but I employed fill-in flash to bring out the colour of the scarlet flowers. Pentax MZ5n, 28–70mm zoom.

Triminor for instance can be used down to a minimum height of 0.26m (8in) because the centre column can be divided into two and the legs splayed accordingly. There is also a trend developing for the use of carbon fibre for tripods, which combines portability with strength.

It is difficult to give advice on heads. Provided you select one of robust design commensurate with your tripod, it will do the job. I often use a large ball and socket head, which I screw into the AF400T bracket of my Pentax LX and Z1-P to save the constant wear and tear on the tripod socket of my camera bodies. Although I have become a dab hand at this, I also use a quick release platform – particularly with my medium- and even large-format cameras.

Every book on photography gives the same basic rule regarding when to employ a tripod. Each one indicates using a support when the reciprocal shutter speed value drops below the equivalent focal

When I took this shot of the Turkish coastline between Kaya and Ölu Deniz it was 95 degrees – not at all weather suitable for carrying a tripod. Thus I used a T-shirt to stabilize the camera against a rock.

The above shot can be compared with this second one of the Turkish coastline at Cavus. Here I used a sturdy but lightweight Manfrotto tripod to stabilize my Fuji GA 645Wi which was used at a small aperture to obtain good depth of field. Both shots are acceptably sharp.

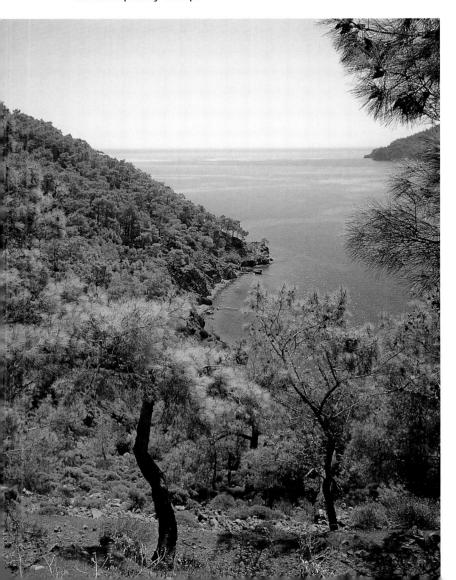

length value of the lens being used – in other words, use a tripod at shutter speeds below 1/50sec, 1/100sec and 1/200sec for 50, 100 and 200mm lenses respectively. This simply doesn't apply in close-up work. I can photograph alligators in the Everglades of Florida at approaching infinity focus with no problem using my 90mm lens hand held at 1/90sec. However, extended to give life-size magnification, 1/90sec hand held would produce a terrible fuzzy image no matter how careful I was. You need a tripod (or flash) because as you magnify the image, you magnify any movement. Compromise to gain shutter speed means either wide apertures and or fast film speeds. This is not the answer, for you lose depth of field (and hence apparent sharpness) and resolution due to the grainy film. If you are half-way serious about nature photography you will take the tripod (or flash) option.

A tripod has one very distinct advantage over flash: it provides the opportunity to compose and recompose an image – to consider aspects of composition and design. Most importantly, it engenders a patient and considered approach to your work.

My personal feeling is that at the point at which lens extension combinations become too unwieldy (say 200mm of extension on a 200mm lens to give life-size reproduction), the use of a tripod is obviously essential. But the cumbersome photographic kit is becoming less applicable to the field situation, and far removed from the convenience of a tripod with a 100mm macro lens with or without moderate extension, which is the ideal combination for most macro situations in the field – plant work especially. For normal telephoto applications, I often use a 200mm lens hand held, but would never attempt using my 300mm f/4 lens hand held – a tripod has to be used with this heavy lens, and for anything longer, even on the brightest day.

When travelling by air, I stash my tripod in my suitcase with my clothes, wrapped in a few towels for extra protection – and have never had any problems yet. Putting it unprotected directly in the hold of the plane is a recipe for disaster.

Although our focus of attention has been the tripod, don't overlook the myriad of other supports available for your camera, from rifle stock rigs and clamp type assemblies which can be attached to tree branches and car doors, to bean bags or, as I often use, a rolled-up T-shirt or towel. Whatever you use, a properly supported camera and lens will almost always give you better results than can be achieved hand held.

Focusing *close*

By now you may have guessed that one of my passions is close-up photography. I make no apologies for my tendency to steer this book towards this aspect of the subject. After all, it provides the amateur naturalist with a larger array of potential subjects than any other branch of nature photography – butterflies, lizards, snakes, beetles and flowers – and I haven't even begun to exhaust the possibilities.

There is a variety of ways of focusing close, some more expensive than others. The Asian tree frog was taken using a 100mm macro lens at 1 x magnification; the green toadlet was shot with a 50mm macro lens at life size; and the southern form of speckled wood butterfly using a second-hand 50mm lens + a mid-sized extension tube giving 3/4 x magnification.

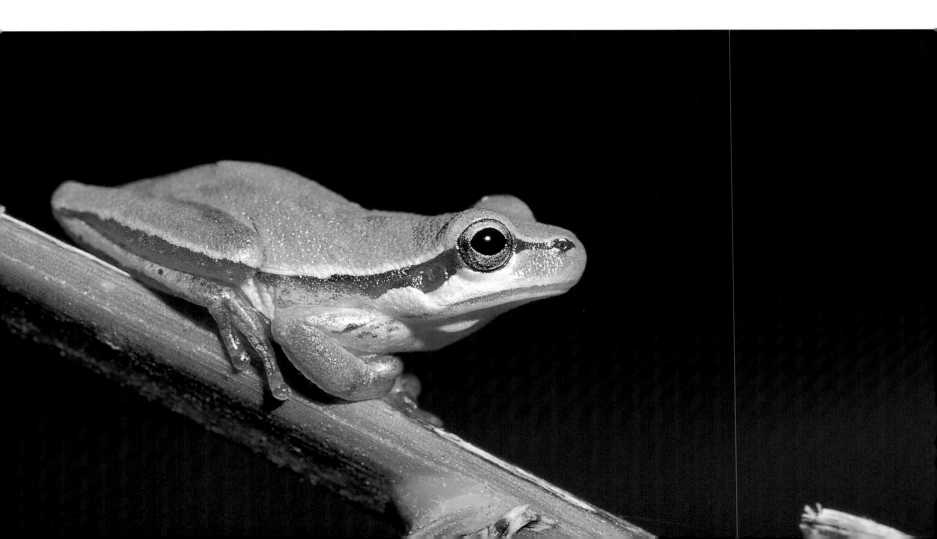

The rules of general photography start to vary as you shoot closer. For this reason, I'll go into some detail in describing the ins and outs of close-up photography.

I have read what is considered to be an extremely authoritative text on the subject of close-up photography and was amazed at the misguided list of priorities cited for this type of work. The most apparent disparity between that author, who cites the importance of camera design without mentioning lenses, and me is that I would ignore camera design and put the emphasis on quality optics. By adopting my pragmatic approach, and given good-quality optical glass together with a knowledge of the accessories available to help you focus reasonably close, I am confident you will acquire far greater skill in this field than by poring over detailed books on equation-rich theory written by 'armchair experts' and illustrated by a plethora of different photographers whose 'stock' photos appear to illustrate concepts but probably don't.

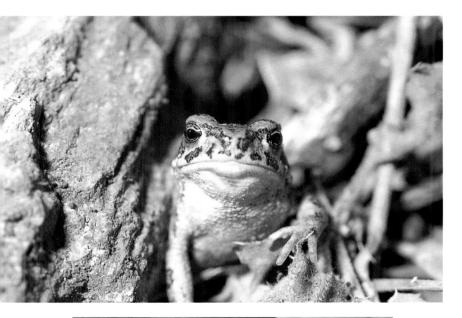

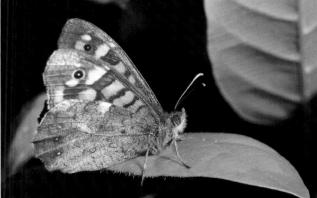

detail on a transparency reflect the resolution of the imaging system, and are the most likely casualties of an extended circle of confusion.) Ultimately we end up with another compromise, this time between the need for adequate depth of field and the associated loss in resolution which is related to small apertures and extension.

The images which get in close to animals and plants in my book were actually exposed using the techniques that are being taught and have an accurate technical and biological provenance. In fact, in all your future photographic reading I urge you to focus on texts written and illustrated by a single expert since you will undoubtedly learn more. Names that spring to mind include John Shaw, Ken Preston-Mafham, Joe McDonald and Heather Angel.

Having made my 'statement', here are the techniques that I personally use for my photography. There are other, more peripheral, ones for achieving close-up images of nature, but as these are not a practical option for out and about work I mention them only briefly at the end.

Focusing close by extending the distance between lens and film plane

This is one of the most useful and convenient techniques available for the close-up wildlife photographer since it allows ordinary, non-macro lenses to be used up to and slightly in excess of 1x magnification without degrading image quality. Two accessories can facilitate this technique: a set of extension tubes or a bellows unit.

In the field only an extension tube set is sufficiently robust to take the punishment necessary to obtain good pictures. A set of tubes is represented by metal rings of approximately 12, 24 and 36mm. Their inner surfaces are painted matt black to reduce internal reflections. Only consider purchasing a set that retains the automatic diaphragm coupling of your prime lens. While tubes are extremely well constructed, by comparison a bellows unit is less utilitarian. It consists of an extendable, concertina-like, light, tight fabric supported on an adjustable rail. This flexible construction generally precludes the bellows unit from hand-held fieldwork in harsh environments.

My favourite lens for tube extension is the standard 50mm. Until fairly recently most people bought their camera body with this lens attached since it best approximates to the perspective of the human eye. It is also of a superior optical quality and requires only moderate extension to achieve respectable magnification rates. If you consider that the approximate magnification rate equals the length of extension/focal length of lens, a 50mm lens with 50mm of extension provides life-size magnification (50/50 = 1). The table on page 48 illustrates the amount of extension required for what I consider to be useful focal length lenses in order to achieve 1/2 x, 3/4 x, 1 x and $1^{1}/_{2}$ x magnification.

I would recommend the 50mm standard lens with up to 50mm of extension as a very workable combination with flash. However, as you will learn in chapter 11, the closer your flash to your subject, the more critical the positioning of that flash for correct exposure, and a 50mm lens when extended does get very close to the subject.

It becomes apparent that for a given extension value, less magnification is obtained as the focal length of a lens increases. So, 50mm of extension on a 50mm lens provides life-size reproduction while 50mm of extension on a 100mm lens provides only 1/2 x

Lenses

Macro lenses

You will have become aware from my comments in the previous section that you don't actually need a macro lens to take first-rate close-up pictures. That said, there are very good reasons for investing a substantial amount of money in a quality macro lens.

At the time of writing, true macro lenses from a variety of manufacturers are available in the following focal lengths: 50, 55, 60, 90, 100, 105, 180 and 200mm. Clearly, these fall into three distinct ranges, approximating to round numbers of 50, 100 and 200mm. I will discuss macro lenses in broad terms by referring to these three focal lengths only, given that the difference between 50 and 60 or 100 and 105mm etc is negligible.

Until recently, macro lenses were mounted in helical tubes which provided sufficient built-in extension to give up to 1 x magnification, but more typically 1/2 x. Lenses that provided 1/2 x magnification were usually supplied with a specially constructed extension tube to take the magnification factor to life size. For instance, the Nikon 55mm micro lens, since updated by the 60mm micro lens, needs the PK-13, 27.5mm-long tube to extend the lens from 1/2 x to 1 x life size i.e:

$$\frac{27.5mm \text{ (built in extension)} + 27.5mm \text{ (PK-13 tube)}}{55mm \text{ (focal length of lens)}} = 1x$$

Fortunately, in nearly all cases, modern macro lenses have done away with this need and are capable of focusing to life size without recourse to any tubes or other bolt-on extras. The need for further extension has been removed to a certain extent by using a floating element design. Modern macro lenses also tend to possess faster maximum apertures than their predecessors.

So what makes a macro lens so special? Well, the optical quality of these lenses is so high that few other types of lens can compete with them at any focused distance. In the close-up range they are corrected for image curvature leading to enhanced flat-field reproduction. This is achieved in the Pentax 100 and 200mm macro lenses by incorporating a fixed rear element extension (FREE)

Diffraction

This is the second factor to influence extension. As light rays pass by your iris blades, they bend. This diffraction of light becomes enhanced at small apertures. Therefore since at high magnification

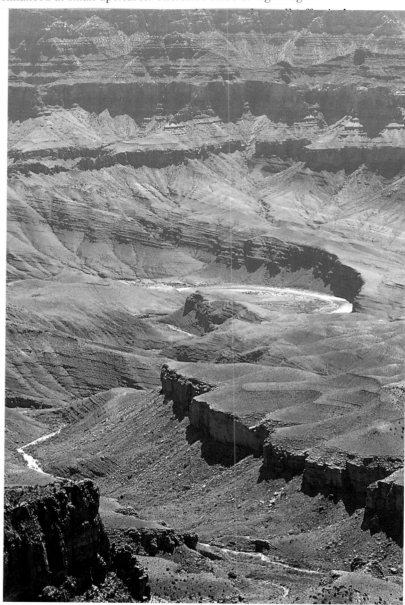

A telephoto lens was used to compress perspective across the Grand Canyon from Cape Royal. Pentax LX+ 70–150mm zoom.

which also reduces spherical aberration and improves image definition. Minimizing curvature of field makes macro lenses ideal for photographing documents and other flat, two-dimensional subjects. In the field, where subjects are three-dimensional, optical correction is perhaps less useful and is the reason why 'uncorrected' normal lenses when extended can apparently produce results as good as a purpose-built macro lens. However, the single most important feature of a macro lens is its ability to provide a continuous focusing range from infinity to life size, something you cannot do with extension tubes or screw-on supplementary lenses.

Great blue heron (white form), Anhinga Trail, Everglades National Park. 200mm lens on Pentax SLR.

I especially like the graphic quality of the close-up of this feather. 100mm macro lens + flash.

Thus in a split second, you can change your point of focus from a minute wasp to a distant mountain scape. On more than one occasion I have had 75mm of extension on my 50mm standard lens to achieve $1^{1}/_{2}$ x magnification for shooting hoverflies, jumping spiders or some other diminutive organism, when a new or spectacular species of butterfly presents itself within feet of my camera. Unfortunately the amount of time and movement required to reconfigure my 50mm standard lens with, say, a 12.5mm tube will, in all likelihood, frighten the butterfly away.

For this reason more than any other, macro lenses are a dream for the wildlife photographer. Remember always that macro lenses are not only superb in the close-up world but also razor-sharp at and up to infinity. In fact, the prudent among you should consider buying your camera body with a 50mm macro lens rather than a 50mm standard lens (or standard zoom) since the macro lens does almost everything the standard lens does and more. The standard lens is likely to be slightly faster (typically f/1.7 vs. f/2.8), but whoever uses a standard focal lens at this aperture? I don't – optical quality would be awful.

How much would you expect to pay for a quality macro lens? Given fluctuating exchange rates and inflation, let's price them up with respect to a standard f/1.7 50mm lens. Very roughly, a 50, 100 and 200mm macro lens will set you back five, ten and twenty times the price of a standard lens respectively. Clearly they are not cheap, so do consider the second-hand market – if you know what to look for, you may get a bargain.

Before considering the characteristic image-making qualities of individual macro lenses of specified focal lengths between 50 and 200mm, you may find it worth going through the optical terminology glossary, because your final selection may well be influenced by reading the comparative tests featured in many photography magazines. To help you wade through the typical optical jargon, take a look at my lens-related definitions. The terms apply to lenses of all focal length, and are also important for longer telephoto lenses designed for use at large apertures.

Optical terminology: a glossary

Chromatic aberration

Chromatic aberration or colour fringing is a particular problem of telephoto lenses and wide apertures. Some modern lenses, termed apochromatic lenses, have been designed to eradicate this problem. These lenses are variously referred to as APO (Apochromatic), AT (advanced technology), ED (extra low dispersion glass), L (luxury) or LD (low dispersion glass). All lenses with these designations identify high-quality, colour-corrected optics. This means that they can focus the different wavelengths (colours) of the spectrum to the same point of focus and therefore produce very sharp, punchy images. A lens manufactured using ordinary glass is usually achromatic which may render green light sharp at the point of focus while the red and blue light is unfocused, producing colour fringing. This effect is reduced at small apertures with their attendant increased depth of focus and depth of field, hence unsurprisingly APO lenses are particularly useful at producing punchy sharp images at wide apertures. Leica makes 100mm f/2.8 and f/4 APO macro lenses; Sigma has 180mm f/2.8 and f/5.6 APO macros; and Pentax a 200mm f/4 ED macro lens.

Spherical aberration

The spherical surface of lenses tends to bring non-central rays of light to a different point of focus from those at the centre of the image. Such aberration is accentuated at large apertures, short focal lengths and in the close-up range.

Distortion

Non-symmetrical lenses, particularly zoom lenses, produce 'pincushion' and 'barrel' distortions, i.e. parallel lines towards the edge of the image may transform into convex lines at shorter focal lengths and concave lines at longer focal lengths.

Diffraction

Diffraction is the bending of light rays around an opaque object, such as the iris blades of a lens. This important subject is reviewed extensively on page 48.

This feeding hoverfly was shot with 50mm of extension on a 50mm lens to give life-size magnification on film.

At the risk of being a bore, allow me to reiterate: good glass doesn't come cheap. If you want to use photomacrographic techniques to produce quality pictures and insist on new equipment as opposed to second-hand, you must be prepared to part with a significant amount of money – for some macros lenses well over ten times the price of a standard 50mm lens.

The 50mm macro lens

If you already own or are proposing to purchase say a Nikon 60mm micro lens, these comments are as pertinent to you as to the owner of a Pentax or Canon 50mm macro lens because the extra 10mm of focal length makes very little difference to lens characteristics in this range.

The Pentax 50mm macro lens is a personal favourite of mine. In general, however, professionals seem to frown upon the 50mm macro, citing such problems as reduced working distances and the need for more critical application of flash lore (i.e. positioning of flash becomes more critical at reduced working distances). While I can't deny these points are true, my Pentax is light, sharp as a razor, and doubles up as a fine landscape lens. It is also easier to hold by hand and less tiring to carry over distances. On a foreign trek its small size and portability could prove invaluable. I feel too that it is the best lens for critical slide duplication.

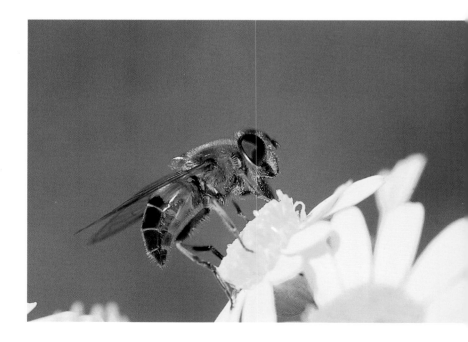

At life-size reproduction the minimum focusing distance of my 50mm lens is 0.195m (7¹/2in), so it is important to gauge the distance between lens and subject. For instance, I have accidentally knocked the odd spider from its web using this focal length lens, and the degree of scratching on the protective UV filter over my 50mm lens compared with the one on my 100mm lens highlights the problems of getting too close to your subject. However, if you can live with its drawback, this small, light lens is very easy (if not ideal) to extend with a minimum of tubes or to reverse with an appropriate adapter. When you consider that the large 47-degree angle of view records scenes in a perspective similar to the way the human eye perceives images, you realize that this close-up lens doubles as a good all-purpose lens. As a compromise for all occasions I reckon this lens to be one of the best.

The meadow brown butterfly feeding at a rock rose flower was taken with a 100mm macro lens. The advantage of a macro lens over tubes or dioptres is the continual focus from life size to infinity. This means you can quickly adapt to moving subjects and subjects of differing sizes.

In apparent contradiction, the greatest disadvantage to this focal length when working close-up in the field is its tendency to record a cluttered, distracting background, owing to its relatively wide angle of view. The longer the focal length of a lens, the less the angle of view and hence the more the subject is isolated from its distracting background. Remember, you will usually be working at small apertures which optimize depth of field. So with close-up subjects viewed through a 50mm lens, you need to scrutinize the background as well as your subject to assist in your composition and design. I recommend you utilize your depth of field preview button wherever possible.

The 100mm macro lens

Few people would argue that this focal length represents the most practical one for close-up wildlife photography in the field. The increased working distance at life-size reproduction compared with the 50mm lens (0.3m/1ft for my Pentax 100mm f/2.8 lens) makes this optic better suited to photographing certain types of animal which do not welcome close attention, among them snakes, lizards and many butterflies. This is true particularly in warm climates where cold-

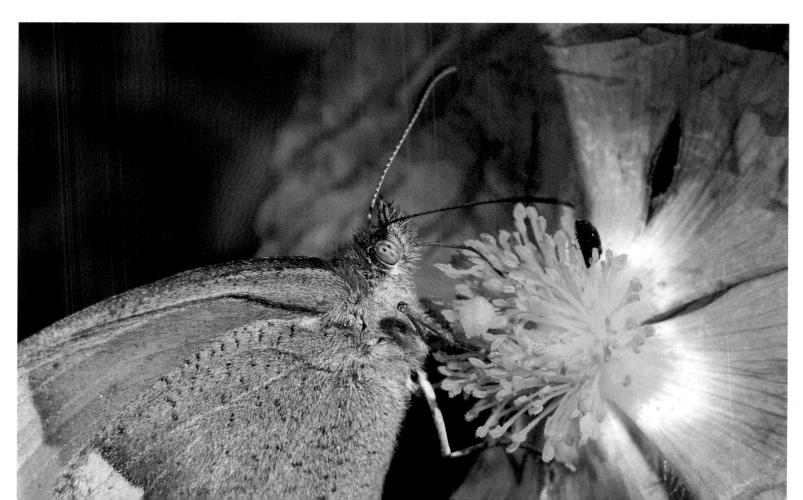

Turkey vulture in Florida's Everglades National Park. This was one of several birds attending a road kill. Pentax LX and 90mm macro lens.

The shot illustrates how convenient and versatile macro lenses in the 100mm range are. Within seconds you can shoot either minute insects or portraits of birds or mammals.

blooded organisms are often quick to evade the attention of any prospective wildlife photographers. Again in comparison to the 50mm lens, the 100mm macro's diminished 24.5-degree angle of view will help to reduce any distracting background intrusion into your pictures.

I might mention that in one magazine's comparison of eight 90–105mm macro lenses, all with the exception of an independent brand provided an outstanding optical performance. In fact, if I was assembling a photographic kit from scratch and money was no object, I would not be able to decide which of the macro lenses on test was best. Top-marque brands such as Nikon and Canon were comparable to the Pentax and Tamron lenses. Both my Pentax FA 100mm f/2.8 and Tamron 90mm f/2.5 were featured and turned in

results which were truly superb. The Tamron probably just had the edge but unfortunately, used solo, it can only focus to 1/2 x life size, unlike the Pentax which can focus down to 1 x life size. Tamron has since released a new 90mm macro lens capable of life-size magnification which replaces the older lower magnification model. My reason for referring to this test was that while lens performance varied little, prices varied greatly (with the most expensive one being very nearly four times the price of the cheapest) – consequently your equation for selecting a lens should probably derive the most economic optical quality.

Bearing the cost in mind, I would suggest you also consider the following factors which are less evident from comparative tests:

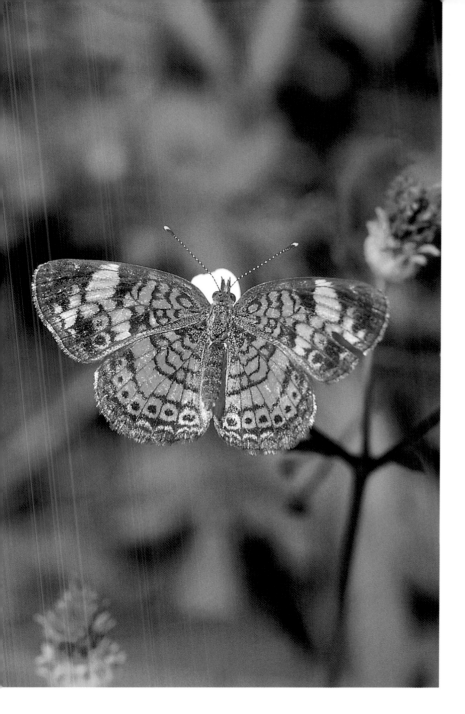

I took this shot of a pearly crescent spot in Florida using a 200mm lens + Nikon 3T dioptre to give around 1/3 life-size reproduction on film. This is an active butterfly and the extra working distance of this setup is useful.

I attach great important to this last point. When I make a considerable investment in my bread and butter macro lens, barring disasters, I want it to last me a lifetime, not until the camera manufacturer decides to make it redundant by introducing replacement technology.

The 200mm macro lens

This is hardly the type of lens most stores would hold in stock. Nevertheless, it is a serious option for the wildlife photographer. Compared to the 100mm macro lens, the Pentax A Star macro 200mm f/4 ED lens, for example, further increases working distance at life-size reproduction to 0.55m (1.8ft) and reduces the angle of view to 12.5 degrees, making it perfect for keeping a good working distance between you and flighty or inaccessible subjects while facilitating excellent control of the background. At the time of writing, Pentax has released the latest version of its 200mm macro lens (200mm FA macro f/4 ED (IF) autofocus). The down side to these long lenses is, of course, their increased bulk. Invariably these macros come with their own built-in tripod socket. These are definitely not as 'handy' as 100mm lenses but are absolutely ideal for photographing poisonous snakes, shy animals and plants that are best shown in isolation from their surrounding habitat.

One word of warning: do make sure you know what you are buying. A 200mm lens may not in fact be 200mm at life-size (or maximum) reproduction. Some of these objectives – the Sigma APO 180mm f/5.6 macro lens for one – are varifocal lenses, that is their focal length changes between infinity and 1/2 x life size. In doing so, it removes the normal requirement of a macro lens for extension-related exposure compensation as you focus progressively closer to the subject. This means in practical terms that, taking the Sigma lens as the example, focal length is almost halved between the extremes of the focusing range. Even the marque 200mm lenses can change their designated focal length at 1/2 x life size, owing to their internal focusing (IF) mechanism. Ultimately, though, whatever you may think of an individual design, it has to be preferable to adding 200mm of extension to a 200mm 'normal' lens to achieve life-size reproduction.

- robustness of lens construction
- maximum magnification rate
- weight
- compatibility of lens mount with obsolete camera bodies

Only Nikon and Pentax technology allows their latest autofocus lenses to be used with their older manual-focus cameras and conversely their manual lenses to be used on their modern autofocus cameras.

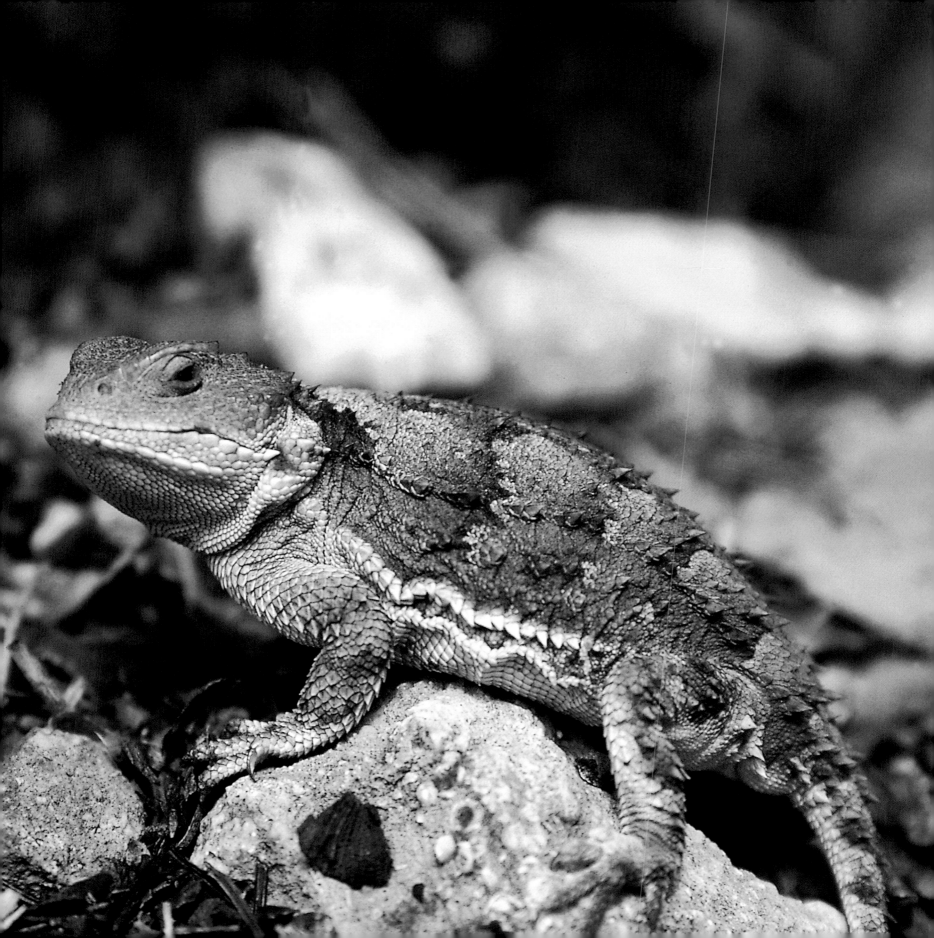

Manufacturers are constantly improving and changing their products. As a lens evolves, its catalogue description may remain the same. Always check out the capability of individual lenses at the time of purchase. The Tamron 90mm macro lens was updated from one that manually focused to 1/2 x life size to one that could autofocus down to life-size reproduction. Similarly, the 200mm f/4 Pentax macro lens has also changed its specifications.

Supplementary lenses

These are cheap, lightweight glass elements that screw into the front of a prime or zoom lens to allow increased magnification via closer focusing. They are of greatest use for prime lenses in the 150–200mm range.

Magnification = focal length of prime lens/focal length of supplementary lens*

* Dioptre power	focal length (mm)
+0.5	2000
+1.0	1000
+1.5	666
+2.0	500
+3.0	333
+4.0	250
+5.0	200

Therefore, to take one of my favourite combinations, a 200mm Pentax f/4 plus a Nikon 3T (+1.5 Dioptre), magnification = 200/666 = 0.3x.

I photographed this mountain short-horned lizard in ponderosa pine forest in Arizona. It was shot with a 28–70mm zoom and Nikon 3T dioptre. Illumination was provided by built-in retractable TTL flash.

I would urge you to opt for dual element dioptres, since these are better constructed for aberrations. Nikon and Canon both supply dual element dioptres. Alternatively, look for elements that employ quality Schott glass.

Increasingly these days, when I'm planning a long hike, which means my photo kit must be lightweight, I tend to put my Nikon 3T dioptre onto the 28–70mm lens of my Pentax MZ-5n and use my built-in RTF flash to achieve close-up shots of lizards and snakes. The results are nearly as good as with a macro lens, but not quite.

Lens reversal

Prime lenses are optimized for the lens to subject distance being greater than the lens to film distance. Adding extension reverses this relationship and results in image degradation. Therefore, in principle, this means that reversing the lens should augment image quality as the rear element is now closer to the subject than the front element is to the film plane. This technique provides magnification in the region of 1x, but it is awkward in the field, as it requires dual cable release and loss of communication between lens and camera.

If you can master this approach, though, it does offer one of the best methods for producing extreme magnification ratios in the field. To obtain high magnifications you must stack your lenses. Since magnification = focal length of prime lens/focal length of reversed lens, a 50mm standard f/1.7 with a 52mm filter thread reversed on a 200mm f/4 telephoto with a 52mm filter thread via a 52mm male–male adapter can yield a magnification rate of 4x. I would recommend that you stay within sensible limits, though, and never use a long, heavy lens as the reversed optic, as this would strain the filter thread.

Although this chapter shows how to get as close to your subject as necessary, exposing sharp, vibrant images often as not requires good skill in using flash. This is the topic of the following chapter.

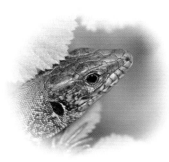

Flash for wildlife photography
in the field

Understanding flash

In some respects, this is perhaps the most important chapter of the book. If you read it carefully I hope you will acquire the expertise necessary to use electronic flash subtly yet effectively. Mastering the technique will impart a special quality to your photographic images of the natural world. Few camera owners really understand how to get the most from their flash gun and I suspect that as such this versatile tool is likely to spend much of its time stashed away in a forgotten corner of the average gadget bag. From now on it must become one of the most significant elements in your kit.

Flash guns can work in three basic modes; auto, which is rather impractical for out and about nature photography and the two most useful ones – manual and TTL. These two modes are complementary, for between them they can cope with all likely situations.

Flash techniques provide images which have punch in the form of vibrant colours and sharpness beyond that possible using ambient light alone. Snail (*Manacha cantiana*), Majorca, Balearic Islands.

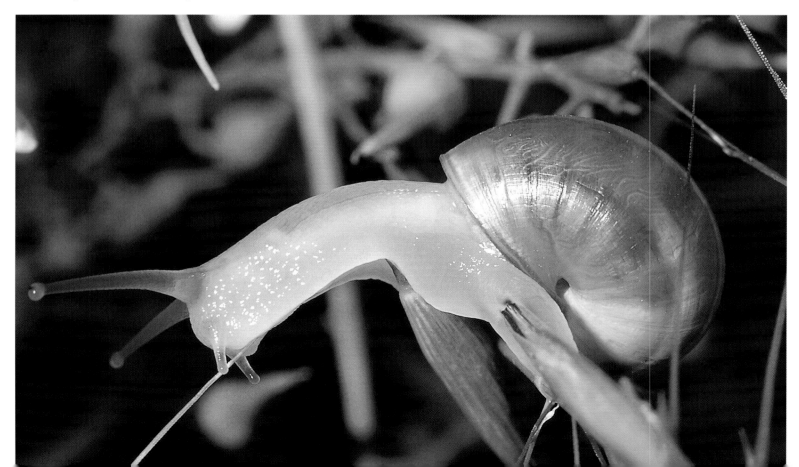

In auto mode, flash guns can give inaccurate exposure, because sensors designed to measure reflected flash light and quench output when appropriate are either located on the flash gun, or in the case of some units – the Vivitar 283 is one – in a special discrete housing which can be used remote from the gun. In each case there is a risk that the sensor will receive a different quantity of light to the film. The potential for such a disparity means auto mode cannot be relied upon, particularly in close-up work where parallax problems (i.e. lens axis and sensor axis are offset) are likely to occur. In order to guarantee consistently good results you need either TTL or manual flash.

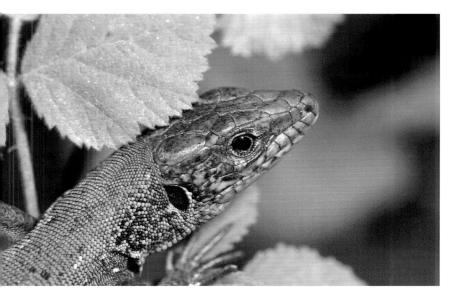

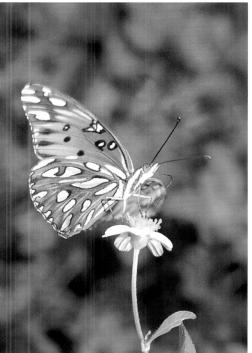

Balkan green lizard on the Greek island of Thassos, and Gulf fritillary in the Everglades National Park, Florida. I took both images with TTL flash using a Pentax LX.

I have devoted a separate section to TTL flash (see page 65). Briefly, a TTL flash module interfaces with the camera so that feedback from sensors in the camera body which integrate the incoming flash and ambient light received at the film plane automatically terminates flash output the instant sufficient light for correct exposure has reached the film. Different manufacturers give various names to what is essentially the same process. For instance, Pentax call their system TTL autoflash while the Olympus version is known as off-the-film flash (OTF). With OTF, light is measured after it is reflected from the film surface. Given that automation, including TTL flash, cannot replace the thought process entirely, we need to address some of the basics of flash theory by discussing manual flash, which is a flash unit of fixed output.

All light diminishes in relation to the square of the distance it travels from its source. For this reason, the distance between the subject and the flash becomes the key element in achieving correct exposure, and not camera to subject distance. Before considering flash in close-up work, arguably its most valuable use, I want to introduce the subject in general terms.

Manual flash units can be purchased with a variety of possible outputs. The intensity of output determines the aperture (f stop) which can be used for a given flash to subject distance. The output is measured in terms of a guide number (GN). The larger the GN, the greater the output (and, unfortunately, bulk). This relationship can be expressed as a simple equation:

$$GN = aperture \times flash\ to\ subject\ distance$$

You would be well-advised to double check your flash's quoted GN because manufacturers calibrate their kit under average reflective indoor conditions which do not translate into the same GNs for outdoor photography. In effect, you run the risk of underexposure if you use the quoted GN in an outdoor environment. To work out the correct GN for outdoor photography of your manual flash unit, shoot a typical mid-toned subject at several f stops plus and minus the recommended optimum obtained from the manufacturer's quoted GN. (Of course, any determination of this kind must be carried out outdoors without any filters or extension tubes attached to the lens.) I can use my Pentax AF280T flash gun set to manual as an example. It has a GN of 28 for ISO 100 film. At a flash to subject distance of

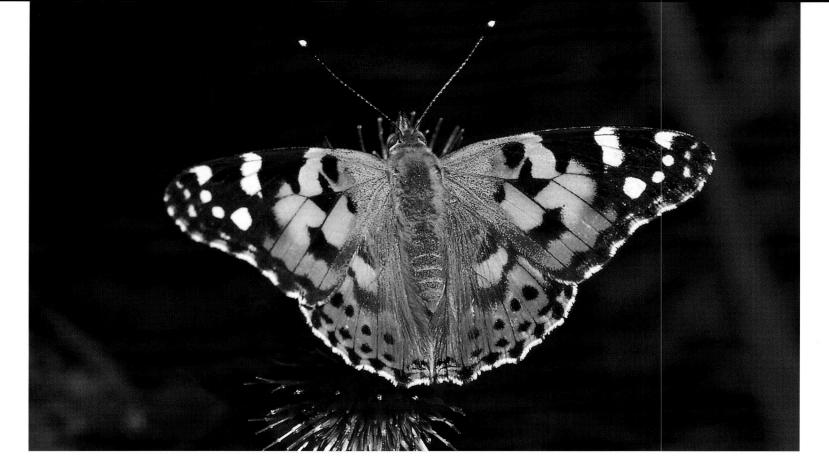

Illumination using manual flash as the sole light source and magnification gained using extension tubes. Painted lady on knapweed, Suffolk, England.

1.75m (5ft 9in) an aperture of f/16 would give perfect exposure if the manufacturer's quoted GN were correct. Let's say f/16 does not give optimum exposure for a typical outdoor subject. Review your slides side by side in order of increasing aperture. Select the slide taken at an aperture which in your opinion is optimal. If the one you select was taken at f/11 then the correct outdoor GN is f/11 x 1.75m, or 19.25 (call it 20).

GN changes according to film speed. However, it is an easy matter to work out the new flash GN for any given change in film ISO number: our hypothetical calibration test on the AF280T indicated an optimum outdoor GN of 20 when using ISO 100 film. If you now want to use ISO 50 film at the same flash to subject distance you need to gain one extra stop of light to compensate for the halving of ISO number – i.e. open the aperture from f/11 to f/8. This new aperture (f/8) multiplied by the flash to subject distance (1.75m/5ft 9in) provides the new GN of 14.

There is an even simpler way to work out the new GN for a change in film speed providing you work in stops and pretend GNs are f stops. Remember our calibrated GN is 20 for ISO 100 film. If I once again swap to ISO 50 film, this requires an increase in exposure of one stop. Call your GN of 20, 16^{1}/$_{2}$ (20 being roughly mid-way between f/16 and f/22). Since the new film requires an extra stop of light, open f/16^{1}/$_{2}$ up by one stop to f/11^{1}/$_{2}$. This becomes your new GN i.e. f/11^{1}/$_{2}$ is equivalent to 13^{1}/$_{2}$ (13^{1}/$_{2}$ being mid-way between f/11 and f/16). Therefore your new GN is 13^{1}/$_{2}$, a figure which is close enough to be equivalent to the GN of 14 calculated in the previous example. This second method is a much quicker and simpler approach for fieldwork.

In any event either approach is better than resorting to the kind of equations given in many books. Imagine the hassle of swapping from ISO 64 to ISO 25 film in the field to capture an exquisitely patterned snake in moderate close-up using manual flash. In order to calculate the correct flash to subject distance for a given aperture you must first work out the flash GN for your new film speed. You'll need your pocket calculator to obtain the new GN = quoted GN x the square root of the new film speed divided by quoted film speed. Now, where did that snake go?

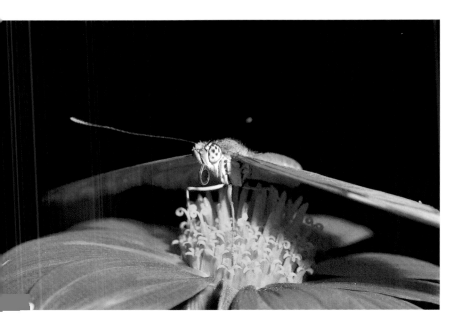

Here again, illumination using manual flash as the sole light source to capture this Flambeau (*Dryas julia*).

As you move closer towards your subject, that is as you reduce the flash to subject distance, so you will require a smaller aperture. This can be calculated by rearranging the equation for determining GN i.e. aperture = GN/flash to subject distance. Once again an alternative is to work in stops by converting the f stop series of numbers into a distance scale i.e. as you move the position of your manual flash gun relative to your subject from 8 to 5.6 to 4 to 2.8 ... centimetres, metres, inches, feet or whatever units of measurement you want to work in, you are increasing the light intensity by one stop each time. To compensate for this you must close the aperture by one stop each time.

Let's consider a hypothetical situation. I have a very old and much used manual flash gun which cost £3 or £4 about 20 years ago. Half of all my stock shots were taken with it. The guide number of this gun is 16, therefore with ISO 100 film and a hypothetical subject, perhaps a large marine iguana 4m (13ft) away from the flash, I need an aperture of f/4 for correct exposure. However, I decide this is neither close enough to the subject, nor is it a sufficiently small aperture to facilitate a good depth of field. So by moving the camera with flash to 2.8m (9ft) from the subject and closing the aperture to f/5.6, I maintain my exposure and get close. If I still feel that f/5.6 provides insufficient depth of field I can always move the camera

and flash to 2m (6ft 6in) from the subject and close my aperture to f/8. Of course if the subject magnification rate was adequate at 4m (13ft) then I could achieve greater depth of field by simply moving the flash closer to the subject i.e. at a flash to subject distance of 2.8m (9ft) I would reduce the aperture to f/5.6 and at 2m (6ft 6in) to f/8. Generally speaking though, in the field situation, flash to subject distance and camera to subject distance are one and the same because you will probably have your flash attached to the camera with a bracket of some kind.

We can now move the discussion to close-up work. When I show my macro images at lectures, one question which is repeatedly asked is: what sort of flash did you use? The reply I give depends on the specific shot, but ultimately the answer is the same – a low power unit. Careful positioning of a low output unit near to the subject produces a saturating light of even illumination. A more powerful unit at a distance produces the same quantity of light but risks becoming a point light source, like the sun. These sources of illumination can produce a harsh, contrasty light. The other question I get asked is: do you use two flash guns on either side of the lens axis? The answer is no, never, since such elaboration is generally unnecessary. Consider your low power flash unit in proportion to the subjects you are photographing. On their scale your flash acts as an enormous studio light set-up. If you position a small unit carefully most shadows can be avoided.

I have a number of different flash units from manufacturers such as Pentax and Vivitar. My advice would be to focus on guns with a GN of about 10–15 for this sort of nature photography (my Pentax AF280T has a half power option i.e. GN 28 becomes GN 14). I am particularly attached to a trusty old manual Hanimex which cost under a fiver. It does the job for me and my Pentax gun, which cost twenty times more, doesn't do the job any better, although it is more versatile. I seldom use a ring flash. The halo tubes of such guns produce two-dimensional shadowless illumination which in itself appears unnatural. Given the likelihood of doughnut-like highlights on shiny reflective subjects like the elytra (wing cases) of some beetles or the beady, bulging eyes of tree frogs, such pictures will look doubly unnatural, even ridiculous. Some photographers advocate taping off a portion of the flash tube, but even then I would be worried that the weight of such ring flash units could damage the alignment of my expensive macro lenses.

I nearly always use a hand-held camera, usually my Pentax LX, with a flash mounted slightly above and to the left of the lens axis, the tube tilted to an angle of minus 15 degrees for close-up work or horizontal for normal use. Using flash in this way I can arrest the motion of small busy organisms, even flying insects, and capture these small subjects in remarkable detail with a combination of slow, fine-grained film and small apertures. Under these conditions the effective exposure time becomes the duration of flash discharge (typically between 1/1000 and 1/25,000sec) and not the set shutter synchronization (sync) speed.

Note that under these circumstances we do not require a tripod – in fact, it would be a liability in close-up flash work. In most cases of insect photography, by the time you've set up your camera and tripod the subject will have moved on. Suppose you spot a tiny froglet that you want to photograph using ambient light and a tripod. For reasonable magnification, say 1x, you need to add 50mm of extension to your 50mm standard lens. This extension loses you two stops of light, so an exposure of 1/15sec at f/11 on Fujichrome 100 drops to 1/4sec at f/11. You run a real risk of camera shake but that is preferable to opening the aperture to f/5.6 because the subject requires a significant depth of field. Remember, as you increase magnification rate so you decrease depth of field. Wildlife photographers used to stick their bug or mini-beast in a fridge to comatose it. Cruelty apart and the fact that your subjects will look half dead (but sharp), access to refrigeration is unlikely if you're trekking across savannah, through rainforest or any other natural habitat. Instead, the clued-up wildlife photographer will always resort to flash to avoid slow shutter speeds and tripods, and to maintain small apertures.

Unfortunately, in close-up work, the basic rules for determining correct flash exposure change. This arises because when you focus at close quarters, the distance between lens and film increases to a point where the indicated aperture is no longer accurate. In fact, the effective aperture is significantly smaller than the marked aperture. Clearly under these conditions the flash GN no longer applies. Therefore, when shooting macro subjects, you need to apply the following formula:

$$\text{required aperture} = \frac{\text{GN for general use}}{\text{flash to subject distance x}\ (\text{magnification rate} + 1)}$$

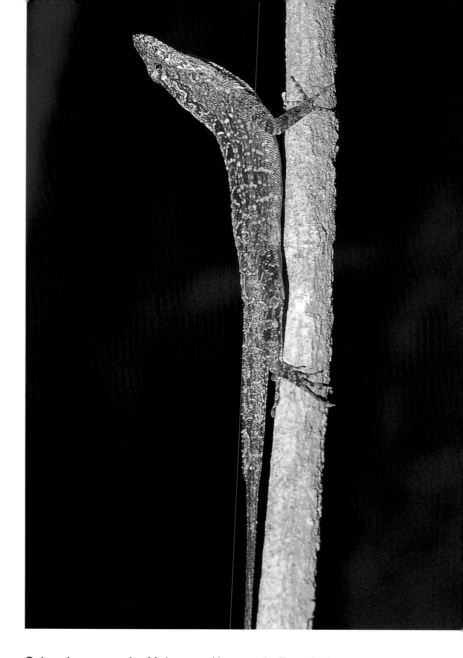

Cuban brown anole, Mahogany Hammock, Everglades National Park, Florida. Pentax LX + 90mm macro lens. Flash as dominant light source.

Consider the same froglet photographed at life size using my Pentax AF280T, which we have already determined has a GN of 20 for outdoor photography. We also decided that we need an aperture of f/11 to maintain a good depth of field.

$$\text{f/11} = \frac{\text{GN 20}}{\text{flash to subject distance x}\ (1+1)}$$

Damselflies (*Ischnura elegans*) mating. To provide punch in the dappled, contrasty light of this grassy marshland, I resorted to flash. Pictures that I obtained of these mating insects with ambient light alone were all insipid and promptly consigned to the bin.

By rearranging the formula we get the correct flash to subject distance, i.e.

$$\text{flash to subject distance} = \frac{GN\ 20}{f/11 \times (1+1)} = 0.9m$$

Thus we can now configure our flash–camera–subject setup for an ultra close-up of our hypothetical froglet. However, if the flash to subject distance is too great for your optical setup as in the example above, reduce your aperture further. For instance in this example f/22 would halve flash to subject distance to 0.45m (18in). The alternative is to use a flash with lower output or go to a slower film. If we use ISO 25 film the flash to subject distance becomes 0.45 and 0.23m (18 and 9in) for apertures of f/11 and f/22 respectively (note the GN of 20 for ISO 100 film is reduced to GN 10 at ISO 25), while changing to a flash with a GN of 14 using ISO 25 film yields a flash to subject distance of only 0.16m (6in) at f/22.

All this theorizing is rather laborious and impractical for fieldwork. I use two techniques for my close-up wildlife flash photography which greatly simplify things. Both methods can be used to control exposure at different magnification rates fairly easily. One technique is manual flash using the inverse square rule to determine flash exposure; the second is TTL flash.

Manual flash and extension

Using equations to calculate the appropriate flash to subject distance for correct close-up exposure with manual flash is not only a bind, it's problematic too. This is because in the field, subjects don't always conform to your preselected magnification rate. Successive frames may require say 1 x magnification to shoot a face-on close-up of a defoliating gypsy moth caterpillar grazing away, and 1/4 x magnification for capturing the ugly brute-like character of a large wind scorpion. Happily, there is a way round this problem.

Assuming we are using extension to achieve magnification and manual flash to expose our subject, a simple law of physics applies. This is the inverse square rule of light fall off (i.e. as the distance between the light source and subject is doubled, the level of light at the subject is divided by two squared or four. Conversely at half the distance, the illumination on the subject is increased by two squared or four). This simple rule allows us to cope with changing magnification rates without recourse to a pocket calculator. As you add extension to a lens so the magnification rate is increased. 50mm of extension with a 50mm lens gives 1x magnification while a fairly cumbersome 100mm of extension is required with a 100mm lens to give the same rate of magnification. It is fortuitous that adding extension causes a loss in the amount of light reaching the film, since this reduction will be offset by the gain in light obtained from moving the lens and flash closer to the subject. This rather convenient lore is dependent upon keeping flash and lens in the same position relative to one another. However, for this system to work, you must establish a base exposure via a series of test shots, preferably on a mid-toned subject. Many people opt to extend a lens in the 90–105mm range. Such extension can become unwieldy; less extension is required for a 50mm lens to achieve the same magnification. 50mm lenses are cheaper and given their standard nature, mass production has produced what is usually an optically excellent lens. I often add sufficient extension to my f/1.7 50mm standard lens to achieve $1^1/2$ x magnification with superb results – see *Syrphus ribesi* on page 3. You don't have to worry too much about working distance; true, a 50mm lens at 1 x is closer to the subject than a 100mm lens at 1 x, but I often opt for the 50mm set-up since it is actually lighter and easier to use. It works well for most small animate subjects, although for butterflies the greater working distance of a 100mm lens is probably preferable. Make the lens-extension selection of your choice, and place a manual flash near the front of the lens but to the left and slightly above it – ensuring it is angled towards the subject. Now shoot a series of test shots from f/8 to f/22 in 1/2 stop increments. When your transparencies are returned from the developers compare them side by side. The slide with optimum illumination is your basic exposure for that magnification rate based on the amount of extension and lens you used. Providing you keep the flash gun in the same position relative to the lens, you can now add or remove extension tubes to vary magnification but maintain the same f number (which would ideally be f/11, $f/11^1/2$ or f/16 for good depth of field and the best optical resolution), avoiding the need for any further complex calculations.

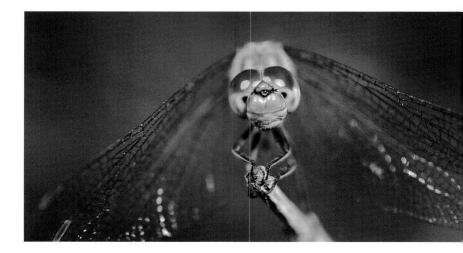

Sympetrum dragonfly, face-on. Illumination using manual flash balanced with the ambient light. Magnification gained using extension tubes.

What happens with manual flash and an extension-based system when your subject is not mid-toned? Simple, start at your base exposure and close the aperture down 1/2 to 1 stop for very bright subjects and open it up 1/2 to 1 stop for very dark ones. With practice comes perfection, and you soon learn that small, iridescent butterflies like the common blue need the aperture closing down by a small amount, while the dark cryptically camouflaged underwings of peacock and small tortoiseshell butterflies, necessitate the aperture being opened by up to one stop.

I would recommend you configure and calibrate your setup using ISO 50 or 64 film, aiming for an aperture of f/11.5–16, because changing film to ISO 25 simply involves opening your aperture by one stop to f/8.5–11, and changing to ISO 100 film means closing your aperture by one stop to f/16.5–22. This, I have found, is a more practical option than retaining the f number and moving your flash to compensate for altered film sensitivity.

The one remaining problem with an extension-based system concerns focusing – you don't have the constantly variable focusing range to which you are probably accustomed. Instead, with a judiciously selected extension-lens combination giving a magnification rate suitable for the subject, move the camera back and forth until your subject 'pops' into focus and always use this technique of moving the camera to focus rather than twisting the lens barrel in the 'normal' manner.

Florida soft-shelled turtle, Everglades National Park. Illumination using TTL flash control and a dedicated macro lens.

TTL flash

In this mode sensors in the camera measure the light coming through the lens and quench flash output at precisely the right moment. TTL flash metering provides the most convenient flash technique for close-up photography in the field and I reiterate that I would not consider investing in a camera system that did not offer this technique as one of its options. Modern TTL guns are extremely versatile and generally offer TTL, auto and variable output manual modes in a single unit. This is the case with my Pentax AF280T which is particularly useful for close-up work because its 'bounce' head orientates to a minus 15-degree angle as well as turning 270 degrees horizontally.

The full potential of a TTL flash unit used for close-up work, though, can only be realized when it is used off the camera. My AF280T connects to my LX via a special cord (4P sync cord A) and a hotshoe grip; my Z1-P and MZ5n connect via a 4P sync cord B. When the hotshoe grip is attached to the camera by means of the AF400T bracket and clamp I have a solid flash-camera configuration which is ideal for practical close-up and general-purpose wildlife photography in the field. Most manufacturers have similar setups and many modern systems offer a great deal more than the AF280T. However, these electronic trinkets don't produce any better photographs –

remember simplicity is often best. The most important point to bear in mind is that, like your camera's built-in TTL meter, TTL flash does not provide a panacea for all situations – you and not the equipment must have the last say in determining exposure.

GNs don't concern us quite as much with TTL flash as they did with manual flash. However, your gun must be within a defined range for the metering system to 'kick out' an appropriate amount of light. Clearly, for a given film speed this is determined by aperture – as the f number increases, the effective working distance decreases. For the Pentax AF280T the TTL range is effective from 0.25 to 20m (8in to 65ft) at ISO 100 with an f/1.4 lens (or 0.25–10m/8in–32ft at ISO 100 with an f/2.8 lens such as the Pentax 100mm macro). Large flash to subject distances and/or small apertures necessitate increased flash output. This means that the discharged flash capacitor needs longer to recycle. At full output my GN 28 AF280T will provide 100 flashes with an 8sec recycling time using 4xAA alkaline batteries or 80 full output discharges with a 6sec recycling time using NiCad batteries. It is fortuitous that in close-up work with a good balance of ambient lighting, my GN 28 TTL flash often provides a negligible recycle time even with reasonably small apertures. In fact, if I chose to, I could confidently use my autowinder with this setup.

The TTL flash sensor located in the heart of your camera reads light after it has passed through any filters, extension tubes and lenses whose varied focal lengths alter the sensor's angle of view. Unlike manual flash, this means that no exposure compensation is necessary. This is equally true for any light modifiers placed over the actual flash tube itself. Remember, though, that like your camera's TTL reflected light meter, TTL flash will automatically make your image a mid-tone – even if your subject is not mid-toned. Therefore, exposure compensation is necessary for non-mid-toned subjects and tricky lighting where a small bright subject is dominated by a dark background or vice versa. Very bright subjects need more exposure while very dark ones require less exposure (essentially the opposite of manual flash exposure compensations). Small bright subjects with a dominant dark background need less exposure and dark subjects surrounded by a dominant light background need extra exposure. Exposure compensation cannot be achieved by altering either aperture or shutter, instead you must alter the exposure compensation or film speed dial.

Lesser spotted fritillary. Although I used flash for this image, what makes it remarkable is that I took it with my LX camera held in one hand. Ambient and flash exposures are perfectly balanced.

Controlling background illumination using flash

When you use a flash gun, aperture rather than shutter speed determines the level of flash light exposure. However, the shutter speed is important since it determines the level of ambient light reaching the film. When employing a flash gun, the camera shutter speed must not be set faster than its maximum flash sync speed i.e. the shutter must be open long enough for the flash to fire. In older cameras this is usually about 1/60sec, but for modern ones sync speed is now typically 1/250sec. The flash will synchronize with the opening of the shutter at sync speed or slower. This is important, because slow sync speeds are exceedingly useful in controlling background illumination and for creating 'fun' effects.

Daylight balanced manual flash (manual daylight sync)
The balance of ambient and flash exposure is important in close-up wildlife photography. Your calculated aperture for manual flash to subject distance is appropriate for illuminating your subject only.

What of the background? Assume we are photographing an elegant ribbon-wing, which has momentarily alighted on a fragile plantain stalk. The magnification required for your flash-camera configuration dictates an aperture of f/16 and you use your maximum sync speed of 1/250sec. If the ambient exposure is actually 1/60 at f/16, your

Ribbon wing. This beautiful insect was shot using daylight balanced manual flash. 90mm macro lens + small manual flash gun, above and to the left of the lens axis (f/16 at 1/60sec).

background exposure is going to be two stops less than your perfectly exposed ribbon-wing. Given that slide film has a latitude of ± 2$^{1}/_{2}$ stops, you will end up with an almost featureless black background. By reducing the shutter sync speed by two stops to 1/60sec but retaining the f/16 aperture, the exposure of ribbon-wing and its grassy backdrop are harmoniously balanced.

Unfortunately, problems can arise when photographing a moving subject. If you use a slow shutter sync speed, the ambient exposure could produce a second blurred image, offset from the sharp and discrete flash exposure. This phenomenon is known as 'ghosting'. To avoid ghost images, employ the fastest shutter speed possible for synchronization. In bright ambient lighting this may still permit ambient and flash exposures to be balanced, although this cannot be guaranteed. If we return to our example of the ribbon-wing this subject remains perfectly still at rest and f/16 at 1/60sec balances background and flash exposures perfectly, providing a sharp image with no ghosting. If this was a moving subject, bad ghosting would occur. However, by returning to our 1/250sec shutter sync speed we would reduce this ghosting by losing almost all ambient illumination. Under these conditions the duration of flash discharge becomes the effective shutter speed. For most units this is less than 1/1000sec so our subject is perfectly illuminated and frozen in motion by the speed of the flash. However, we have an unnaturally dark background.

Personally I don't mind dark or black backgrounds, I think they give colourful subjects real punch and look good in magazines. Editors can readily incorporate white or coloured captions that contrast strongly against the black background. Another positive aspect is that this approach removes cluttered, distracting detail from the background, helping viewers to focus their attention on what matters. It becomes a matter of personal preference. I would soon become bored with my photos if they all had the same black background – it is, after all, rather unnatural. Therefore, I try to strike a balance between shots taken with flash that balance subject exposure with background exposure, and shots that use electronic flash as the sole form of illumination. Often though, conditions of illumination and levels of activity or wind movement dictate what your best option will be. For instance, to photograph hoverflies over a daisy or similar composite, and arrest wing movement totally, is a simple matter with electronic flash, but you must accept a black background as almost inevitable since only the brief duration of flash can completely freeze

This owl butterfly was taken using a ring flash set to manual exposure. Although the picture has impact, the lighting tends to be flat and featureless.

the movement of these adroit creatures – any ambient exposure whatsoever will cause ghosting and should be avoided. If you can't live with this fact, consider using multiflash (see page 68).

Lest this all sounds rather objective and clinical, you should always remember that sometimes ghosting can be used to your advantage to produce 'fun' images or what might be better described as surreal effects – this approach is well used by Frans Lanting for some of his more haunting images.

I will summarize with my rule of thumb for obtaining effective manual daylight sync photography of macro subjects. It's a pretty simple matter – with your camera set at its maximum shutter sync speed, select your calculated or empirically derived aperture for close-up manual flash. Then activate your camera's metering system and reduce the set shutter speed until it matches the camera's 'suggested' optimum. This usually involves bringing together two flashing LEDs visible inside the camera viewfinder (one for set speed, one for optimum speed). Under these conditions flash and ambient exposures are balanced. Depending on the situation, it may be best to point the camera away from the subject and more directly at the background when metering – but don't refocus. This technique also gives you a constant indication of the disparity, in stops, between ambient exposure and any preselected shutter sync speed.

Daylight balanced TTL flash ('auto' daylight sync)

Providing you select an aperture within the range of your TTL flash gun and a sync speed which allows correct exposure for ambient lighting, your TTL flash should respond with light output no greater than the ambient illumination. However, it is possible to expose solely on the basis of the flash light. If you recall, aperture and shutter speed together determine ambient exposure; aperture alone determines the flash exposure. So, in close-up work, a small aperture, which you need to obtain good depth of field, will also help to reduce the ambient light. My rule of thumb for 'auto' daylight sync is simple; select a shutter speed which balances the aperture with respect to ambient exposure and check that the aperture suits the flash to subject range for the particular TTL unit–film speed combination. For instance, say you were photographing a torpid lizard in a shady thicket.

Viviparous lizard, UK – open aperture for shallow depth of field. TTL flash.

Ambient exposure is 1/30sec at f/5.6. You need greater depth of field than f/5.6 offers, so you go to f/16. To balance this aperture for ambient exposure you need a shutter speed of 1/4 sec. Therefore, establish that the aperture is within the distance range for your TTL flash and set f/16 and a shutter speed of 1/4sec, making sure that at this slow speed you employ a tripod (or bean bag/towel) and cable release, otherwise ghosting is likely to occur. If on the other hand ambient light levels are high, set your camera, with TTL flash, to aperture priority and decrease f number while monitoring the coupled shutter speed LED in the viewfinder. Providing you don't exceed maximum sync speed and the aperture remains smaller than f/8 for a reasonable depth of field, flash and ambient exposures can be balanced and provide good hand-held close-up images without a tripod or the risk of ghosting.

You soon learn that daylight sync can sometimes be even more unnatural than a pitch black backdrop. Personally I dislike all shades of blue in my backgrounds, I consider this very unnatural. Greens and browns, particularly if slightly underexposed look far more natural. Sometimes the mottled out of focus background detail can enhance an image, other times it detracts. It's impossible to generalize – if you're pleased with the final image, that's all that matters.

Unlike 'manual' daylight sync, 'auto' daylight sync can result in exposure errors. These occur when your subject is outside the camera's metering area or is not of average tonality. Also extremely bright and reflective subjects risk quenching the flash prematurely. I indicated earlier that you can override the foibles of TTL flash by altering the ISO setting or exposure compensation dial of your camera.

Viviparous lizard – smaller aperture for greater depth of field. TTL flash.

Using multiflash to illuminate background

Using a second flash unit to illuminate beyond the feature of interest you can control the level of contrast between subject and background. As always there is a very simple approach to achieving correct exposure. It is a rule of thumb and assumes the use of manual flash units of equal output. Consider the hypothetical situation of a darkly coloured scolid wasp which, illuminated with a single flash, disappears into the equally dark background – except for its bright yellow tail, which produces an unusual photograph that is difficult to interpret. Illuminate the background, and the wasp's profile is picked out much more effectively. Flash also helps to arrest the wasp's perpetual quivering motion and avoids any ghosting which would otherwise occur by balancing flash and ambient exposures using daylight sync.

Imagine the wasp is less than a metre (say 2ft) from your flash gun and you want the background balanced to an exposure value that matches that required for the wasp. Simple, place a second flash of equal output the same distance from the background. If, like many people, you prefer a slightly underexposed backdrop (say one stop underexposure), move the flash which illuminates the background back to 0.8m (2ft 8in) i.e. distance and aperture represent scales which are from the numerical point of view unitary and interchangeable. Therefore, using manual flash units of equal GN it is a simple matter to determine the precise lighting ratio between points of interest. In the case of our scolid wasp, its dark body probably stands out best with a subject:background illumination of 1:1.

Another way of controlling the contrast between subject and background is to use the inverse square law. Light intensity diminishes to one quarter as distance doubles, so that a unit at a distance from the background which is double the distance of a second unit from the subject will produce a background a quarter as bright as the subject.

If more than one manual flash gun is used to illuminate the subject, which I consider generally unnecessary in close-up work, life becomes slightly more complex since the distance of the background flash must be calculated from the 'equivalent distance' of the main plus fill-in-flash. If the main unit and fill-in unit give a highlight to shadow ratio of 2:1 and the main flash is a metre (3ft) from the subject, the equivalent distance of the combined front subject lighting can be worked out from:

$$\text{equivalent distance} = \text{mainflash distance} \times \sqrt{\cfrac{1}{1 + \cfrac{1}{(\text{lighting ratio} -1)}}}$$

Or, for a ratio at 2:1, 0.7. Therefore 0.7 x 3 = 2.1ft (0.6m). If the background is to be lit with, say, one stop less light than the subject, the background flash must be moved to approximately 2.8ft (0.85m) which affords one stop less light than the main unit at an 'equivalent distance' of 2.1ft (0.6m) from the subject.

Multiflash setups are simple to arrange using either multi PC socket adaptors such as the four-way distributor which can be fed from the 4P sync terminal of my Pentax LX for multiple manual or TTL flash, or by means of a technique which is more convenient for fieldwork with manual flash – photosensitive slave units. A slave unit on a second flash is activated by firing the first unit and avoids a spaghetti-like tangle of wiring.

Changing focal length
When using a flash gun at a fixed point relative to your camera, different focal length lenses will affect the level of illumination at different points in your picture.

As a hypothetical example, consider a neutral-toned backdrop of ivy leaves 8in (20cm) from the gaudy red bloom of a poppy. Your flash gun is the same distance in front of the poppy. How much darker will the ivy be with respect to the poppy? Unify distance and aperture scales. The flash to subject distance is 8 while the flash to background distance is 16. Since the difference between 8 and 16 is two stops (8–11, 11–16), the background will exhibit two stops less exposure than the subject, i.e. it will be almost black. To control the level of illumination falling on the background we can change the focal length of the lens. Say the above hypothetical photograph was taken with a 50mm macro lens. What happens when we use a 100mm macro lens? If we maintain the magnification rate of the poppy we need to move the camera and flash back to 2 x the previous flash to subject distance i.e. to 16in (40cm). With a flash to subject distance of 16in (40cm) and a flash to background distance of 24in (60cm), the ivy is now little over one stop darker than the poppy.

Using this same principle a 200mm macro lens at an identical magnification would produce almost equal exposure of poppy and ivy. Obviously, by moving the flash further from the subject you need to open the aperture accordingly. It is worth noting that by keeping the 50mm macro lens at 8in (20cm) from the poppy we can increase exposure of the ivy by simply moving the flash back and opening the aperture – that is, at a flash to subject distance of 16in (40cm) and maintaining exposure by opening the aperture by two stops, the resulting flash to background distance of 24in (60cm) yields an image of the ivy which is only just over one stop darker than the poppy.

The simplicity of this concept extends itself well to field technique, but for completeness and not so much for its use in the field, an equation exists to calculate the level of illumination at the background assuming the flash is at or near the camera hotshoe.

A1 = subject to background distance
A2 = camera/flash to subject distance
B = camera/flash to background (A1+A2)

$$\left(\frac{A2}{B}\right)^2 \quad \text{x level of intensity at subject}$$

i.e. for our poppy 8in (20cm) and ivy 16in (40cm) from our camera/flash/50mm macro lens:

$$\left(\frac{8}{16}\right)^2 \quad = 0.25 \text{ x level of intensity at subject}$$

In other words, the background will be underexposed by two stops. This agrees with the inverse square law, which states that the intensity of light becomes one quarter as strong as distance doubles.

In my discussion of background illumination I have made no mention of using coloured backdrops. This is because I feel strongly that such props provide incredibly artificial pictures – as do most studio shots. Many such images get published each year and poorly reflect the natural habitat of the subject. I would urge you to utilize the other more visually pleasing options for manipulating background exposure that I have described in this section.

Fill-in flash

This technique is extremely useful if exposure by natural light imparts heavy contrast or shadows on your subject. Fill-in flash can reduce this contrast to produce an image with a tonal latitude which improves the photograph and looks very natural.

Let us consider the example of a European larch flower. The male flowers of this tree appear in mid-spring and are a yellowish-green colour. Their highly photogenic and delicate structure of overlapping scale-like petals creates tremendous shadow. One way to overcome this heavy contrast is to use a judiciously angled fill-in flash. For a single fill-in manual flash, you need to use the GN to select the appropriate aperture for the flash to subject distance. Meter the ambient exposure to ensure the shutter speed is below the top camera sync speed. Now move the flash (not the camera) back from the subject. A 2:1 fill ratio of ambient to flash puts the flash gun at 1.5 x the camera to subject distance.

Larch flower. Subjects with extensive relief require overcast or diffuse natural light, fill-in flash or reflectors.

An alternative to moving the flash gun back from the camera position is to reduce flash output by shielding the flash discharge tube with a neutral density (ND) filter. This is my favoured technique and I make good use of ND filters. A Wratten ND 0.3 filter will reduce flash output by one stop while an ND 0.6 reduces output by two stops. Used together the total filter density equals the sum of their individual densities. In other words, in tandem they reduce output by three stops. At this degree of filtration only 13% of flash discharge is transmitted from the filter. These manual flash fill-in techniques can therefore reduce contrast altogether, perhaps risking a rather two-dimensional image, or retain sufficient tonal

range to create an interesting three-dimensional effect without losing all the detail to shadow that would have been the result without fill-in flash.

With TTL fill-in flash, maintain the flash gun's position relative to the camera, and trick the gun by altering its ISO setting to a higher value so that the gun will emit less light than required for the set aperture. If you double the ISO number from, say, 25 to 50, the flash will only emit half the amount of light.

Many photographers opt to use fill-in flash that gives between one and two stops less light than is required for the ambient exposure. This, of course, is a subjective point and entirely up to you.

For completion I should make you aware that a simple approach to reducing contrast in our larch flower would be to use a small white or crumpled silver reflector to 'bounce' light into the areas of shadow. However, as with all tips and techniques in this book, experiment and pick your preferred method.

Selecting an appropriate flash system

It is no accident that I have made this the last section in the flash photography chapter. My rationale is simple, the majority of existing texts teach little in the way of useful techniques and seem obsessed with the latest equipment. This is particularly true of the photo magazine press. Sophisticated flash equipment does not on its own make wonderful pictures. First comes an understanding of the principles involved; only then are you in a position to realize the full potential of stroboscopic flash, units which sync at shutter speeds of 1/4000 sec, off camera TTL flash, and other newly developed flash hardware. In keeping with the philosophy behind this book, I will review some flash system features which you may find useful.

I own three of the lowest output manual guns produced by Jessops and Hanimex. My most powerful manual gun is a classic Vivitar 283 with a GN of 36m at ISO 100. I don't think I have ever used this gun on any of its four auto settings. My favourite, you will have realized, is the Pentax AF280T (I have two). Its flash head can be adjusted 270 degrees horizontally, 90 degrees upwards vertically and for close-ups minus 15 degrees downwards vertically. It offers TTL, auto and high and low output manual flash. A Fresnel adaptor AFT2 augments output for use at greater working distances. Perhaps most importantly with a

4P type sync cord and hotshoe grip it can be used off the camera. Other TTL/manual units designed for the Pentax LX, and through Pentax's philosophy of backwards compatibility, also my Pentax Z1-P, include the smaller AF200T and extremely powerful AF400T (GN 40 at ISO 100/M). It also has its own ring light set (AF080C).

The more recent SF, Z and retrostyled MZ series of cameras (designation varies according to country of sale) by Pentax take the degree of sophistication even further with faster shutter speed sync, zooming flash heads, trailing shutter curtain sync mode (second curtain sync) and autofocus spot beam projectors – none of which actually helps one iota in making great macro wildlife photos.

Clearly, I am committed to Pentax, others reading this may be committed to Nikon, Canon or Minolta to mention but a few of the leaders. I have no intention of reviewing all flash systems. Some, however, are worthy of note for certain innovative features. The later generation of Nikon speedlight, the SB25 for instance, has a high speed sync to 1/4000 sec. The Minolta program 5400xi offers remote off-camera control and multiburst flash, as do the latest guns from independent manufacturer Metz and finally, for our purposes, the Canon 300EZ speedlight is capable of auto TTL flash metering for subject/background balance. The choice is yours. However, I do recommend you look for the following features as a minimum:

- TTL and manual modes

- sync cable for off the camera TTL flash

- a TTL flash that works through the aperture priority mode and switches itself off fast enough at a reasonable close distance to your subject. Some more powerful guns may not switch off in time and could overexpose when used for close-ups.

Remember that simple is often best. Don't buy the latest gadget unless you can fully justify its usefulness for your brand of photography, otherwise all you are doing is pandering to what is essentially the photographic jewellery market.

This chapter completes our consideration of the basics of photographic theory. The following section addresses the applied aspects of nature photography.

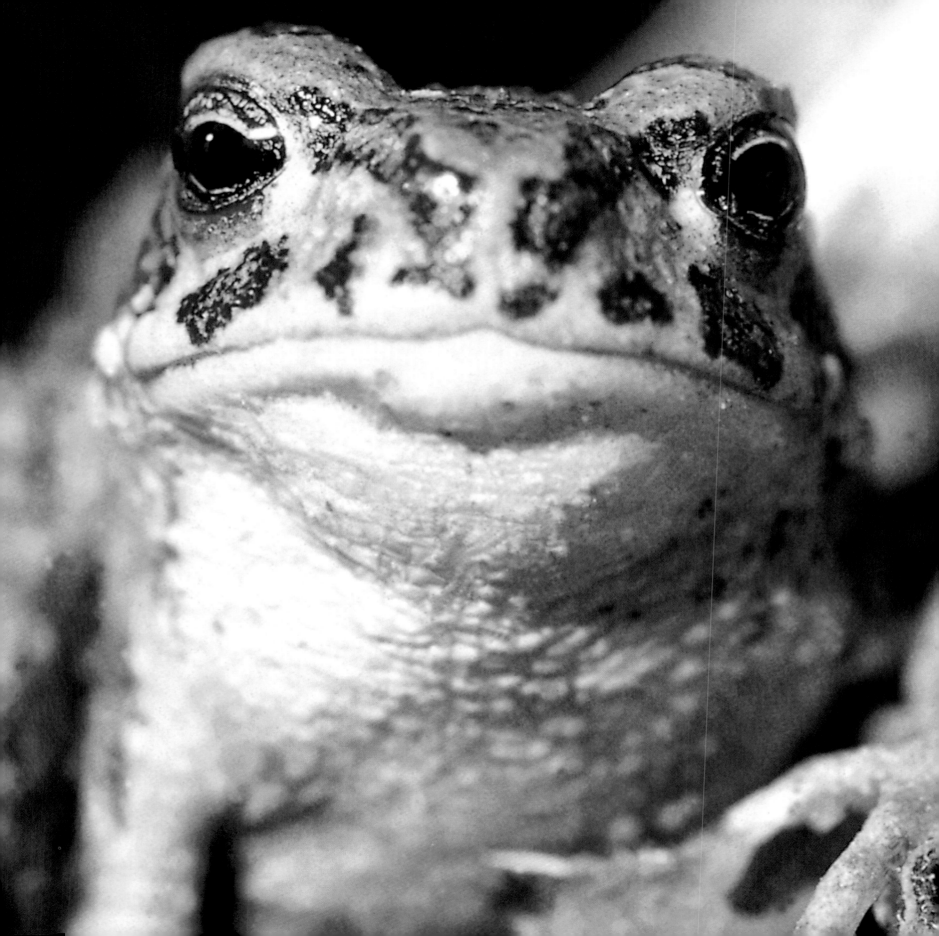

Applied Nature Photography

This section puts the mechanics covered in the Basics section into practice and sums up some of my field experience – and experiences – during the twenty-odd years I have been photographing nature subjects.

Where to look

Amphitheatre being reclaimed by nature, Patara, Turkey. Fuji GSW69iii f/16–22 at 1/60sec. Velvia, tripod.

There are so many marvellous places in the world to observe wildlife and nature's geologic marvels. In Europe alone I could list a hundred entries, from Spain's bird-rich Guadalquiver Delta in Coto de Doñana National Park to the wolf-haunted Bialowieza Forest in Poland. Such photographic jewels exist in every country, on every continent. But providing a gazeteer to the world's finest nature reserves does little to open the amateur naturalist's eyes to what is on his or her own doorstep. As you learn to see, your local patch will yield endless possibilities for the viewfinder. Finding, recording and ultimately learning to understand the nature that is all around you, wherever you happen to be, is surely the real issue. I can offer a few ideas of where you might look, by using three anectdotal examples from my recent photographic experiences.

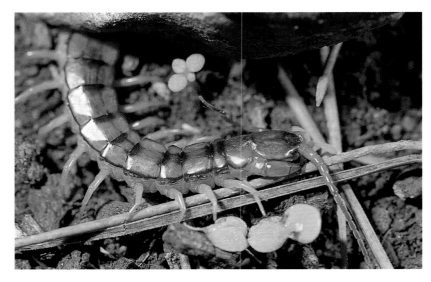

Scolopendra centipede, Turkey. Pentax LX + 100mm macro lens, AF280T flash, f/22 on Kodachrome 64.

Looking for new life in old ruins

As surely as metal will rust, nature will reclaim land and buildings abandoned by people. Witness the speed with which your tended plot or garden can resemble a mini-jungle while you take a summer holiday. And as the plants take over, creatures large and small take up residence, too, in what is a marvellous orchestration of life that ultimately binds together the entire planet.

The entire fringe of the Mediterranean is peppered with decaying ruins of great antiquity, and those that are isolated, and therefore unexploited by the tourist industry, can be home to all manner of wildlife. One of my favourite destinations for great photographic opportunities is the magnificent ancient Lycian ruins of Patara on

Turkey's Mediterranean coast. Turkey is an emerging economy, where development remains focused on a limited number of resorts, outside of which nature is still wild, yet accessible. Tourists don't flock to Patara in any great numbers, few guide books take you through the site's history and no locals offer advice – except to avoid some of the sites because of poisonous snakes.

Like Ephesus, Patara was once an ancient port on a grandiose scale but here, unlike its more famous counterpart, an entangled jungle of Mediterranean buckthorn, grey thistle, rock rose and heady aromatic herbs buzz with the rhythm of cicadas as they shroud the once grand metropolis in an almost impenetrable veil of nature – an inexorable force slowly reclaiming what was originally hers. The barriers for this natural succession are not particularly awesome, for Turkey is a fertile land where nature is abundant and where ruins provide a habitat which for many organisms is actually better than their original one.

At quiet, partially excavated sites as exemplified by Patara you have to discover its hidden treasures within the tangled *maquis* (and take time to enjoy the scent of crushed herbs with every step). The unfolding elements of a ruin well off the beaten track enveloped in foliage and alive with reptiles and all manner of photogenic mini-beasts provides dual impact – nature and history first-hand. To a biologist like me, here is a pool of life – a secret refuge for the beautiful and bizarre. Robberflies take out day-flying moths. Agama

lizard stealth eliminates robberflies and, flying above them, vivid scarlet *crocothemis* and luminous blue *orthetrum* dragonflies vie for smaller pesky mosquitoes. When I first stumbled across the territory of these aerial warriors it was a revelation. Tucked away, nestling between the ornately inscribed ruin walls, was a marvellous watery oasis brimming with life, just waiting to be photographed with everything from 35mm up to 6 x 9cm film.

The fecundity of all nature in Patara's ruins was clearly tied up quite intimately to the surrounding marshland and these ancient 'roman baths' reclaimed by a beautifully delicate architecture of rush and grass stems. I set up camp with my cameras next to the water's edge, and spent literally hours chasing after photos of a dozen species and a variety of scenes.

The Patara site between Fethiye and Kas was founded by Lycians 2,500 years ago. The present-day dense marshes were once a bustling harbour which fed the port of Xanthos. The city could be entered through a majestic arched gateway and guards would have patrolled this triumphal triple-arched city gate of Metticus Modestus. Armoured patrols still amble around the remains of the arch: Hermanns tortoises abound. These latter-day centurion guards mimic their Roman counterparts, even though their only offensive weapon is pressurized ejection of bodily fluid from their bladder. A couple of years back in Thassos my Pentax LX camera was christened in precisely this manner.

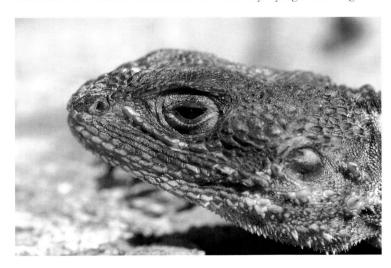

Agama lizard, Pentax LX + 100mm macro lens.

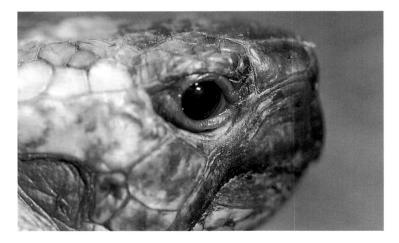

Hermann's tortoise, Pentax LX+ 100mm macro lens, AF280T flash, f8.5 on Kodachrome 64.

Once through the gate, today's 'city' dwellers occupy a range of niches. In this area of the Mediterranean, with the exception of an odd Erhards's wall lizard, the otherwise ubiquitous small Lacerta and green lizards seem to have been largely, but not entirely, usurped by the prehistoric-like agama. These extremely nosy yet flighty tenants occupy extensive real estate within every nook and cranny of the tumbledown ruins. A minority group of more secretive reptiles sharing the lower tenements are ocellated skinks. Also, here and there, you can pick out the frenetic maternal pandering of black and yellow paper wasps as they tend their small papier mâché nests glued to the irregular stone surface of the ruins.

Water for life

A source of water, running or still, is always a good spot for wildlife photography. Patara's flooded Roman and Vespasian baths are home to organisms with a most peculiar sexual habit – edible frogs. As you approach the water's edge you hear a synchronous plopping of these green frogs as they dive consecutively into the water, like a carpet unrolling before you. In Europe three green frogs exist – the pool, marsh and edible frogs. Marsh and pool frogs interbreed and produce

Grass snake in Patara's ruins. Pentax LX + 100mm macro lens, AF280T flash, f/11 on Kodachrome 64.

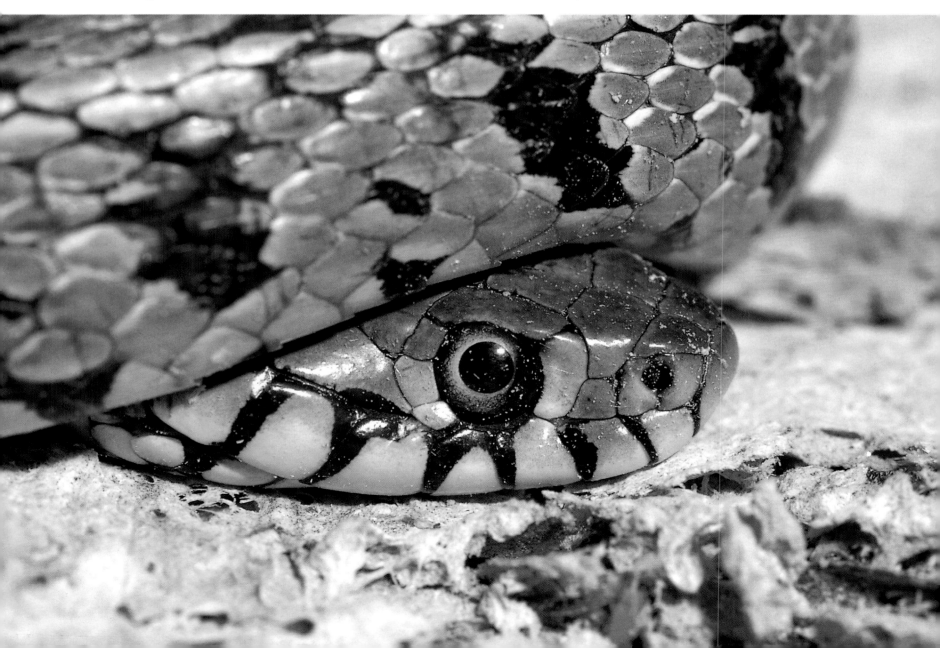

rather ugly, if colourful, edible frogs. Unlike most other hybrids, edible frogs can interbreed with either of their parent species to produce not intermediates but more edible frogs. In fact their reproductive biology gets even more complex and convoluted. To photograph them you must use stealth and be prepared for wet feet and knees.

The aquatic aspect of the Roman baths in particular held my attention. These water holes offer up a complete and vibrant, if somewhat compact habitat. Pond crowfoot, with its delicate emergent white and yellow flowers, provides a shady underwater labyrinth for a remarkable density of tadpoles which in turn attract stripe-necked terrapins, lithesome grass snakes, great diving beetles and even crabs. As I walked between the many watering holes I counted and photographed four grass snakes – big and small. Three made their escape when they sensed my presence, but one feigned death, even though it was in the middle of a pool.

Wind scorpion, Turkey. Pentax LX + 100mm macro lens, AF280T flash, f/16 on Kodachrome 25.

Man-made structures provide diminutive creatures with shelter from the sun and refuge from predators. Nooks and crannies in masonry can attract all manner of mini-beasts. Hidden away from passers-by, under ancient masonry which shelters them from the desiccating sun, I found Patara's vagabonds – large malevolent wind scorpions which are so ugly they could, like Medusa, almost turn you to stone. Their disproportionately large jaws contain no toxin, but are capable of breaking human skin and causing infection. One flew up my leg and down again so fast I soon realized they were christened with a particularly apt name. They share their sub-stone niche with a smaller yet much more dangerous cousin – *Buthus occitanus*, a ginger scorpion with a toxin very dangerous to young children. I've got into the habit of checking the ground before sitting down when I'm trekking around the Mediterranean.

I ambled around the wetter ruins of Patara, trying to photograph the five or six obvious species of dragonfly which controlled the airspace by darting, skimming and hawking with amazing alacrity. I discovered that the gaudier, almost luminescent, species – scarlet Crocothemis and blue Orthetrum dragonflies – were so flighty and timid it gave me a headache attempting to get sharp macroscopic images of them on film. In contrast, snapping the Sympetrum dragonflies with their drab livery was child's play. Intermediate in colour were Gomphus species, which also proved intermediate in difficulty to photograph. I can't be sure, but I put this colour–behaviour corollary down to the drabber species relying on camouflage for protection from bird strikes while the startling red and vivid blue species use rapid movement and evasive manoeuvring to avoid predation.

Silver studded blue on felty germander, Pentax LX + 100mm macro lens, f/11 on Velvia. TTL flash.

Painted lady resting on the ground, Pentax LX + 50mm macro lens. TTL flash.

As the aerial display reached its zenith with half a dozen colourful species on the wing, an audience of green frogs began to register its apparent approval with a raucous melody. Within a minute, though, all was quiet again, owing to the small, beady-eyed green and black head of a grass snake protruding from the dense mat of pond weed. Grass snakes are accomplished aquanauts and are most usually spotted in water rather than on land. Be warned: if you could catch one it would regurgitate its half-digested amphibian breakfast, emit a foul liquid and play dead.

Biological elements are not the only forces of the natural world to be reclaiming the ruins at Patara. Shifting sand dunes are slowly engulfing an amphitheatre, cistern and tombs, in an intractable amoeboid mass. The sands may seem inimicable to life, and yet limb-numbing, toxic back-fanged Montpellier snakes venture into this dry zone – I know, because I accidentally trod on one.

Anticipating the seasonal rhythm of life

Nature is seasonal, and the months of spring are optimal for natural glory and a profusion of flowers, insects and birds. If you carry out a little research, and anticipate in advance the species you are likely to encounter, you can ensure that you have the most suitable equipment with you before you actually get out into the field. As spring moves towards summer, the aromatic herbs which garden the ruins of Patara survive the drier conditions by using their heady oils to prevent water loss. Their survival aids the survival of others. Dancing around the

Misumena vatia photographed in Croatia. You need a keen eye to spot it: this yellow crab spider is perfectly camouflaged against yellow daisies. Pentax SFXn + 50mm macro lens. Manual flash.

ruins in a colourful frenzy are sapphire coloured silver-studded blues and the odd ilex hairstreak – small butterflies which congregate in a mass of twenty or so at every diminutive, aromatic felty germander plant. These metallic beauties are the young maidens of the ruins. Indeed, they are even attended by ladies-in-waiting, in the form of ants, which protect the caterpillars from unwanted parasitic attention. In return, the ants obtain a nutritious cocktail exuded by the caterpillar. Above the hairstreaks, dashing frenetically from flower to flower, are the princesses of this world: swallowtails, cardinals and painted ladies with a single queen of the Mediterranean – the two-tailed pasha butterfly. Despite all my endeavours, I have never managed to shoot this species in the wild – one day maybe…

Patience, and a keen eye

Your success in nature photography depends to a large degree on your spending time getting to know a site, and looking carefully for creatures who may be masters of disguise. In Patara, quivering against the gentle wind-blown grass stems which carpet the Byzantine basilica, are perfectly camouflaged grass-like Empusid mantids which every visitor, no matter how eagle-eyed, will overlook (see page 91). Only a tenacious naturalist is likely to find these amazing creatures. Experience has taught me that when I photograph them, should I defocus for a second I'll have great difficulty finding my quarry again, so perfect is their subterfuge.

On the yellow chrysanthenums which embellish the ruins another exponent of deception plies his deadly trade. Yellow crab spiders, *Misumena vatia*, are invisible to their pollen and nectar-seeking quarry. Interestingly, yellow crab spiders on yellow flowers convert to white specimens on white daisies – testimony to the remarkable jigsaw of life which leaves few square pegs in round holes.

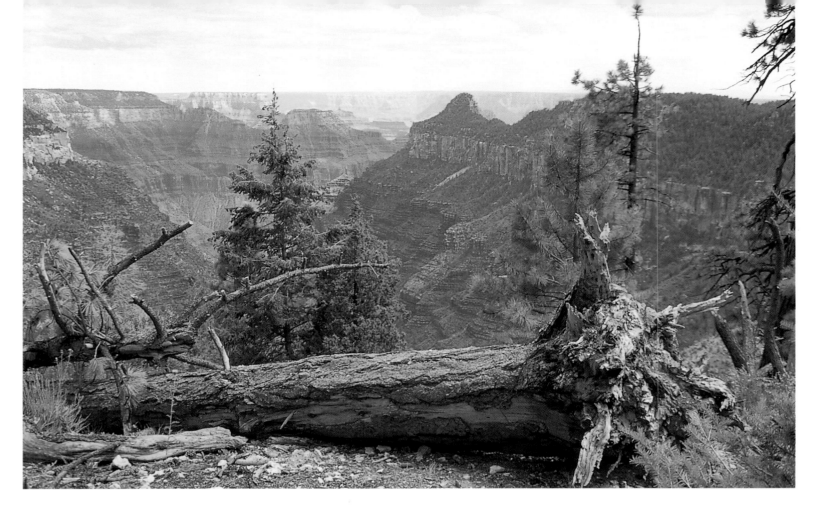

This view down Transept Canyon, a tributary of the Grand Canyons North Rim, was taken on a Pentax MZ5n + 28-70mm lens. An 81B filter was used to reduce the blue cast. The tree was struck by lightning some years ago.

Beyond the tourist trail

Clearly, anywhere can become a wildlife photographer's adventure if you look beyond conventional horizons. I had a couple of weeks to get under the skin of Patara. When you tour large areas and can spend only short periods in one place it is important to do some research prior to your trip, then you can focus your time on the most profitable photographic activities. I have toured the deserts of the American Southwest on several occasions. On one trip, I opted to stop off at the quiet North Rim of the Grand Canyon in preference to the busier, more developed, South Rim. Although my stay was only brief, a bit of homework taught me which trails were available and where might offer the best views of the canyon and its wildlife. This preparation enabled me to discover the hidden nature of the Grand Canyon's North Rim, even though I could only spend three days there.

I grew up in Britain, in East Anglia's interminably flat countryside, so it is fitting that I wax lyrical about a uniquely special, yet tenuous strip of land which circumscribes the deepest chasm on our planet. This ribbon-like biological tension zone is a meeting place for Grand Canyon creatures derived from the ponderosa pine forest, with its mosaic smattering of quaking aspen and white fir, and the Mediterranean-like pinyon–juniper woodland of the warmer rim edge. For the inquisitive hiker, willing to shed the blinkered perspective imposed by car travel, a convoluted labyrinth of snaking trails wends its way either side of the North Rim's only arterial road, providing access to disparate wildlife communities existing cheek by jowl – the difference between alpine and desert habitats being no more than a stone's throw. To the west, Widforss Trail follows the perimeter of Transept Canyon, leading on to Widforss Point, a few miles distant,

where Gunnar Widforss painted immortal views of the Grand Canyon in graphic geological detail. To the east of the Widforss trailhead lies the Ken Patrick Trail, and its circular offshoot the Uncle Jim Trail.

Most visitors to the Grand Canyon are familiar with its more visible wildlife: kaibab squirrels, mule deer and a range of shy lizards. As my family and I approached the head of Transept Canyon on Widforss Trail we met the only other walkers of the day – another family, who admitted to giving up long before they reached Widforss Point. Predictably, on exchanging notes, they had seen no more than mule deer. By the time we had reached the trail's end, we had seen all the most obvious species and also desert spiny-, tree-, northern plateau- and mountain short-horned lizards. We spotted numerous butterflies dancing in the dappled light filtering through delicate aspen leaves. We identified weidemeyers admiral, atlantis fritillaries and pine whites with complete accuracy and guessed at the identity of many diminutive species, such as the adroit leda hairstreak. We managed to corner a harmless gopher snake and were strafed by an irridescent green hummingbird. Among the larger birds we saw, perhaps the most interesting were the wild turkeys which strut across Harvey Meadow at Widforss trailhead rather like ridiculous medieval dandies. Although our three walks to Widforss Point did not reveal bobcat, coyote or mountain lion, what could be more fascinating than a reptile such as the mountain short-horned lizard? Members of this family of mini-dinosaurs ably defend themselves by elevating the blood pressure in their heads until it is sufficient to squirt blood through the corner of their eyes at any would-be predator. I don't think my daughter would have picked one up had she known this dark fact.

Mountain short-horned lizard in my daughter's hand. I used the same setup to shoot the plateau lizard which was indignant about my daughter borrowing its log at Widforss Point, Grand Canyon North Rim. Pentax MZ5n + 28–70mm lens with Nikon 3T dioptre. Illumination with RTF flash.

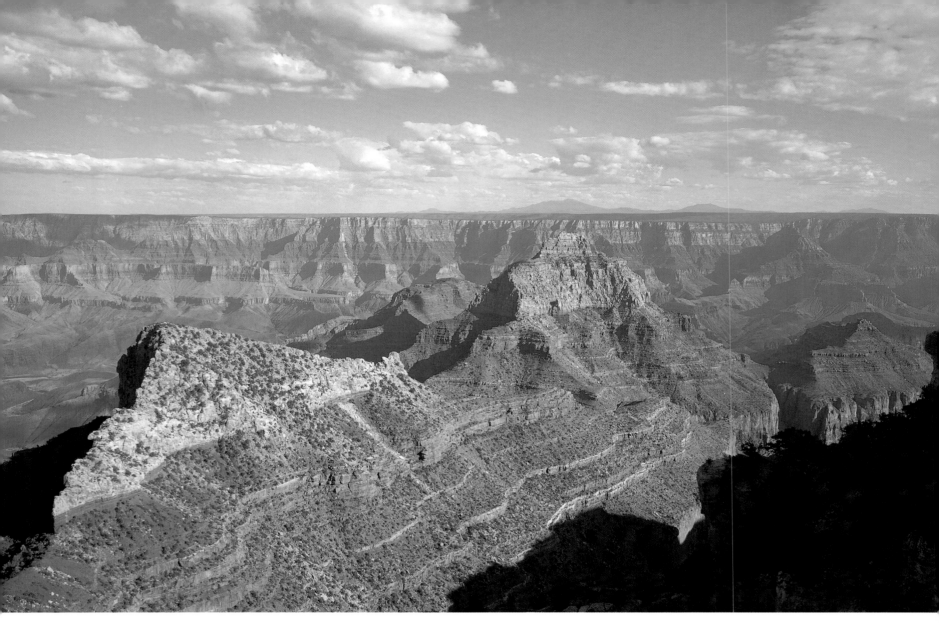

View from Bright Angel Point, Grand Canyon North Rim. Fuji GSW69iii f/16-22 at 1/60 sec. Velvia, tripod.

Planning your safety and comfort

Hikes at the temperature and altitude I experienced in the Grand Canyon are fairly demanding. You need to think about what equipment you will carry, and always ensure you have a good supply of water and a hat of some description. I was grateful for the lightweight nature of my Pentax MZ5n + 28–70mm lens and Nikon 3T dioptre. This combination of equipment provided a permutation for most likely situations – including both scenics and close-ups. If you are using a medium-format camera to obtain high-quality

landscapes, your preparation needs to be even more thoughtful, since tripod and camera will require extra physical effort on a long hike. However, many scenic vistas at the Grand Canyon are easily accessible by car, or are only a short walk from the lodge.

Despite my extensive travels around the world, to say nothing of the insight into the natural world we have grown accustomed to on our screens and in publications, nothing could substitute for the awe I felt looking at the canyon's perimeter landscape. Not even the

hoardes plying Cape Royal's mesh of tarmac paths that cut across the viewing area from North Rim can detract from the views of a distant azure Colorado River or Angels Window. The people didn't seem to impinge upon the beautiful Mediterranean-like landscape which typifies Cape Royal – a floral Eden with contrasting yellow snake weed and crimson paintbrush. It was here that I realized just how many native red flowers the Southwest has – penstemons, cacti, buglers and paintbrush among them.

Adding a sense of scale

Although you can view across the almighty grandeur of this immense chasm to Mount Humphreys near Flagstaff – 112km (70 miles) distant, a scene like that from the North Rim, devoid of any influence of man, is surprisingly less dramatic than one in which the human element is caught. By including an overlook or a viewing platform complete with tourists in your photographic perspective, you add a sense of scale which communicates the true immensity of this geological feature. The only other measure I could find to add scale to my photographic view was the hair-like North Kaibab Trail winding itself down to Phantom Ranch. The view of this feature from Ken Patrick Trail is a truly humbling sight, making the human condition, for all its inventiveness, seem very insignificant indeed.

The view at sunset from the North Rim of the Grand Canyon is truly spectacular. However, to nature lovers who open their eyes, the world is full of opportunities for taking equally superb photographs of the living world, often as not, without travelling to the ends of the earth. Pentax Z1-P, 28mm lens, f/16 on Velvia.

Although we can wonder at man's diminutive scale compared to the canyon and its natural history, human activities have started to influence the character of the canyon environment beyond the inevitable effects of tourism. Coal-fired power plants, such as the monstrous Navajo Generating Station which sits incongruously outside Page on the main route to Monument Valley, a good half-day's drive from the North Rim, emits sulphite particulates and is one likely source of the haze which obscures air clarity across the canyon and beyond to the San Francisco Mountains.

This dramatic, three-dimensional land is not merely a repository of wildlife in abundance, and a place for artists and photographers to congregate and contemplate recording vermilion sunsets. It is a place which can illicit both understanding and awe. It is these two qualities that, perhaps more than any other, make this ancient land, one that *is* actually wild and inaccessible for almost 480km (300 miles), a very special place indeed.

Rim shot of Point Imperial, Grand Canyon North Rim. Fuji GSW69iii f/16 at 1/60sec. Velvia, tripod.

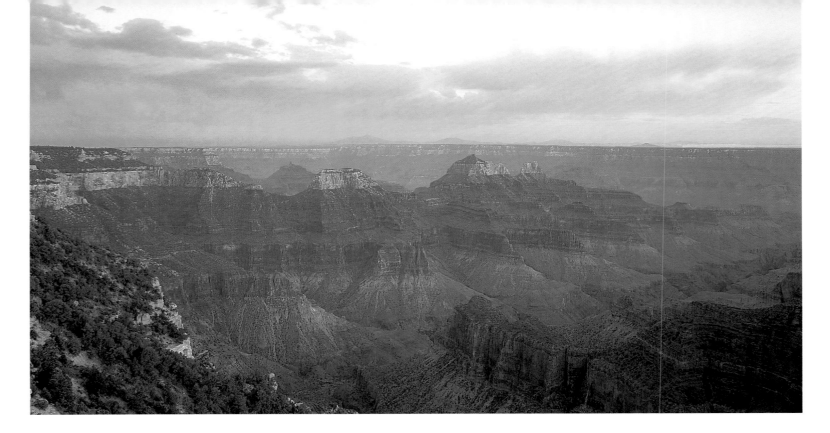

Sunset at Grand Canyon North Rim. I needed a sturdy tripod for this shot, more for stabilizing the camera against the jostling crowds than the wind. Fuji GSW69iii, around 1sec at f/5.6 on Velvia.

Light quality sets the mood

There are some superb images of Grand Canyon on the walls of the North Rim restaurant. Here you can see prints made from 6 x 17cm panoramics which are breathtaking in their sharpness and mood. The best I could muster were half that size at 6 x 9cm. Still, my dusk shots caught storm light over the North Rim very nicely. Dusk at the Grand Canyon is a special time. The narrow window of opportunity for photographing sunset undoubtedly produces the most colourful and evocative images of this landscape. The vibrancy of the transition light, as day becomes night, is possibly augmented by the pollution haze that can otherwise impair daytime shots (the particulates scatter light, enhancing the sunset effect). At dusk I was shooting with a tripod set to f/5.6 and 1sec. I couldn't stop down any further because I had no watch with which to time the exposure beyond the camera's longest timed 1sec setting. Still, my Fuji GSW69iii produced marvellous images even wide open. The wideangle 65mm lens was focused at infinity and therefore a limited depth of field was not an issue.

These examples from two very different geographical locations describe my experiences in environments where light is generally not a limiting commodity. In a further account of an interesting and slightly off-beat habitat in which to photograph nature, light is very much limiting, and use of flash plays an important role. It shares many of the photographic problems of dense tropical rainforests which I discuss later (see page 129).

A jungle adventure of sorts

At the extreme tip of peninsular Florida, just north of the Tropic of Cancer, lies a remarkable zone – a tension zone if you wish – where the familiar temperate vies with the curious tropical. I set the scene for the photographic opportunities of this particular habitat in the Introduction. Here, in the heart of the Everglades National Park, dense jungle islands punctuate a sun-drenched sward of sawgrass. These small hardwood enclaves, known as 'hammocks', blend the biology of the Carribean islands with life from more northerly latitudes. The product is a set of unique ecological enclaves where West Indian trees such as the gloriously named gumbo-limbo are incongruously embellished with Virginia creeper, while northern species of oak can be held in the tenacious and fatal grip of the tropical strangler fig. A nature photographer's paradise – but one with particular problems, notably a lack of ambient light.

Giant golden orb web spider, Gumbo-Limbo Trail, Everglades National Park, Florida. Pentax LX + 90mm macro lens. Flash balanced with ambient lighting, hand held.

The evocative tang of southerly latitudes was wholly evident on my first excursion into this eerie, dark world of tangled wood. Penetrating deep into the shady heart of these few humid acres, I quickly became aware of what at first appeared to be the first drops of a summer shower breaking the serene tranquillity. It turned out to the sound of Cuban anoles – small flighty lizards – dropping from branches all around me, onto the crisp, brown leaf litter carpeting the forest floor. Safely down, these agile imports quickly scuttled away. I was bewitched by a galaxy of dazzling wildlife forms: the less competitive native green anole – a pseudo New World chameleon, tetchy southeastern five-lined skinks and many other animals which, to my way of thinking, belonged more appropriately to Amazonia. Photographs of these fast-moving creatures in their dark world require flash with a hand-held camera.

Heliconius zebra and flambeau butterflies glided effortlessly through the forest's inner space, clearly showing a predilection for the laser-like shafts of sunlight which shot through the dense foliage wherever the canopy allowed. The contrast here could be as high as it gets –

ideal for testing out fill-in-flash. At eye level I spotted a bizarre, star-shaped spider that looks as if it could rip open the gullet of birds – *Gastracantha cancriformis* – which had set up home next to an enormous golden orb-web spider whose legs spanned the size of my hand. (Close relatives of this particular monster produce silken webs with a tensile strength that allows South Sea Islanders to construct nets and baskets from them.) Unlike the earlier fast-moving hammock residents, this fellow was still enough to let me balance flash and ambient exposures so that the subject and its background were equally exposed. I hand-held this exposure, yet miraculously managed to avoid any significant shake or ghosting.

In search of colourful livery

Since I belong to the temperate Old World, the steamy jungle islands of southern Florida offer a novel distraction with their diverse and vibrantly colourful assemblage of creepy-crawlies amidst the strange bustic, mastic, machineel and poisonwood trees. Colour would seem to be of paramount importance here: the yellow and black stripes of the zebra butterfly seem to break up their outline as they adroitly flutter in the pools of sunlight. As with other Heliconius, the zebra butterfly's striking aposematic colour pattern blatantly advertises the

Zebra longwing butterfly. Photographing these busy Heliconius butterflies in dappled lighting and dense undergrowth is difficult and requires manual flash for good results.

noxious cocktail of chemicals contained within. In similar vein the sloth-like lubber grasshoppers indicate unpalatability by dressing up in bright livery. I photographed these gaudy denizens using flash as the dominant light source because I wanted their colours to stand out against a black background – a favourite rendition with editors, since it affords greater visual impact. Indeed one image (see page 9) has sold so many times it has paid for my visit to the US.

Colour provides the signals in a more complex code where anoles are concerned. Both the green and Cuban brown anoles have startling red throat fans called dewlaps which are employed in threat gestures, courtship and territorial defence. Expert herpetologists studying colour change in the chameleon-like green anole reckon camouflage, temperature and emotions all elicit a shift between the green and brown states. I can add one more factor: being in front of a camera. Successive bursts of flash and constant eye-balling with my lens precipitated the characteristic russet transformation, although whether my lens won a territorial dispute with the anole or if I precipitated a reptilian bout of depression will remain forever a mystery. Another, more sensible, conclusion I came to while photographing hammock anoles was based on the relative ease with which I could record the behaviour of the green anoles. I found the Cuban brown anoles much more timid and difficult to photograph. It seems reasonable that if brown anoles have a better developed predator avoidance strategy than green ones it could be a contributory explanation of why green anoles are on the decline and brown ones are expanding their range. Again, to shoot and freeze anoles I utilized flash as the dominant light source – balancing flash with ambient light would have meant that severe ghosting would occur.

A cautionary tale

Although the anoles are clearly the most abundant reptiles of the Everglade hammocks, more sinister members of this group abound. The deadly cottonmouth water mocassin is one snake to be avoided at all cost. However, the same curiosity which killed the cat led me to reinvestigate the precise spot where, the previous day, a park ranger had seen a cottonmouth twice the length of his arm. The serpent had held its ground – mouth open it had exposed both the white cotton-like lining, and bared fangs within. Unsurprisingly, when I visited, the cottonmouth had moved on, but serendipity intervened. Sitting at the base of a shady tropical tree near where the cottonmouth had been the day before was another colourful inhabitant of the hammocks: a dusky pygmy rattlesnake. I immediately threw caution to the wind and focused my camera ever closer until the front lens element was almost flat against the rattler's nose. Whenever I recall the experience, I realize my scientific inquisitiveness and passion for photography had overcome common sense, since this ridiculously small snake has not only a nasty temperament but a highly potent venom which it delivers through repeated strikes. The venom causes great pain as well as tissue necrosis, but since only tiny volumes are injected death is unlikely. Nevertheless, the loss of a digit or two would have been a high price to pay for the photographs I obtained. Understandably, I was rushing my photography, and again used flash as the sole light source. When I look at this shot I find myself wishing I had taken the time to balance flash and ambient light, as this would have undoubtedly produced slightly better results. However, with hindsight, I count myself lucky not to have been badly bitten in the process.

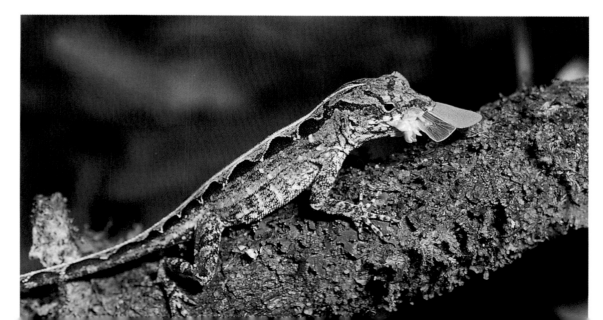

Walking through Mahogany Hammock in the Everglades I spotted this Cuban brown anole eating a juicy bug. While it concentrated on its meal, I was able to photograph it with relative ease. Pentax LX + 90mm macro lens. Flash as dominant light source.

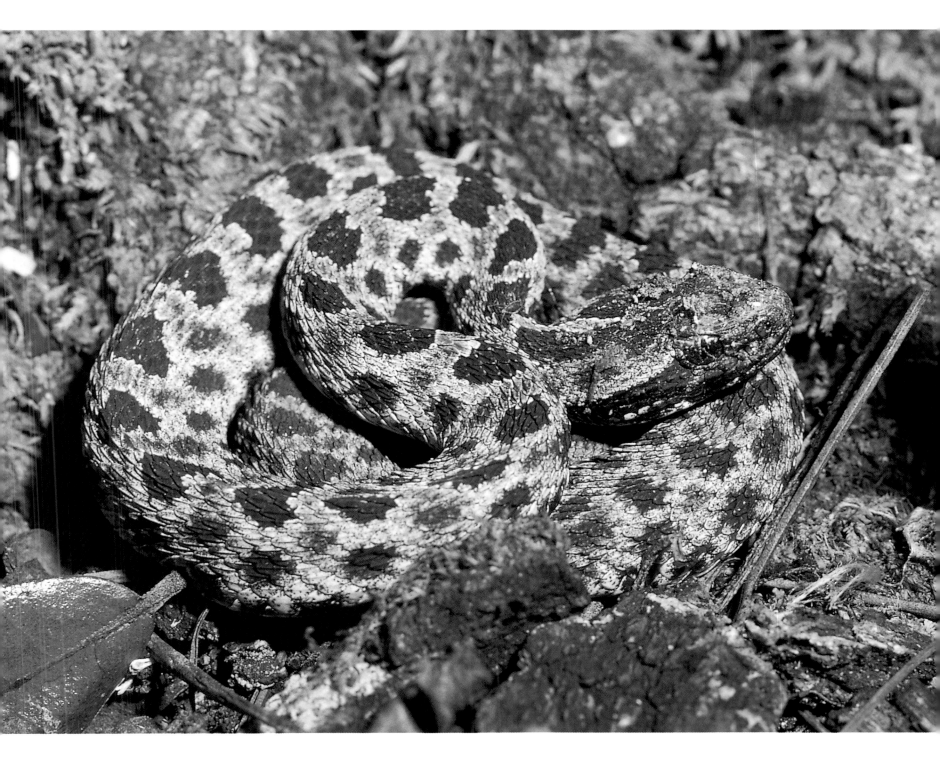

Dusky pygmy rattlesnake, Gumbo-Limbo Trail, Everglades
National Park, Florida. Pentax LX + 90mm macro lens.

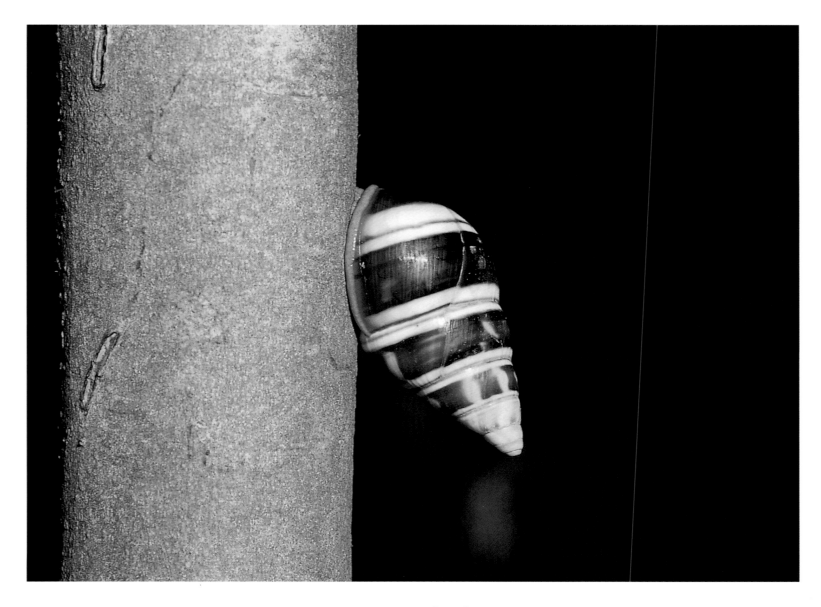

Rare liguus tree snail, Mahogany Hammock, Everglades National Park, Florida. Pentax LX + 90mm macro lens. Flash as dominant light source.

Tree life

Of all the West Indian imports to have drifted to Florida's shores on the warm currents of the Gulf Stream, perhaps the most famous in the Everglades are the nocturnal liguus tree snails. The only places these animals exist outside Florida are the islands of Cuba and Hispaniola. When I visited the Everglades, most of these tardy creatures were in a torpid state of dormancy on their tropical resting places – Jamaican dogwood, wild tamarind and other smooth-barked trees. Despite this, the snails were so ubiquitous I had soon identified a good selection of the fifty kaleidoscopic colour forms. Many of them were in awkward locations, which meant I needed to stretch out with my camera. This posture again justifies using flash as the dominant light source to freeze any camera shake on my part.

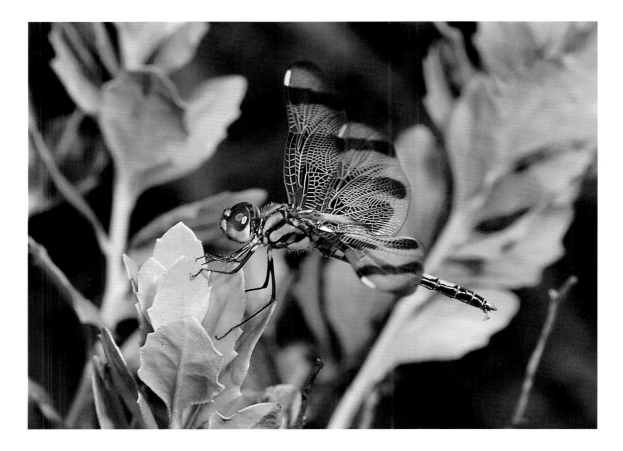

Halloween pennant dragonfly, Anhinga Trail, Everglades National Park, Florida. Pentax LX + 90mm macro lens, AF280T flash, f/16 on Kodachrome 64.

There is even more to this macrocosm than is seemingly apparent at eye level. An abundance of life persists in every stratum. Epiphytic plants form a rich aerial garden high in the trees where wild pineapple bromeliads, various other airplants, familiar Spanish moss and less well-known orchids gain precarious purchase amongst the lichen-encrusted branches. In dark Mahogany Hammock, perhaps the most famous of Florida's jungle islands, some of North America's largest mahogany trees can be seen festooned with bright red flowering bromeliads.

Larger bromeliads may themselves be a microcosm of life because their overlapping leaves provide a reservoir of life-sustaining water where insects, tree frogs and other small fauna eke out a perilous existence. Even during dry periods the dew that collects here can help sustain life. Far below these aquatic receptacles, on the lowest stratum of all, is a lush world of ferns which, along with all the ubiquitous tough, glossy and roughly elliptical drip-tip leaves add the final touches to this quite unique semi-tropical environment.

I found that the character of these jungle islands varies – inland at Mahagany Hammock the vegetation is dense, creating a dark habitat where the air is laden with moisture, whereas along the Florida Keys hammocks provide a more open, drier and better-lit environment. Likewise the sawgrass prairies which surround the hammocks provide a much brighter environment. These prairies are home to numerous dragonflies which I succeeded in photographing using a balanced flash/ambient illumination

Wherever you find yourself, environments exist which are full of interesting wildlife that can yield equally interesting photographs. All you need do is open your eyes to the possibilities that are available, and never overlook the ordinary in favour of the exotic. Every locale has opportunities. The following chapters concentrate on specific wildlife groups and habitats, as opposed to locations or equipment. They are designed to help you deal with the photographic challenges peculiar to individual groups as well as to understand these organisms and their habitats a little better.

Insects

13

If you want to photograph something a little different, insects are the subjects for you. Collectively insects seem to elicit one of two responses – either they make the skin crawl, as with cockroaches, or they make us marvel at their delicate beauty, as with butterflies. Both reactions are very good reasons for photographing them. Their abundance and variety of form are awesome. Dinosaurs are often credited with being the most successful animals that ever lived – successful in terms of how long they endured – yet the insect lineage extends back twice as far. Currently, over a million insect species grace our planet with representatives in every terrestrial habitat. In fact, their lives are inextricably bound to ours for very good reasons, not least because of their predilection for flowers. Probably the most significant association on our planet is the mutually beneficial relationship between flower and insect. Enticed by a blossom's colour and scent, butterflies, bees and other aeronauts are drawn to the rich sources of delicious nectar. As they imbibe they both pick up and discharge the minute pollen grains essential to the reproductive strategy of plants – and we benefit because our own success is dependent upon a 'green', well-oxygenated planet.

Opportunist naturalists and wildlife photographers can make good use of this highly orchestrated biological phenomenon to record on film the pulsating activity of a typical flower patch. You might catch a carder bee gathering pollen with great alacrity or a butterfly delicately extracting nectar through its flexible probosis. In warm climes, sinister subterfuge can also be snapped as camouflaged mantids hide below petals, awaiting the arrival of a tasty repast in the form of bluebottle or similar fly. For many readers of this book I suspect their early trials of wildlife photography will be in their own gardens, frenetically pursuing these diminutive entities as they go about their daily chores among a galaxy of dazzling blooms. The reward from your photographic studies will be a record of some of the most colourful, yet bizarre, forms of life imaginable.

Photography as a learning tool

Your slides can offer interesting insight. A garden in summer in temperate latitudes can reveal a kaleidoscope of easily photographed colourful insects as readily as exotic locales – without the travel expenses. But how often do you connect that colourful livery with an adaptive response to the basic problem of survival in a hostile world? Striking aposematic or warning colours, usually red, orange or yellow, when mixed with black, frequently imply that an insect can either inflict a poisonous sting or bite or produce an unpleasant secretion, or that it possesses chemicals which make it unpalatable, even toxic, if ingested. We all know that wasps sting, but how many people are aware that the humble red and black ladybird is conveying the same message as the wasp – although in the ladybird's

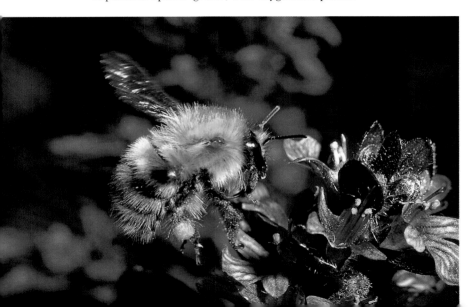

Carder bee (*Bombus pascuorum*) in flight collecting pollen. Pentax ME Super, 50mm lens + 50mm of extension. Manual flash using inverse square rule of exposure. Kodachrome 64.

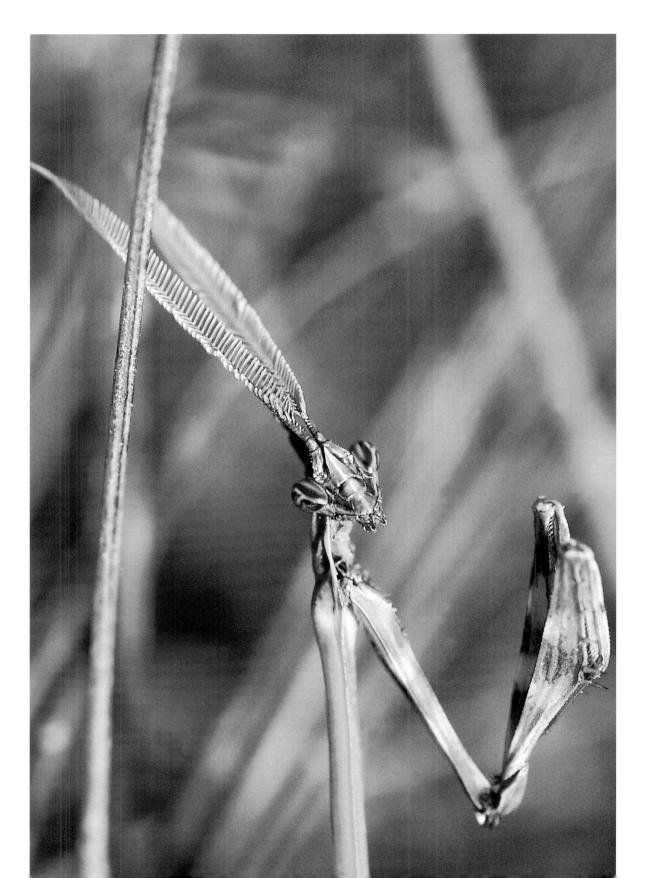

The resemblance of an empusid mantid to a grass stem is quite uncanny. Pentax LX + 100mm lens.

case it is distasteful owing to a smelly, irritant alkaloid called coccinellin. When handled, this protective substance is liable to be excreted from their leg joints – a phenomenon scientists term reflex bleeding. Similarly, the beauty of the variously spotted burnet moths, Zygaenidae, which are often seen feeding with impunity upon scabious flowers, belies their capability to synthesize hydrogen cyanide. As with the ladybirds, burnet moths use black and red to warn of their toxicity. At first sight these mundane creatures may not engender the same photographic interest as tropical creatures such as noxious arrow poison frogs or Heliconius butterflies. But remember that with insect photography you are exploring an inner world where images on film frequently do not reflect what is perceived by the human eye. A tight cluster of aposematic yellow and black-banded cinnabar moth caterpillars, *Callimorpha jacobaeae*, shot in a 'boring' field can, on film, have visual impact equal to any exotic arrow poison frog.

Paper wasp at nest. Patara, Turkey. Pentax LX + 50mm macro lens, AF280T flash, f/22 on Kodachrome 25.

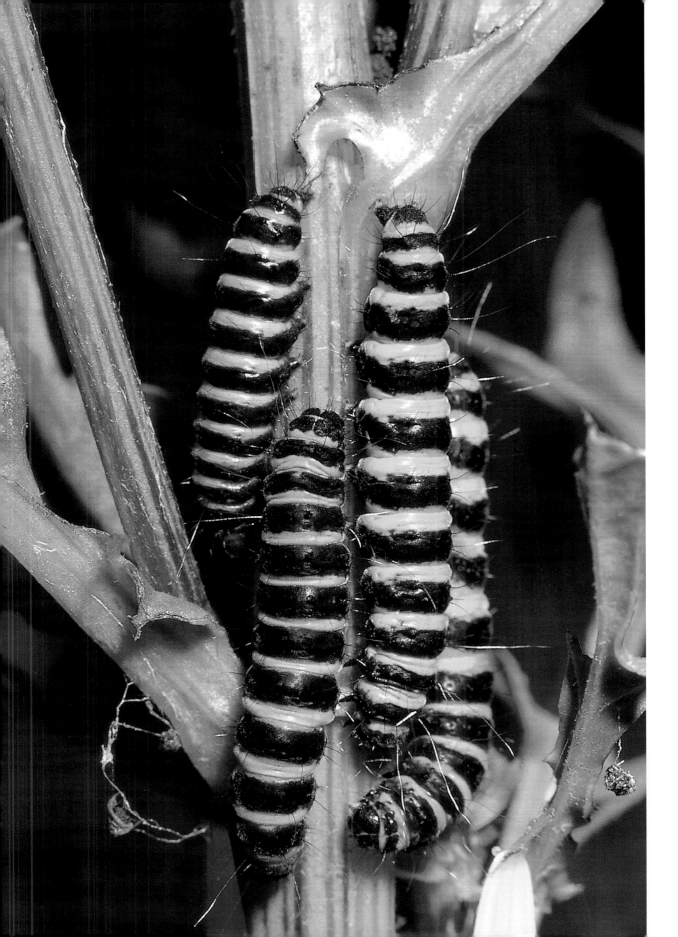

For visual impact, shoot small but colourful subjects en masse. Cinnabar moth caterpillars. Pentax SLR, 50mm standard lens + 50mm of extension, manual flash.

What is an insect and how do you identify one from another?

Irrespective of their appearance all insects are arthropods which share certain characteristics. They have an external skeleton protecting a body divided into three: head, thorax and abdomen. This basic theme has been moulded by evolution into a range of insects, from almost invisibly small thrips to the elegant giant peacock moth and repugnant yet fascinating tropical stick insects.

It is in their adult form that insects provide the best photo opportunities, for with the exception of moth and butterfly larvae, immature insects are generally rather boring and nondescript (and quite unidentifiable!).

Identifying insects can be a daunting task – but don't be put off. It is fairly easy to recognize and name your local butterflies as well as larger moths, dragonflies and damselflies. Even seemingly confusing insects such as hoverflies, crickets and grasshoppers are not too difficult to identify. Often as not, entomologists with some considerable degree of expertise, need to refer to authoritative texts for accurate identification. If you are in some distant locale photographing unfamiliar species, there is every chance that you can identify your subject from the resulting slide. However, most photographers recognize that on occasion it is necessary to return with reference specimens to ensure accurate identification based on features not apparent on the photographic image. After all, if you are to sell your work, accurate captioning is critical.

The caterpillars of many moths make more interesting subjects than their adult forms. This defoliating gypsy moth caterpillar was shot with Pentax LX + 100mm lens with TTL flash control.

Damselfly, Pentax MZ5n + 100mm macro lens, AF280T flash, f/16 on Kodachrome 64.

Every school child is taught that insects have six legs, a fact which allows us to distinguish between insects proper and similar animals belonging to the phylum arthropoda, which literally means 'jointed feet'. These other members include centipedes, millipedes, woodlice, spiders and mites. I discuss them in later sections.

I would urge you to become familiar with your subjects. The way forward is to invest in a good identification guide. In western Europe, for instance, there are 393 species of butterfly (excluding subspecies). The majestic form of the scarce swallowtail gliding through the air in Provence in the south of France is totally

unmistakable, but blues and ringlets are another matter. Despite my training and keen interest, I couldn't differentiate a common blue from, say, an Escher's blue in the field without resorting to a good guide book. In North America there are almost 700 species of butterfly making a guide an even greater necessity. But to highlight the richness of tropical ecosystems, Trinidad, one of the small Caribbean islands off Venezeula, has over 600 species of butterfly – almost as many as the entire US. Britain is somewhat deprived by comparison, having less than a tenth the number of species found in the US. So if you live in Britain this does make it somewhat easier to become familiar with – even expert in – your local butterfly fauna.

Important as it is, identification is only the beginning. As your confidence and knowledge increase you will need to address new questions – perhaps an explanation for some behavioural trait. It is this ever-increasing number of questions which draws me to what seems a magical synthesis of the biological and the photographic – an added dimension to the observational sciences of ecology and ethology. Through the lens or simply by using your eyes, it is observation of the natural world which has led to many of the main tenets of modern biology.

Learning to identify individual insects, and reading about their behaviour and general life requirements, will equip you with the knowledge you need to find and shoot these creatures in the wild.

How and where to photograph insects

Let's deal with the 'how' first. Two schools of thought seem to exist. Some photographers recommend using a tripod; others shun the idea, preferring electronic flash. I have never used a tripod for any of my thousands of insect shots and would recommend you don't either. A good tripod is heavy to carry, slow to erect and difficult to position precisely. My tried and tested methods for insect photography are based on the two flash techniques discussed in chapter 11, namely a small manual flash gun used in combination with the inverse square rule for calculating exposure, or TTL flash exposure using aperture priority to control depth of field (see pages 59 and 65).

Flash wins because it can arrest the movement of flighty insects. When the flash duration is short enough it can even freeze an insect's wing movement mid-beat during flight. If you opt for flash, it keeps the setup simple – a combination of camera and lens with a single small bracket-mounted flash is much more convenient, especially in hot latitudes when scrambling over rough terrain more suited to mountain goats than man. Try carrying a good-quality Benbo or Manfrotto tripod for the three or four hours around midday in June on a mountain hike, or while you scramble through thick vegetation – you'll soon come around to my way of thinking.

Behaviour shots are often the most interesting: here mating graylings. Pentax LX + 90mm macro lens, AF280T flash, f/16 on Kodachrome 64.

Stalking technique

Before discussing the hardware I would select for photographing specific types of insects there is a general skill you need to acquire. It may sound trite but you will only succeed if you master good stalking technique. There are a number of points to remember.

- ensure your lens/extension/flash combination is appropriate for the subject you are stalking. It helps to make your selection before you have your quarry in sight.

- move slowly, making no sudden movements. It is crucially important to keep your shadow off your subject, or it will be away – this is especially true of butterflies.

- very slowly take up your shooting position. Use your body to support the camera, pull your elbows in towards your chest or lie flat out, making a 'tripod' with your elbows and chest. I often kneel with my elbows either supporting the camera through contact with the ground or by pulling them rigidly towards my chest. To achieve this in certain terrains I recommend you carry a towel. It is far more useful than a tripod. It protects knees and elbows from the hard and often sharp ground during photography. Rough grassland in particular can be murder on bare knees. A towel's versatility extends to protecting your shoulders and head from the harsh sun. It will, of course, also give the same protection to your camera, and give you something to sit on when you have your sandwiches.

- the most difficult shots to make are when you are standing and leaning forward enough to exceed your centre of gravity. However, good muscle control and releasing the shutter as you exhale will help to avoid camera shake.

I have read in numerous magazines that the enlightened wildlife photographer must dress in khaki combat-type gear to blend, chameleon-like, into the environment. Rubbish – clothes, whether bright or drab, will not affect your success in insect photography. In fact, a bright tee-shirt may well attract some insects which mistake you for a flower patch. More pertinent, though, is hand movement during film advance. This presents no problem if you have a bolt-on or built-in winder but if you are overly enthusiastic at advancing a manual wind-on lever, owing, perhaps to excitement at having a rare specimen in your viewfinder, your movements could frighten away your quarry.

Above all, when out stalking insects, learn to focus your thoughts. Concentrate on what you are doing. Your success will depend upon your degree of dedication – don't be put off by mosquitoes or deer fly and learn to ignore the odd nettle sting.

If you have digested the necessary theory in chapters 4–11, the following examples will help you to apply this knowledge to real-life situations in the field.

Butterflies

Butterflies make some of the best photographic compositions in the insect world. Strong, well-designed shots are quite easily achieved. In the insect colour stakes, butterflies – and moths – are at the zenith. Surprisingly though, their wings are actually transparent. It is the cladding of thousands of tiny, flat scales with their uneven surface of ridges and valleys, often combined with pigment cells, that gives butterflies and moths their majestic beauty. Their scientific name, lepidoptera, means quite literally 'scaly wing'. Evolution has taken hairs and modified them into colourful scales whose appearance and structure assist the butterfly with its life-style; the scales which sit like roof tiles on the wing control thermoregulation, provide 'lift' during flight, and assist in many colour phenomena, including irridescence and pattern formation.

The ilex hairstreak uses deception to avoid the consequences of a lethal bird strike. It has a false head on its rear end. Pentax LX + 100mm macro lens and TTL flash.

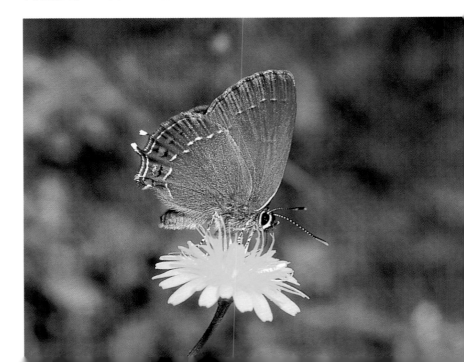

Your garden or local park is the ideal place to learn butterfly photography and the following list of plants will provide an attractive nectar-rich lure. The best shrubs are: buddleja, hebe, lavandula, ligustrum and syringa; and perennials, including alyssum, michaelmas daisies, *Sedum spectabile* and candytuft. If you can bear to leave a corner of your garden to nature, do so. Nettles, brambles, grasses and other native plants will play host to many stages of insect life cycles.

Lens selection

Which lens would you use for a given butterfly? I don't think there is a universal answer. My rule of thumb is to use my Pentax f/2.8 100mm lens whenever possible – the quality is exceptional and I get 1 x magnification. However, it is a heavy lens, 600g (nearly a pound and a half), and since I seldom require greater than 1/2 x magnification for butterfly shots, I frequently use my lighter (410g) and equally sharp Tamron f/2.5 90mm lens. Neither lens, though, can easily capture butterflies that are what I term 'busy', that is, they are in a constant state of motion, and seldom let you get within shooting distance. In my experience offenders include clouded yellows, cleopatras, some of the fritillaries and Heliconius, orange tips and quite a few others including common ones such as pearly crescent spots. To avoid frustration and failure, swap your 100mm macro lens for a 200mm macro or as I use, because it is portable and highly functional, a Pentax f/4 200mm with a 1.5 dioptre Nikon 3T dual element supplementary lens. This gives magnification rates between approximately 1/3 x and 2/3 x life size depending on whether the lens is set at infinity or its closest focus. This setup translates into more respectable working distances of just over 0.6 and 0.3m (2 and 1ft) respectively. I am hypercritical of my own work and I can't tell the difference between slides taken with this lens–dioptre combination and my prime 100mm macro lens.

Whatever lens I select, I would almost certainly use flash – not even excluding its potential for use out in the open, under an equatorial sun, at midday. Flash works especially well for butterflies since there is little relief on their flat wings, whether held together above their body during feeding or held outstretched while sunning themselves. Flash gives even illumination with little chance of harsh shadowing.

The grecian copper is quite a rare butterfly, and is considered threatened within its small distribution range. Pentax LX + 100mm macro lens and TTL flash.

Creating visual impact

Assuming that you are working with a single flash unit for convenience, how can you control the impact of a butterfly shot? One solution would be to make it stand out against a black background by providing a short burst of flash sufficient only to illuminate the subject and not its surroundings. This can give butterfly shots real oomph – see the painted lady on page 60. Another option is to make the butterfly stand out against a more realistically coloured background, but ensure that no detail or contrast is present (i.e. no horizons etc) so the butterfly pops out against a diffuse, amorphous, but real backcloth. (Never use articificial props like coloured card, it destroys scientific integrity and natural harmony – put simply: it looks tacky.)

To do this, you need to balance the flash exposure with the ambient light i.e. if you are using a manual flash unit, maintain the calculated aperture for your flash to subject distance, but reduce your shutter speed below its normal flash sync setting until it equates with the shutter speed your camera's TTL meter suggests to be appropriate for the aperture you have calculated. Since the aperture is usually very small to maximize depth of field, the balanced shutter speed will inevitably be slow. This means any movement during exposure will produce ghost blurring, i.e. two offset exposures – one due to the flash and one due to the ambient exposure. If you are not particularly strong you can avoid this ghosting by supporting your camera with a beanbag or tripod. However, this shouldn't really be necessary as most people can usually hold a camera still enough under these circumstances to obtain really excellent pictures.

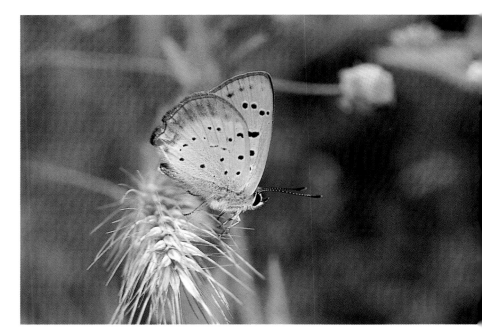

I am especially pleased with the shot of a lesser spotted fritillary on page 66, which was photographed using this technique. However, in this case I actually held the camera in one hand – the shutter speed was 1/30sec. You may wonder, why use flash at all if you are obtaining ambient exposure? Switch off your flash and find out! Flash illuminates only your subject, rendering all its detail as a sharply frozen image. Ambient light exposes its surroundings, but will never produce a sharp image of the butterfly on its own (especially at 1/30sec held in one hand). Basically, flash gives the shot punch.

Many photographers frown upon black backgrounds, considering them unnatural, but I disagree, as do many editors, since this sort of photography produces dramatic images. Daylight balanced flash shots are often less dramatic but can still have punch, particularly, as in shots with a dark background, if there are no distracting details in the photograph. For a complete review of controlling background exposure, go back over the detail in chapter 11.

Lessons to be learned

I can present two specific problems I have faced when photographing butterflies. Zebra longwings represent one of the few tropical Heliconius which have extended their range into the southern US. Their striking black and yellow wings make them highly photogenic. However, not only are they unrelentless in their aeronautical forays – never settling in one place for more than a microsecond, but their usual habitat is the interior of dark jungle-like thickets where ambient exposure, even at midday, may exceed one second. How do you obtain razor-sharp images of these apparently impossible to photograph subjects? The answer is to use the short duration of manual flash to arrest movement. Given their dark livery, their wings should be shot against lighter coloured foliage or tree bark, but not open space, otherwise their outline will be completely lost (as nature intended). My experience with this butterfly is that you can never balance flash and ambient lighting without getting significant ghost images. In any event, to achieve an ambient image at one second you would need a tripod – hand-holding would be impossible. But remember the rule for using manual flash with non-mid-toned subjects (see page 63). In this case, the butterfly's dark uniform will require 1/2 to 1 stop extra exposure – essentially the opposite of what you would do with a TTL flash metering system to compensate for the same non-mid-toned subject. The necessary increase in exposure can only be realized by opening the aperture (say from f/16 to f/11 or f/11^{1}/$_{2}$) and not by slowing the shutter speed.

The second problem involved using TTL flash to photograph a scarce swallowtail in Greece. The regal butterfly alighted among a marvellous thicket of pink rockrose, its large cream wings perfectly positioned at right angles to the ground. As I merrily clicked away relying entirely on my TTL metering, I was cock-a-hoop at the prospect of obtaining a series of perfect shots. Two weeks later, when my Kodachromes dropped through the letterbox, I was mortified to find a series of drab, under-exposed images. The reason was immediately apparent. The pale cream butterfly was not mid-toned, but my camera had made it so. You don't need too many lessons of this kind in order to develop a sense of when to compensate and by how many stops.

The upshot of these examples is: don't become wholly dependent on your camera's automation, there is a need for understanding beyond most people's unquestioning reliance on TTL flash metering. Remember TTL metering is not a panacea for all situations. However, when you look at the gulf fritillary on page 59, you can see just how valuable TTL flash can be. The picture was exposed at f/11 which gave the fastest shutter speed possible, while still allowing my Pentax LX to trigger the TTL flash (1/60sec). The punch from the flash has brought out the rich kaleidoscope of colours on the butterfly's underwings and this undoubtedly is what makes the photograph. The russet upperwings are quite dull by comparison.

What makes a good shot?

What should you be looking to record? Simple: anything and everything. Every one of my butterfly pictures tells a story that is of at least some ecological or behavioural interest. For instance:

Camouflage

In Britain one of the best exponents of this form of anonymity is the alert and jumpy grayling. The photograph on page 95 shows how well this butterfly blends into its parched surroundings on the Suffolk coastal sandlings (stretches of heathland punctuated by golden gorse). In tropical Asia, kallima leaf butterflies take this deception one step further. With wings closed they have the appearance of a dead brown leaf complete with veination.

Kallima leaf butterflies like this one are perfect mimics of fallen, decaying leaves.

Deception

Many people will be familiar with hairstreaks. These clever butterflies have doubled their chances of survival by evolving a pseudo 'head' at their wing's tail end. They feed with their wings held together above their bodies, slowly turning as they delicately extricate nutrition from within the flower head. Any bird that spots them is as likely to go for the pseudo head as the real one and so the butterfly survives. Hairstreaks with their duplicitous head are generally quite easy to photograph using flash because they tend to dwell when feeding. (See the ilex hairstreak on page 96.) You might also look out for specimens that have lost their false heads through bird attacks.

Aposematic coloration

Warning colours starkly emblazoned on wings are particularly common among the tropical Heliconius butterflies which synthesize cyanide in their tissues, possibly from amino acids in the pollen on which they feed. The basic uniform of Heliconius varies from region to region. However, within a given region, more than one Heliconius and other unrelated butterflies and moths, have evolved the same basic colour pattern. Once an insectivorous bird tastes a poisonous Heliconius it remembers the package labelling and all similar products are left on the shelf. The nineteenth-century German zoologist Fritz Mueller was first to describe 'mimicry' as a means to reinforce a strong visual image that birds do not forget. Longwing butterflies are only found in the New World but many Old World moths rely on aposematic coloration – keep an eye out particularly for tiger and burnet moths.

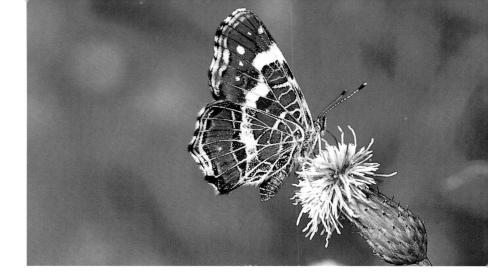

This map butterfly exists in two distinct forms. This is the pattern of the second generation. Pentax LX + 90mm lens.

Polymorphism

The meaning here is literally many forms. In Europe the best example of this phenomenon is to be found in the map butterfly which is common throughout central Europe. Two broods are produced in the summer with wing colour patterns so different you wouldn't think they were the same species. (The phenomenon is due to the difference in day-length which affects the duration of the pupal stage of the broods.) The photograph above shows an example from generation two taken in Austria. Try getting a picture of both generations!

Plant–butterfly relations

Flower heads provide a platform for butterflies which use them as refuelling stations to top up their energy levels. Interestingly, butterflies seem to have a distinct predilection for yellow flowers, so make a beeline for your nearest marigold patch. Of the many temperate garden flowers which are attractive to adult butterflies, buddleja in particular seems to have appeal. Each spike is a long composite of innumerable tiny flowers, each one waiting to encounter a flexible straw-like butterfly tongue. It isn't unusual to find small tortoiseshells, red admirals and peacocks cheek by jowl, bingeing on individual spikes during summer. Plant *Sedum spectabile* with your buddleja. Sedum's plate-like magenta flowers come into bloom as the buddleja flowers wither. They flower on into autumn and provide a source of nectar for red admirals which will help them survive their winter hibernation.

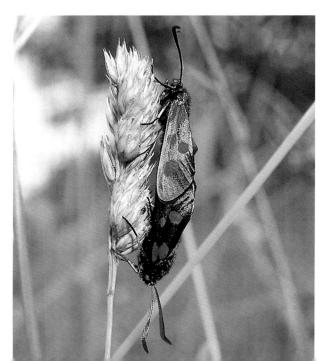

Mating burnet moths shot on a railway embankment. Pentax 50mm macro lens and manual flash.

Feeding time undoubtedly offers the best opportunities for photographing butterflies. If your stalking technique is good you should be able to reach minimum focusing distance with ease. Adult butterflies exhibit eclectic feeding habits – not so their larvae. We all know vanessid caterpillars, particularly those of the small tortoiseshell, live on nettles. Such singularly exclusive relationships between caterpillar and food plant are useful to know and can help when tracking down caterpillars to shoot. Adult butterflies are also never far from their larvae's food plants. In fact, in the case of our old favourite, the Heliconius, their caterpillars' food plant – the passion vine (Passiflora sp.) – has struck back. It sprouts false Heliconius eggs, creating an occupied territory and thus discouraging females from laying their eggs. Clever food plants indeed.

What makes a good pose?
On the whole I feel butterflies make more interesting photographs when their wings are held up above their bodies. Their underwings

Flight photography can be surprisingly easy. I froze the movement of this white-lined sphinx moth shot in Portal, Arizona, using the action-stopping potential of flash.

are usually more interesting than their upperwings (think of the blues, fritillaries and the map butterfly), and you record more body detail including compound eyes, flexible proboscis, sensory antennae and limbs. In this pose butterflies are often feeding and the proboscis is usually cluttered with a liberal sprinkling of pollen grains, making for good ultra close-up shots. Notable exceptions to this generalization are the vanessids, among them the peacock, small tortoiseshell and red admiral, all of which have cryptic underwings and striking colour patterns on their upperwings.

Moths
I make no apology for spending a disproportionate amount of time discussing butterflies, given that they will be a popular target for many photographers. Moths less so, although some, such as the hawk moths, giant silk moths and tiger moths, are as captivating as any butterfly. In North America alone, for instance, there are 42 species of giant silk moth north of Mexico. Look to record the striking colours of the death's head, oleander and eyed hawk moths (all European), or go for behavioural shots of the hovering hummingbird hawk moth or its US desert cousin – the white-lined sphinx moth. The static

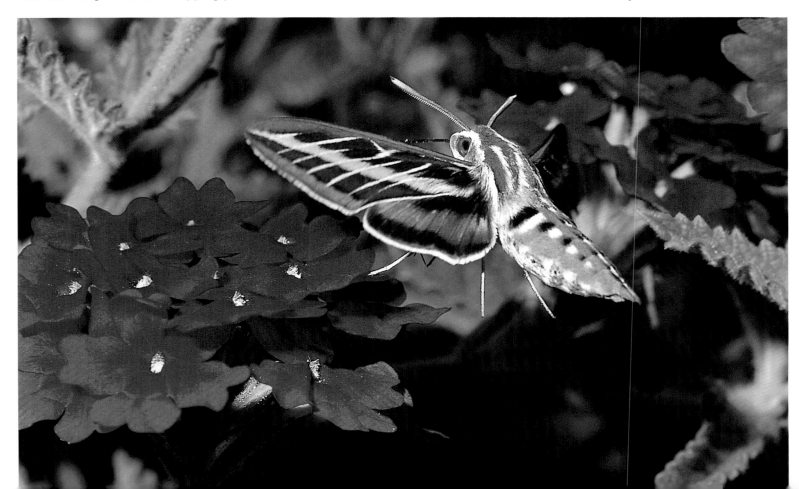

hovering of these last two species as they fastidiously gather nectar is both absorbing and photogenic. Other ones to watch for are tiger and underwing moths which rely on 'flash' coloration to temporarily startle predators. This shock tactic provides them with the advantage they need to make good their escape.

One of the main drawbacks to photographing moths is that most are nocturnal, although some are active during the day, among them the European burnet moths, hummingbird hawkmoths and the silver-Y moth. The techniques described for butterfly photography apply equally to moths, although bear in mind the need to achieve greater magnification rates, since many micro-moths are exceedingly small, even by comparison to some of the smaller blue butterflies.

If you are a beginner, the burnet moths make good subjects. They tend not to fly away when you get close and give you access to all phases of their life history. In one lecture I gave, I used a panel of shots showing a burnet larva, cocoon, adult with aposematic hindwings, mating and flight to illustrate how one might put together a photo article which covers all aspects of an organism's life cycle.

Adult butterflies may, I suspect, hold more appeal than their moth counterparts, although moth larvae are generally more interesting than butterfly larvae. Many of you will be familiar with the large horned hawkmoth or emperor caterpillars. The photograph on this page shows an elephant hawkmoth caterpillar I took in the Austrian Alps among its preferred food plant – rose-bay willowherb. When danger threatens the huge, greenish-brown larvae, it employs shock tactics to bluff itself out of harm's way. In response to predators and photographers alike, its body (which tapers off to form what looks like an elephant's trunk) extends to reveal large fearsome eye spots. These, combined with its size, provide an effective deterrent, especially when seen in dim light among the dense stands of willowherb which shelter this lizard-like creature. To get this shot I paid a dear price. Using my Pentax f/2.8 100mm lens, LX and AF280T flash, I knelt down, braced my arms and started clicking away, ignoring the stinging sensation on my legs – I thought I had merely brushed against a nettle. However, I soon realized that I had defiled a wood ant nest and their legions were wreaking revenge. I suffered great discomfort for that photo. I took it using TTL flash with the sole objective of recording an image that reflected the larvae's intended deception – to make itself appear to be something it is not: snake, lizard or monster, perhaps. It's a predator's eye view, if you like.

When you are presented with an obliging, colourful and splendid subject the tendency is to develop a tunnel vision in taking the photograph. Slow down! I once rushed to shoot an atypically colourful example of *Rhodostrophia calabra* (sorry, it's a moth with no common name). Unfortunately, the moth was below the surface of a Greek spiny spurge. Before I realized it, my enthusiasm had caused me to deeply scratch the front element of my 90mm macro lens on the sharp, thorny bush – was I angry with myself!

So, irrespective of whether your lepidopteran photography employs a 50mm macro lens to record the intricately patterned detail on a post-mortem wing, or a wideangle lens to photograph large swallowtails at lantana bushes, you are now in a position to effectively consider your objective with respect to technical needs, biological content, visual impact (in terms of technique as well as composition) and where, when and how to find your subject.

An elephant hawk moth larva looks bigger and more fearsome than it is, but my problem was the army of ants I disturbed.

The grasshopper *Acrida ungarica*, shown above isolated from its background and below camouflaged into its background. I shot it against the verdant grass that ran either side of a permanent stream in Cavus, Turkey. This parallel green sward extended for less than a couple of paces from the watercourse. Beyond that, the grass was dry and baked brown. Here, the lime-green *A. ungarica* gave way to brown versions of the same species. Two colour forms of the same grasshopper existing cheek-by-jowl.

Other insects

We have taken a close look at the butterflies and moths because they tend to appeal to most people. However, through a macro lens you begin to see the rest of the insect world from a different, more interesting perspective – pesky little hoverflies and related insects exhibit a new fascination. Their beautiful patterns which mimic those of wasps stand out in a stunning way against bold monotone white or yellow daisy petals. Not so beetles, which are a difficult group of organisms to photograph for a number of reasons. They are not particularly photogenic and their large size means depth of field seldom extends across the entire width of their body. Also their shiny elytra (wing cases) means flash highlights can sometimes ruin a picture. Grasshoppers and crickets are also difficult to make good photographs from since they are so very quick off their heels, and so well-hidden when they are not moving. The legend that accompanies the two images of a grasshopper here demonstrates once again nature's extraordinary ability to adapt to surroundings.

Mantids, however, are one of my favourite groups of insect. They make extraordinarily interesting photographs. When their strange alien-like eyes fill the frame, they can provide a superb visually arresting image (see page 91). Their ability to all but disappear, perfectly camouflaged in a forest of grass blades, make an equally fascinating behaviour shot. Mantids are ubiquitous, particularly in the Mediterranean region (Empusid mantids early summer, and praying mantids late summer) although they are difficult to find because of their grass-like form and colour which is one of the most perfect disguises in nature.

Ant-lions and their allies are very similar to mantids in that their shape and form are highly photogenic. The most magnificent species in Europe is *Palpares libelluloides*. The adult is difficult to get close to but it is possible. You might also try to shoot the larvae of certain ant-lions which make a conical pit in the soil. The larvae are notable for their huge jaws that are used to good effect to capture prey which falls into their loose sandy pitfall traps.

Dragonflies and damselfies are common to many countries and readily seen with the naked eye but very difficult to capture on film because they have excellent evasive reactions for avoiding predatory strikes by birds. Good stalking technique as described on page 96 is particularly relevant to photographing dragonflies and damselflies. It

took me nearly two weeks to get sufficiently close to a vivid scarlet *Crocothemis erythraea* dragonfly in Turkey on one of my visits. I eventually managed to get good close-ups, but not without a great deal of frustration over the preceding days. Persistence is all in nature photography.

Bees, wasps and ants are other ubiquitous insects. Ants frenetically trundling around their nests make interesting behavioural shots, wasps are strikingly coloured and make for dramatic close-ups, and bees as they attend flowers are good for practising flight photography using manual flash to freeze wing movement.

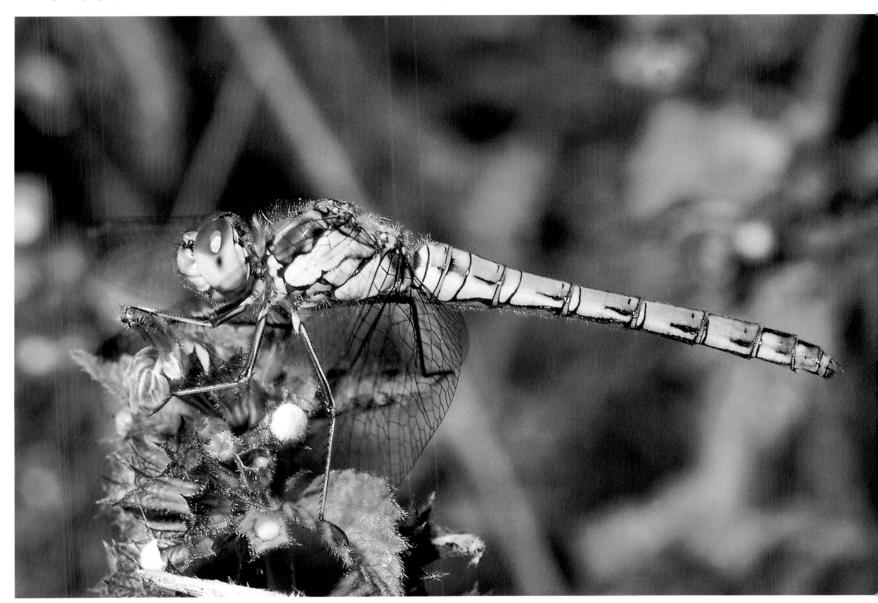

Sympetrum striolatum dragonfly. I shot this specimen in North Warren RSPB reserve, Suffolk, England, using manual flash, extension tubes and a 50mm standard lens.

Arachnids and
other invertebrates

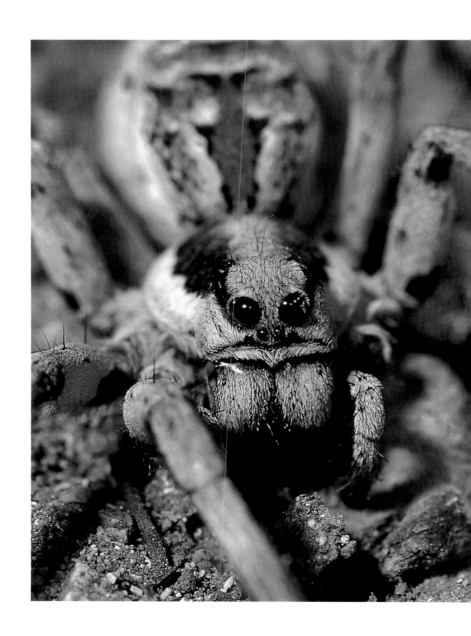

Arachnids, like insects, are arthropods. This group contains spiders, harvestmen, dangerous scorpions and irritating ticks and mites. Although they are not arachnids, this chapter also looks at other creepy-crawly invertebrates – millipedes, centipedes and the molluscs, which include slugs and snails.

Photographing spiders

The varied life histories of different types of spider provide an enormous number of opportunities for photography: their intricate webs, perhaps clad in dew or frost; ordinary house spiders lurking in the bath tub; right through to the marginally dangerous tarantulas found throughout the Mediterranean region, as well as their more infamous counterparts from the American deserts. The bite of a certain *Lycosid* wolf spider found in southern Europe is supposed to be extremely painful. In fact, it is often referred to as the European tarantula and victims of its bite apparently used to avoid death by doing a crazed dance which is now known as the *tarantella*.

A reconnoitre of any flower bed will reveal all manner of spiders. In most European countries, a patch of flowers, particularly those rich in either yellow or white blooms which abound in the daisy family, will reveal many lemon-coloured crab spiders, *Misumena vatia*. These spiders pursue a sinister lifestyle of murderous subterfuge. The small yet effective predators become completely invisible as they hide themselves beneath the bright yellow flowers of the corn marigold, perfectly camouflaged as they await the arrival of their

Europe's very own tarantula – *Lycosa narbonensis* – photographed near Ölu Deniz in Turkey. Pentax LX + 100mm macro lens with TTL flash.

dinner date – probably a juicy winged pollinator. Over a period of weeks this spider can alternate its colour between white and yellow, enabling it to lurk under white ox-eye daisies as well as corn marigolds. True to their name, crab spiders are usually flat and walk in a sideways manner. They are particularly interesting photographed against their varied flowery backdrops – the yellow Misumena against golden marigold; the lilac *Thomisus onustus* against purple tassel hyacynth. Quite often you can catch them with freshly snatched prey.

Butthus occitanus scorpion shot using Pentax LX + 100mm macro lens with TTL flash.

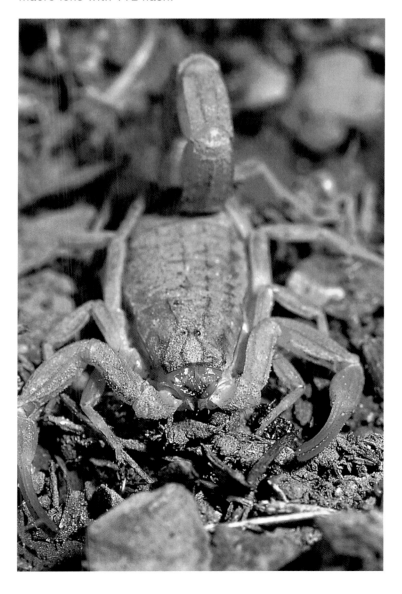

Spiders, especially depicted in their webs, are one group of organisms for which I might recommend using a ring flash. This is because a single flash can fail to illuminate the entire web-borne spider – particularly the legs on the opposite side to the flash. For all photographs of arachnids and related groups, I would recommend you use a 100mm macro lens and TTL flash (manual or ring flash for web borne spiders). Because of their semi-solid structure, take especial care not to damage the web when focusing with short macro lenses in the 50mm range.

Of the spider's relations, perhaps the scorpions are the other most interesting group for photography. However, you do need to take especial care because a sting from one of these can be extremely unpleasant – even lethal, if you encounter species that live in Arizona and other American desert environments. Do treat them with a healthy respect. Scorpions are seldom seen but easy to find. All you need to do is turn over the odd stone in their arid habitats. I find the faces of scorpions are particularly photogenic, simply because they are so ugly – a trait which can make an image highly saleable. Sideways shots of scorpions are also arresting, particularly if the entire organism is in the plane of focus – stinger through to front claws.

If you are looking to shoot scorpions or spiders you may be lucky enough to find a female with an egg cocoon in tow or even dozens of freshly hatched young being carried on her back. These make fascinating behavioural shots.

Preconceiving the image

Many amateur photographers equate photographic excellence with a gadget bag full of the latest technology. Over the years I have come to realize that excellence has more to do with adopting a certain attitude than utilizing the latest generation of SLR. Two elements stand out as being of fundamental importance in nature photography. The first is having an outline vision of the final image required – easier in the studio than the field. The second is having the appropriate tackle for the job. We have already considered this second element, and volumes have been written on the subject of equipment and how to use it to photograph nature. Here I intend to try to instil the first element, forming an outline vision of the final image required, because other things being equal, this is what can really make a shot sell.

My biologist training perhaps gives me an unfair advantage over many amateur nature photographers since I generally know where to find wildlife. On one autumnal trip to the Mediterranean, the legacy of a long dry summer had left the landscape baked dry, with lowland valleys approaching desert conditions. Here, in an apparently sterile moonscape that would make many nature photographers turn their backs, I found a treasure trove of bristling beasties: under every second rock was a fascinating, usually venomous, nocturnal denizen of this parched realm.

This brings me to my example. This environment is where Europe's tarantula, *Lycosa narbonensis*, and related spiders live. As I turned a stone to reveal my first Lycosa – one which almost spanned my hand – my instinct was to focus quickly and press the shutter at f/11 with my Pentax LX set to aperture priority TTL flash. Initially, the whole spider was in the viewfinder at 1/5–1/4 life size, looking down at it from a standard 45-degree angle. This setup was indeed my first frame – it represents a perfectly adequate record shot of a fascinating creature and would probably satisfy most photographers. However, to provide the sort of image that will make people wince at the grotesque detail (to a biologist, remarkable beauty) of nature and, importantly, sell, you need to have a vision beyond the obvious. In this case, I knew that the large size of the arachnid would make a full frontal life-size close-up of the head with eyes and palps a winner. To do this effectively I had to lie flat, eyeball to eyeball with my subject and to use the dusty and stony ground as my camera support. The price for a better than average shot was dirty clothes, a dusty camera and the odd spiky leaf where it hurts. I'll let you judge whether the extra effort that leads to a more thoughtful perspective was worth it.

Photographing molluscs

Moving on from subjects with many legs to a group with no legs, just a single slimy foot, we enter the world of mollusc photography.

Molluscs are understated subjects. After a summer downpour it is well worth searching out snails and slugs because they become active in their hundreds. Gardeners may curse them, but they make superb subjects for your camera. The attraction is largely because molluscs have an amorphous body capable of a thousand different shapes, and the colours and patterns on the humble snail's shell are quite beautiful. Both slugs and snails go through an elaborate courtship procedure which is worth recording.

This common snail (*Helix aspersa*) was photographed in Majorca, one of the Balearic Islands, using a standard 50mm lens and 50mm of extension. Flash was with a small manual unit. It was pouring down when I took this picture.

Flash photography is essential because it can give molluscan flesh a strange translucent character and helps to bring out the highly textured relief on the body and, in the case of snails, the shell. Their tardy movements allow almost any close-up technique to be used, from extension tubes to lens reversal.

Chapter 11 considered the several ways to apply flash to good effect in natural history photography – I would urge you to experiment with all of them. However, there is one method which is of some significance and justifies a mention here because it is ideal for small sinuous creatures that fall into this category. This is known as dark field illumination.

Dark field illumination of a millipede, *Necrophloeophagus longicornis*, on skeletal leaf. Pentax SLR with 50mm macro lens and a shoe box set up as in the diagram opposite

Insects, arachnids and other invertebrates are generally small and require a fair degree of magnification to produce acceptable images on film. However, when you get it right you can produce pictures that show a group of animals in a way few people ever see with their own eyes. Although the following group of organisms are much larger, the same can also be said of them. Reptiles and amphibians are usually only ever seen from a distance or as a sudden flash of movement in your peripheral vision. Close up, they make fascinating and compelling photographic subjects.

Dark field illumination

This is how to isolate semi-transparent organisms against a black background for astounding results. I shot a millipede *(Necropholoephagus longicornis)* crawling over a skeletal leaf to show a saprophyte (one that eats dead material and aids the process of decay and recycling) in context and aglow with light being transmitted through its body. Here's how you do it.

Dig up a bit of lawn or turn over a paving slab to find some true flesh-crawling critters – carnivorous ginger centipedes, lithesome anaemic saprophytic millipedes, minute worms, grubs and other juicy delectables which are sufficiently thin to transmit light through their bodies.

Cut a hole in a shoebox and place it over a sheet of black velvet. Insert two flash guns at each end of the box, pointing at 45° towards the hole.

Use a flash meter in incident mode at the plane of focus to indicate aperture.

Place a petri dish or sheet of glass over the hole, introduce the organism and photograph with a 50mm macro lens + 12mm of extension.

Dark field illumination

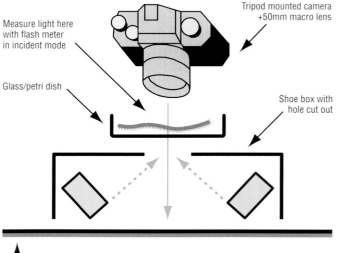

Measure light here with flash meter in incident mode

Tripod mounted camera +50mm macro lens

Glass/petri dish

Shoe box with hole cut out

Black velvet

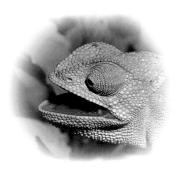

Reptiles and amphibians

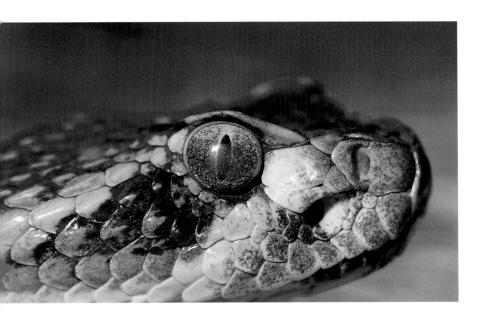

Mojave rattlesnake, the deadliest snake in the American deserts. Selected populations have a lethal neuro-toxic ingredient in their venom. Don't go anywhere near this species if ever you come across it – leave well alone. Pentax MZ5n + 100mm macro lens at f/11–11.5 on Velvia.

Reptiles and amphibians are cold-blooded, meaning that they depend upon solar energy for activity. The closer you move towards the Equator the greater the abundance of reptiles and amphibians: there simply isn't enough sun in northern climes. Britain, for instance, has only five species of reptile and six native amphibians – a poor showing, compared to Europe as a whole, which has around 120 species of reptile and amphibian, concentrated in particular around the Mediterranean. The US has around five times as many, while

Australia, another continent with a rich reptile and amphibian fauna, has, as an example, no fewer than 306 species of skink and 77 elapids (venomous snakes related to the cobra).

So if it's reptiles you want, head for the sun. Southern Europe boasts tortoises, terrapins, snakes, lizards and skinks. For larger subjects – crocodiles, alligators and big lizards – you need to be much closer to the tropics. You may want to start with the simplest of reptilian subjects – tortoises, for obvious reasons. By contrast, snakes and lizards require your best stalking skills to get close-up images. (I've found this applies equally to the geckoes with which I've shared many a bedroom on my travels.) With the exception of the benign grass snake, the snakes shown in this chapter are extremely venomous, particularly the western diamondback. Don't photograph these creatures in the wild. Before photographing any snake in the wild you should take a crash course in snake identification – I know what I'm doing, most people don't. My advice with snakes is: the longer the lens the better.

Black-tailed rattlesnake, a resident of southwest USA. Pentax MZ5n + 100mm lens.

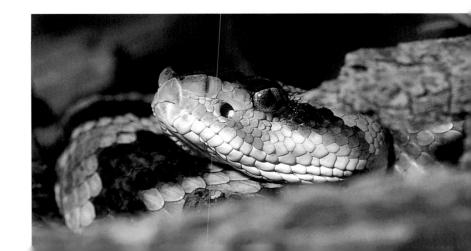

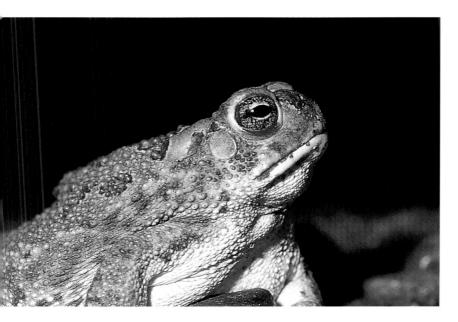

Great Plains toad taken with a small aperture and TTL flash to give a nocturnal appearance to the picture. Pentax LX + 100mm macro lens. Velvia.

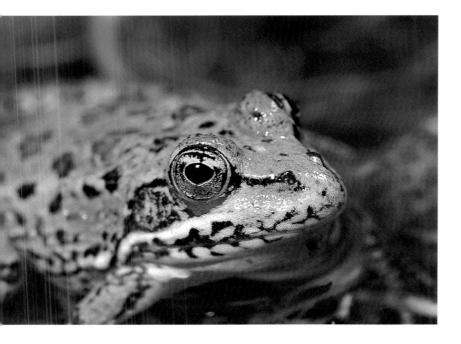

Lizards are busy beasts, and therefore difficult and frustrating to photograph. Frogs, by comparison, are simple to shoot. Pentax LX + 100mm lens with TTL flash.

The difference between amphibians and reptiles is that the former produce eggs which are fertilized externally in water. Reptiles are far more terrestrial and have adapted to a life in hot dry environments generally devoid of water. There are exceptions: turtles, crocodiles and terrapins all depend upon an aquatic environment.

Photographing amphibians

The best way to photograph frogs and toads is by using auto daylight sync TTL flash. Some of my most successful images are of frogs with their bulbous eyes and top half of their head just emergent from the water. Face-on shots are nearly always successful with your subject in this half-submerged position. Frogs, particularly common ones such as *Rana temporaria*, are easy to approach and readily photographed in your garden pond, local stream or ditch. In warmer climes, European green frogs, which include the edible frog, marsh frog and pool frog, are somewhat more difficult to shoot, being flighty and ready to evade any stalking photographer. What is more, I find Europe's frogs quite difficult to identify and most publishing outlets, if you are trying to sell your work, will want images that are accurately identified.

Stalking reptiles

Lizards vary in size; the smallest are very small, among them the skinks, some of which are tiny – the length of a matchstick. They are also very fragile and you need to take great care when trying to capture these minute organisms on film. Skinks bridge the gap between lizards and snakes. Snake-eyed skinks, *Abiepharus kitabelii*, hide from the intense sun in any shady recess. I was amused by the efforts of one of these organisms to evade my attentions. It feigned death when disturbed, but only briefly, for it soon toddled off a few inches then repeated its Shakespearian death throes. This is a process these skinks will repeat until they can make good their escape – or you get bored.

Lizards spend much of the day sunning themselves on walls or rocks. Everywhere I've ever been where the climate is typically hot and dry there is a great abundance of lizards, from the large scaly agama to the many species of smooth flighty wall lizards. Perhaps the best place I ever visited for reptiles was a small coastal village in Dalmatia. I have never seen so many lizards, and snakes, in one spot – they were everywhere. At one point, while we rested from a walk, I saw at least six snakes slither under my daughter's pushchair within 10 minutes. What a time to have left my camera in the hotel.

When you do spot a lizard, stalk it slowly – moving upon it in a way which does not alert it to any potential danger. Pre-focus the lens, have everything set up and slowly bring the camera to your eye moving carefully towards the organism until you have framed it as you wish. Only then release the shutter, gently winding on the camera, ready to take the next frame. The slightest sudden movement and it will be off. Head-on shots are always the most successful because they have a dynamic impact which makes even the smallest lizard assume the magnificence of a dinosaur. Taken head-on, the subject is shown in a way that is totally revealing to most lay-people, who normally get only a fleeting glimpse of an odd lizard or two.

The best lenses for photographing lizards (and snakes) are 100 or 200mm macro lenses. Undoubtedly the convenience of TTL flash makes all the difference for this sort of photography.

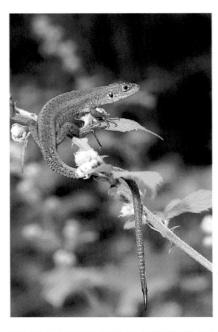

Wall lizard in brambles, Pentax LX + 100mm lens with TTL flash.

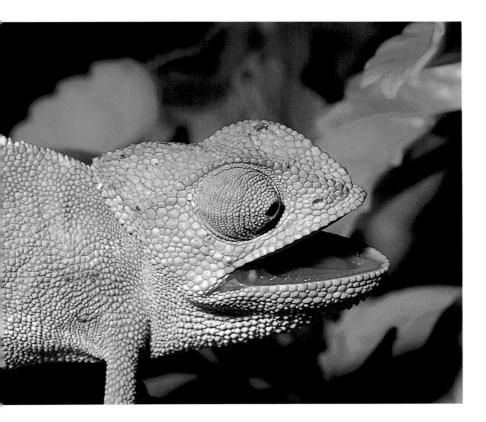

Chameleon. Pentax MZ5n + 28-70mm zoom lens with Nikon 3T dioptre and built in retractable flash.

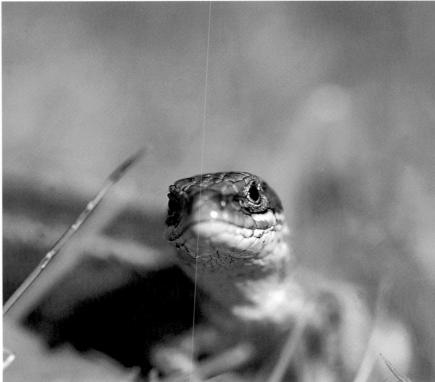

Varying lens aperture influences depth of field. I shot this viviparous lizard with open aperture for shallow depth of field.

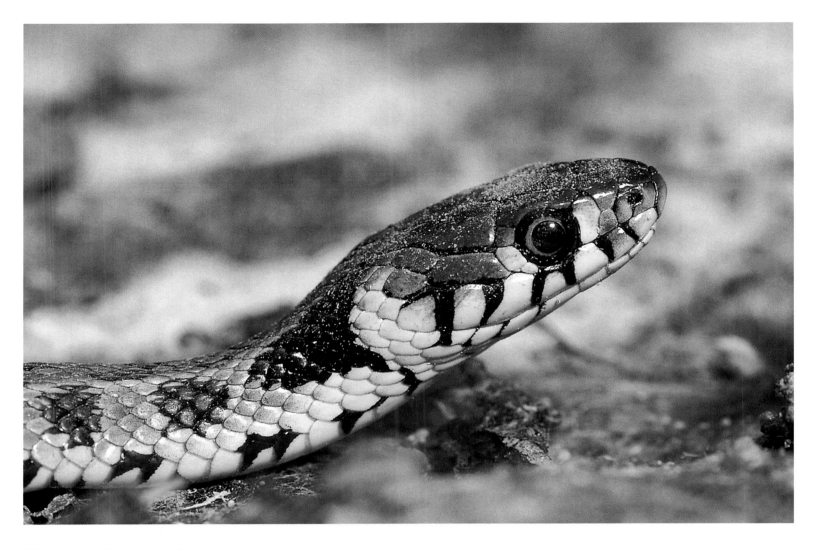

Photographing snakes

Generally speaking, snakes are more difficult to photograph than lizards, and obviously you need to be careful in the extreme because many snakes have a potentially fatal bite. It is particularly important to understand behaviour and be able to identify individual species when photographing snakes in the wild, especially if you are out in the field alone. You will recall my cautionary tale, relating how I came across that dusky pygmy rattlesnake in Florida's Everglades National Park (see page 86). I managed to take an entire film of that rattler without mishap, but it wasn't until afterwards that I realized that my enthusiasm had got the better of me and what I'd done was foolish to say the least. I advise you to take more care – do think before you click.

Grass snake. Pentax LX + 100mm macro lens.

The harmless grass snake is easier to photograph, and it (or closely related species) occurs widely around the world. It is often found near water where it feeds on small amphibians, particularly tadpoles. Grass snakes can be photographed quite close up or swimming in the water. Get too close and they may feign death, open their mouth and regurgitate their last meal – often this looks like jellied tadpole. And if you try to handle one of them, chances are they will excrete a foul-smelling liquid – you need soap and water to regain your social acceptability after this. Grass snakes are creatures of habit and will always return to a favourite site, making it easier to find these fascinating creatures than other, more peripatetic, reptiles.

In general, arid lands, particularly those of the southwestern states of America, such as the Sonoran Desert, are among the best places for finding snakes. They are supremely adapted to life in these tough conditions. That said, many amateur photographers and naturalists would find desert environments too inhospitable for hunting reptiles. The Sonoran, however, is not a flat, featureless desert. It contains numerous aptly named 'sky islands', temperate mountain ranges that punctuate the desert floor, which are ideal for searching out wildlife in reasonable comfort. The surrounding desert isolates these mountains just as surely as the sea isolates an island. Here, in ranges such as the Huachuca, you may be lucky enough to spot black bear, mountain lion and, during August, up to a dozen species of hummingbird undertaking their annual migration (see my account in the following chapter, page 116). In this part of America, the best 'sky island' is also the biggest, and is known as the Chiricahua Mountains. The Chiricahuas lie at the meeting point of four ecosystems: the Chihuahuan and Sonoran deserts to the west and east, and the Sierra Madre and Rockies to the south and north, which means they exhibit a particularly rich fauna and flora. At

Cave Creek Canyon, for instance, the rare and elegant trogon and thick-billed parrot can still be found – along with many other exotic species from Mexico.

If you can embrace some of the danger, you will really enjoy the Chiricahuas as a venue for a photographic hike. They are home to a diverse array of reptiles, incredible standing stones, sinuous babbling streams and beautiful semi-tropical woodland. The Chiricahuas are also the best place I know for finding a diverse array of rattlesnake species, possibly because this mountain range is thought to be close to where these snakes first evolved. On my last visit, my daughter found three completely different species of rattler in as many days: an angry western diamondback having a spat with the local cat (cats are fairly immune to the snake's venom); a minute baby rock rattlesnake hidden in a narrow crack, which was easy to photograph – I used a 3T dioptre on my 28–70mm zoom + the built-in flash of my Pentax MZ5n; then, on day three, a huge and verdantly coloured Mojave rattlesnake – the most toxic and feared rattlesnake of the American deserts (see page 108).

Western diamondback rattlesnake. Pentax MZ5n.

Rock rattlesnake. Pentax MZ5n.

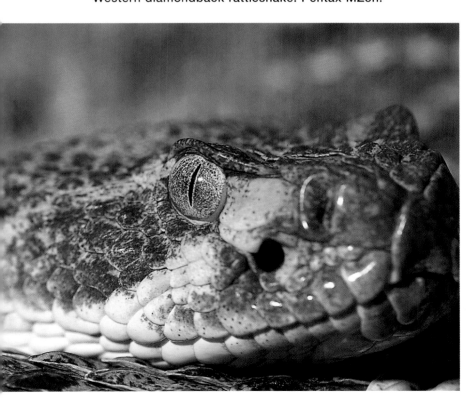

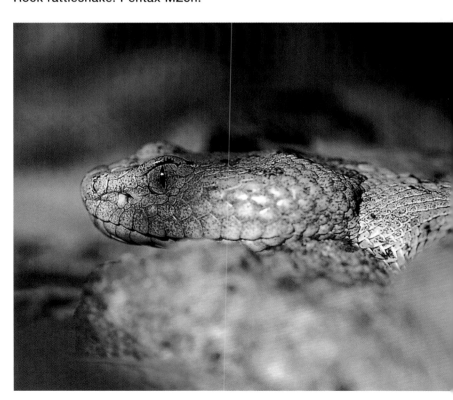

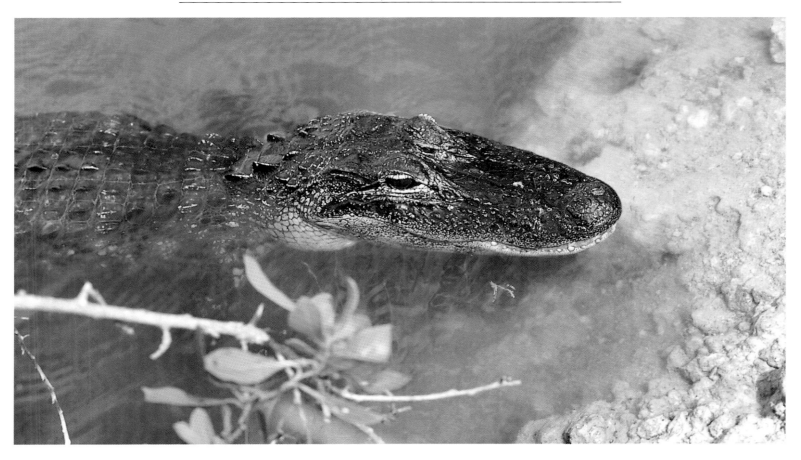

Photographing terrapins and crocodilians

Tortoises are extremely straightforward to find and photograph. Terrapins are not quite so easy to find, although if you do catch one on land, they are relatively simple to photograph and can make very interesting compositions because they have the strangest heads. Despite their slow pace of life, terrapins and tortoises benefit from being photographed using auto daylight sync TTL flash, as with our snake and lizard subjects.

Crocodiles and alligators, on the other hand, are a completely different proposition. Use a long lens and take great care. Don't ever get too close. I wouldn't risk employing flash, either. I once used my Tamron 90mm lens to photograph a close-up of an alligator at Paurotis Pond in the Everglades. Its hissing soon made me realize this lens was inappropriately short – I had invaded its space and future photography (with a far longer lens) took heed of this.

With lizards, snakes and other reptiles (excluding the crocodilians), more than any other subject group, I would say that my Pentax

Alligator, Paurotis Pond, Everglades National Park, Florida, using a 90mm lens with fill-in flash. Learn from my experience and don't ever take a photograph of one of these creatures with a flash and such a short lens. This fellow hissed at me very disturbingly. I may have got a good picture, but I won't be repeating it in this manner again.

200mm f/4 lens in combination with a dual element Nikon 3T supplementary lens provides an effective optical combination. It is also a great deal cheaper than a 200mm true macro lens. This combination affords you a good working distance and allows these organisms enough 'space' to prevent them shooting off at your approach. Increasingly, however, I find myself using my Pentax MZ5n + 28–70mm zoom for lizard photography. This is because with the Nikon 3T supplementary lens attached and the built-in retractable flash employed I can get very acceptable images from a lightweight and relatively thought-free setup. The results may not be quite as snappy as with a purpose-built macro lens, though I feel the practical advantages outweigh this.

Birds and Mammals

Birds

More than any other aspect of natural history photography, shooting birds on film is perhaps the most difficult and highly specialized area. It requires the most expensive of all lenses: a 300mm f/2.8 + a matched 1.4x or 2x teleconverter for instance is probably the minimum requirement for serious bird work. Bird photography is also unique in requiring a huge degree of patience and considerable forethought. For all these reasons, I have kept the discussion brief.

Although the very best bird photographers tend to be a breed apart, everyone is capable of getting reasonable shots. Gardens are the obvious environment in which to practise your skills, and even a modest plot can offer a surprising variety of subjects. I live little more than 6 km (a mere 4 miles) from a major urban centre, Leeds, in the north of England, yet careful planting schemes in my garden – combined with a good supply of nuts – attract many well-known species: blue- great- and long-tailed tits, green- and goldfinches, blackbirds, robins as well as the ubiquitous house sparrows. My garden, joined to those of my neighbours, acts as a green corridor leading into ancient oak woodland, which means I also see jays, black caps, green and great spotted woodpeckers and many others. Chiffchaffs, redwings, goldcrests and coal tits are not uncommon. Although I prefer to forget the magpies which rule my garden like gangland bullyboys, one of my favourite bird shots is, however, of a pair of magpies flying over a distant cityscape.

If staking out elusive woodland birds is beyond your budget, capability or patience, why not head for your local pond? Waterfowl are perhaps the easiest of all birds to photograph especially if they've grown accustomed to people. They can also provide strong behavioural shots; for example, swans taking off and landing in a

Laughing gull, Florida, Pentax LX + 90mm lens.

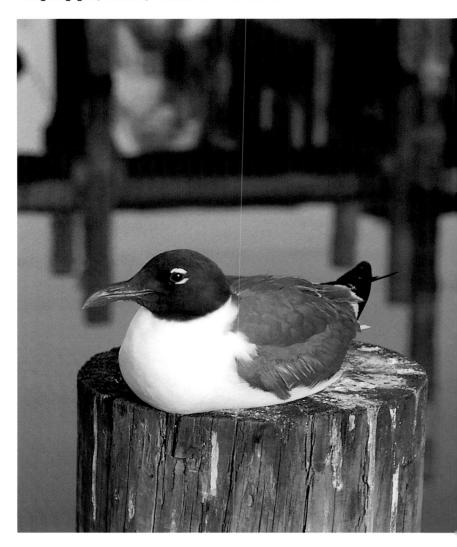

mini maelstrom of splashing water, grebes dancing their way through their elaborate courtship ritual, and mallards squabbling over your children's stale bread.

Although I have a 300mm f/4 lens, I take a lot of my bird shots on a lightweight 500mm mirror lens and even an 80–210mm zoom. Not all photographs of birds need tremendous telephoto pulling power. I have taken roosting starlings en masse in the city centre at the wide end of a 35–70mm zoom, and hummingbirds with a 100mm macro lens and a 28–70mm zoom. If you want to practise your bird photography, you can always begin with a basic 80–210mm zoom to photograph these beguiling creatures. I have had great fun in St James's Park in London shooting sparrows feeding from the hands of passers-by using nothing more than a cheap telephoto zoom and no flash.

Ornithologists make up a large proportion of the nature-loving public. Consequently, nature reserves and bird sanctuaries specifically designed to protect the habitats, breeding sites, or over-wintering needs of migrating birds, are commonplace and represent good locations for you to target. These sites, which may be examples of rare and disappearing ecosystems, such as water meadows, marshes or native woodland, are protecting the natural beauty of the landscape as well as providing a haven for other organisms as well as the birds. Check with your local reserve warden for the best times of year to visit. However, don't expect to be solo. Bird-watchers, or 'twitchers', will be regular visitors, and if a rare sighting has been reported, they can be present in their hundreds. I would urge you to be responsible and avoid nest shots altogether, and never to agitate the birds at this critical stage in their life cycle. Also, you should familiarize yourself with the local legislation that applies to bird photography. Birds are often well protected and heavy fines may be imposed where the rules are broken, however innocent your presence may seem.

Starlings en masse at dusk over Leeds city centre, England, 35–70mm zoom, ISO 400 film.

Whooper swan, 80-210 zoom on Pentax LX.

Hummingbird hovering at feeder, Portal, Chiricahua Mountains, Arizona. Pentax MZ5n + 100mm macro lens.

This wild kookaburra came so close to me each day at breakfast I eventually photographed it.

In my experience, one of the most interesting – and challenging – family of birds I have photographed are hummingbirds (*hummers* to dedicated hummingbird photographers). For many amateur bird photographers, successfully capturing the incredible wing movement of hummers as they hang in the air to sip nectar from a flower is the ultimate achievement. These birds migrate, and it is a memorable sight to witness them making their annual journey. Once I was staying in the remote Ramsey Canyon, a rugged box canyon in southern Arizona that backs onto Mexico and provides a montane enclave within the desert for many temperate species. During August, hummers migrate south from Canada to Mexico, funnelling through Ramsey Canyon and similar bottlenecks in the vicinity. At the time, I was keen to see the extraordinarily rare Ramsey Canyon leopard frog. However, exposure to wave after wave of hummer changed my focus. I've also seen hummers at another mountainous bottleneck about 112 km (70 miles) east of Ramsey Canyon, at Portal, Arizona. Portal Peak Lodge has sugar feeders outside its cabins set up to nourish the birds during their journey. I had spent a couple of hours trying to shoot hummers, with what I perceived to be little success. Eventually, one specimen arrived at the feeder and seemed easy to shoot both in flight and as it imbibed the sugar water. I went home full of pride at getting my first flight shots of a hummingbird. When I picked up my trannies, I found out why this particular hummer had been so easy to shoot. It had lost one of its eyes

– bad for the hummer and bad for sales of this set of transparencies. If you look at a book that covers hummingbird photography, the odds are it will advocate using flash to freeze wing motion (it is usually evident from picture clarity that most published images have been taken with flash). One ardent hummer photographer I know reckons it is stressful to these diminutive birds to use any form of flash technique at all. I am therefore not sure what to recommend. I used flash at Portal and the birds seemed fine. I didn't notice any adverse response by the birds to the brief discharge of light. Indeed, the only organism that I have ever really seen respond to flash in a classic *move your hand away from the heat* way, was a western diamondback rattlesnake (see the shot on page 112).

To summarize, birds are indeed a very popular group of animals for nature photographers, and of course you don't have to travel far to find them. However, as a serious subject for your lens, bird photography requires a highly specialized approach and expensive equipment to obtain results that come anywhere near the professional level.

Mammals

Mammals, unlike many of the other animals described in this book, are a fairly heterogeneous group of organisms. For instance, at the smaller end of the scale, I would tackle photography of diminutive

Wood mouse, This small rodent was caught in a humane Longworth trap set up next to my garden compost heap. I built a vivarium in a large fish tank, and photographed the mouse with an 80–210mm zoom and dual flash guns. The mouse was released immediately after the photograph was taken.

Bonnet Macaque, Dudhsagar waterfall in the heart of Bhagwan Mahaveer wildlife sanctuary. Troops of this monkey are quite common and it is relatively easy to get extremely professional images with nothing more than a 28-70mm zoom lens. In this case I had previously shot a whole roll of film way off the beaten track where I saw a troop of these monkeys playing in the dappled jungle light. Needless to say I didn't make one exposure that I could get excited about. Then suddenly this fellow appears out of nowhere almost begging me to shoot a close-up portrait of him. Velvia, 70mm end of standard Pentax zoom.

wood mice using techniques and equipment similar to those I have described for reptiles and larger insects, although to get good shots would require either an electronic trip based on the mouse breaking an infra red beam for *in situ* shots, or a captive specimen. Humane Longworth traps (which are really only boxes with a door that flips shut when the animal enters in search of your bait) can be used to collect wild mice and other elusive subjects from your garden. You can then use a vivarium set to take pictures using the techniques previously discussed.

Somewhere in the mid-size range you can find mammals that are no more difficult to photograph than another person. Among the medium-sized primates I've photographed are Bonnet Macaques which are not uncommon in India. In certain places, for example at the Dudhsagar waterfall, which is the highest in India, in the heart of Bhagwan Mahaveer wildlife sanctuary in Goa, troupes of this monkey are readily apparent. Bold individuals will sidle up to you on the off-chance that you might have a banana to spare. This makes it simple enough to obtain extremely professional images with nothing more than a 28–70mm zoom lens.

Unfortunately, one cannot condone such exposure of wild animals to uncontrolled human contact. While such behaviour is perhaps easier to understand in a Third World context, for me, it is totally unacceptable in the developed world. I once found myself in Joshua Tree National Park in California watching one tourist after another feed and water a wild coyote immediately adjacent to a sign strictly forbidding this very activity. It makes me wonder just how many impressive-looking shots of mammals are actually taken on such occasions where wild animals have become habituated to contact with humans.

Fair game?

Similarly, I have always been haunted by an image I saw several years ago. It was an aerial shot of several open-top safari vehicles plying the dusty savannah of the Masai Mara reserve in Kenya. These vehicles, stuffed full of tourists, dominated the landscape which was peppered with lions that were totally oblivious to this grossly excessive human intrusion. I felt so sorry for those rather sad-looking big cats and since then I have never really been impressed by a lion shot.

Happily, there are plenty of places that have a lower key approach to safari photography where, given an 80–210mm zoom or an 80–320mm zoom, which I use, you can get stunning images of the big five game animals. The best shots, however, require fast professional lenses, 300mm or 500mm, and that same level of commitment and patience that is required for bird photography.

Africa is the indisputable home to the big game safari. The country is so well endowed with national parks you could write a multi-volume work on this subject alone – from Uganda's Murchison Falls to the Okavango, the largest landlocked delta in the world, which

Mule deer, Ramsey Canyon, Arizona, near the Mexican border. I photographed this secretive mammal with an 80–320 zoom lens. As I didn't have a tripod with me, my wife was brought in as a sturdy alternative. I'm glad no one was around, I can't imagine what we must have looked like trying to stabilize the camera.

radiates across nearly 23,000 square km (9,000 square miles) of northern Botswana. Generally speaking, big game animals are at their most active at the beginning and end of the day, when it is cooler, at which times they are easier to spot, especially around watering holes. You need to be up at dawn to witness most wildlife activity – and to get ahead of the tourists. In Kenya, always a popular destination for people making their first trip to Africa, organized safaris lasting between three and six days (the longer the better) can take in Amboseli, Masai Mara, Tsavo and Lake Nakuru. In neighbouring Tanzania, safaris can be arranged to tour Lake Manyara, the Ngorongoro crater and the Serengeti and Tarangire national parks. Less well-known Tanzanian parks include Mikumi, Ruaha and Selous game reserve.

However, from a photographer's perspective, Namibia offers the greatest subject variety which should satisfy any and all breeds of nature and landscape photographer. Namibia is a country of enormous physical diversity – desert, mountain and bush. It encompasses Etosha, the largest national park in Africa and home to big game, ostriches and flamingoes, huge expanses of sand dune where you can take the most incredible composition shots, and land where antelopes, elephants and hyenas rub shoulders with penguins and sea-lions. Namibia is definitely a place that requires you to join an organized tour, since many of the best sites for photography are remote and difficult to reach – Skeleton Coast, Bushmanland and the virtually unhabited Namib Desert, for example.

What time of year should you go? Well, a high point in the calendar for the Mara would be the annual migration of wildebeest. Millions of these creatures move north from the Serengeti in July and August in search of lusher grazing before doing an about-turn and heading south again from the Masai Mara in October. Some places, Etosha among them, are open all year, but the high season is from mid-March to late October.

In spite of its lure, Africa can be a dangerous place for tourists and photographers alike. Violent crime is not uncommon and, as anywhere, large mammals should always be treated with the greatest respect. Never put yourself or others at risk in pursuit of the perfect picture. I'd say you can easily get your initial photographic kicks on more local turf before spending the considerable sum you need to pay for an African safari. If you are looking for other 'hot spots' around the world for photographing mammals, consider India, Australia, the western USA, Canada or Alaska.

Still life photography

Not all mammal photography is dynamic, involving expensive lenses and distant locations. Quite often you can produce powerful and emotive images from local material. My photograph of a dead fox illustrates this point. This image, taken at dawn on a busy main road, shows one aspect of the adverse impact man has on the natural world. By getting down low to show the badly mutilated fox and including fast-moving oncoming traffic, I produced a shot that sees the world from a fox's perspective. Such an image might sell to environmental or educational markets.

I was travelling down a trunk road to London early one morning when I came across this recent road kill. I tried to photograph the fox in a way that showed the dangers that animals encounter when they cross our increasingly busy highways. Pentax with 28mm prime lens.

Plants and Fungi 17

Don't overlook the possibilities for nature photography offered by the habitats occupied by animals, birds and insects. Plant photography may not, at first blush, offer the excitement of capturing wildlife on film, but it gives the photographer an entirely different challenge, and the chance to create some evocative and dramatic shots of the natural world, either the big picture or in meticulous detail.

Non-flowering plants

Non-flowering plants may not be the most appealing subjects for photography but they are a ubiquitous group of plants and are ideal for practising your close-up photography skills. Horsetails, ferns and mosses are a group of plants with a very ancient lineage. The fine detail on these plants requires some degree of magnification to do them justice, and in general the kind of equipment that would be used for small insects is suitable for these plants. The one difference being while flash remains an option for illuminating them, a tripod becomes a realistic alternative because, unlike arthropods, these subjects do not take off when photographed. As a further bonus, many non-flowering plants maintain their interest throughout the year when other, more obvious subjects are in a state of decay or dormancy.

With all plants, including the non-flowering forms, you are in a position to deviate from using the kind of close-up equipment described in chapter 10. It is possible to use a more standard approach such as a 24–35mm wideangle lens in combination with a

These bluebells line a little-used path through spring woodland. This is one of my favourite pictures because it is not far from my house and provides me with a sense of warm expectation during the winter chill. I used f/22 to get a good depth to the image. Fuji GSW69iii, tripod and Velvia.

Horsetail shot with natural light using my jacket rolled up to support the camera. 70–150mm zoom + extension tubes.

Broadleaved woodland at the height of summer showing a gnarled tree and a luxuriant fern for fore ground interest. To see the effect of the tree canopy on light transmission to ground level, set your hand meter to EV and take a reading at the same spot every month through the summer. You will get a bell shaped curve peaking in July, not far off the time this picture was made. Fuji GA645Wi, tripod and Velvia.

tripod (wideangle lenses can often focus very close and provide incredible depth of field). This approach is particularly useful when photographing, say, horsetails en masse in a swampy bog. In this situation I would go for maximum depth of field and employ focusing using the method of hyperfocal distance (see page 128).

The primeval horsetails belong to the genus Equisetum and are found in a variety of habitats. They are particularly associated with swamps but can also be found along roadsides, rail embankments, forests and overgrown cemeteries. Try photographing the whorls and regular ribbing on the stems, or the cones which contain a lovely pattern of hexagonal spore-bearing scales.

Ferns are a much more familiar group. Worldwide there are several thousand species. Most photographers will know to look for ferns in moist shady places, and it is no surprise that they reach their greatest abundance in tropical rainforests. One of the commonest ferns of temperate landscapes is bracken, a tenacious species which spreads rapidly in grassland and scrub. Bracken is easy to find and makes an important russet or verdant component in many a successful panoramic view.

The delicate woodland ferns are a less invasive plant. The green tracery of jagged fronds of many different species of fern can be found in oak woodlands. Like the sturdier bracken these ferns provide an important architectural component to woodland photography. Whenever I take my medium format cameras into a wood in summer, I make a beeline for the ferns. I always think that there is something perfect about the detailed fractal geometry of these primitive plants that invariably adds something unquantifiable, yet special to a forested landscape.

Beyond the wood itself, microhabitats provided by stone walls can harbour small fragile ferns, such as the maidenhair spleenwort and rusty back fern. Fill-in flash and reflectors may be useful to reduce the contrast which results when shooting deeply recessed ferns, hidden away within their mural niche.

Liverworts and mosses are known collectively as bryophytes. They are small, damp-loving terrestrial plants. The liverworts exhibit a leaf-like structure. Moss morphology exhibits two distinct patterns: the cushion mosses and the feather mosses. It is the reproductive structures of mosses that make them photographically interesting.

Moss capsules shot with a 35-70mm zoom and 100mm of extension. Camera rested on rolled-up jacket. Natural lighting.

Extreme close ups of the spore-containing capsules borne on hair-like setae make unusual, almost esoteric subjects. TTL flash in combination with an extended 50mm macro lens or a 50mm standard lens reversed on a 200mm telephoto can reveal tremendous detail in an otherwise apparently mundane green clod.

Equally diminutive are lichens, which are in fact two organisms - a fungus living in association with an alga. The alga is the powerhouse of this relationship as it harnesses energy from the sun to manufacture nutrients for both partners. Once you start to notice these tiny plants, clinging to rock surfaces and the trunks and branches of trees, you may begin to distinguish three types of lichen structure: those that branch, those that form crusts and those that are leafy (fruticose, crustose and foliose respectively). The varied and brightly coloured patterns exhibited by some of the crustose lichens are extremely photogenic in close up. I have shot many of these on gravestones and tropical hardwoods with patterns in mind using a 50mm macro lens and flash. The hairy fruticose type of lichens, such as Spanish moss and old man's beard, form interesting structures although they tend to blow about in the wind, so you may need to use your flash. Be on the lookout for the delicate pixie cups (Cladonia sp.), as these too make great close-ups.

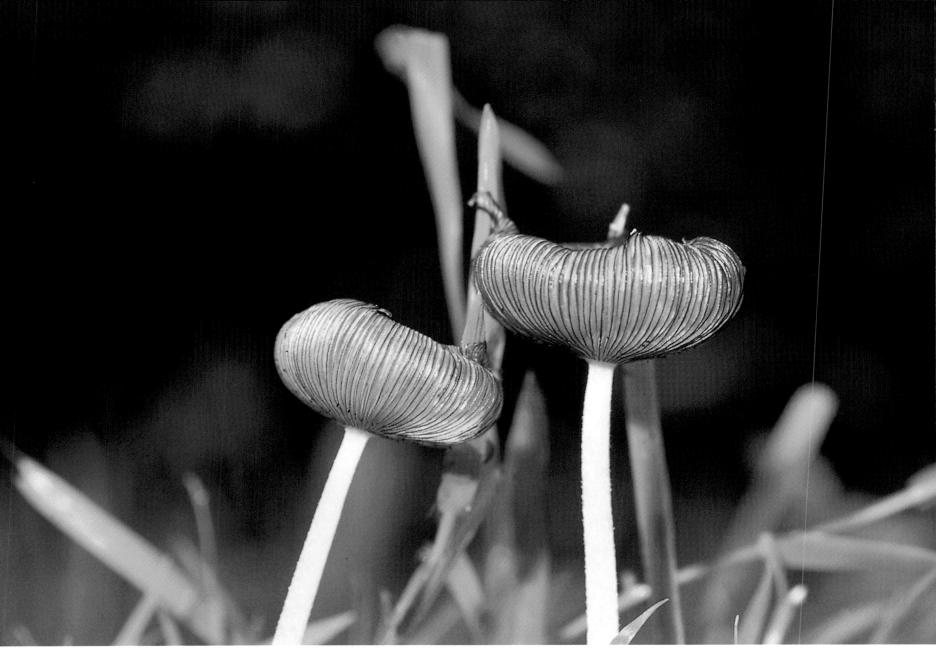

Toadstools such as these tiny *Tubaria furfuracea* are easy to photograph. I shot these in an alpine wood in Austria using a burst of fill-in flash to make the final image crisper. Fungi often appear when the soil is damp. I used the soggy litter layer to support the camera for this shot, getting wet knees in the process. Pentax LX + 100mm lens.

Fungi

Worldwide, fungi form an enormous group of organisms; Britain alone has several thousand species. All fungi have the same make-up: a large, readily identifiable, fruiting body with an elaborate microscopic underground structure. This unseen subterranean web, known as a mycelium, penetrates through the soil allowing the fungi to exist either as parasites, feeding on living tissue, or as saprophytes, living on dead organic material. What we know as toadstools, earthballs, puffballs, rusts, moulds and edible mushrooms are simply the visible fruiting bodies produced by the hidden mat of mycelium.

Autumn is the best time to photograph these fruiting bodies, before any frosts have occurred. Because fungi have a symbiotic relationship with the living root structure of specific trees, certain species are found exclusively in either beech, coniferous or oak woodlands. For instance, one of the most striking toadstools – the striking fly agaric, with its warning red cap with white spots – is almost wholly associated with birch trees.

What is good for the fungi is not good for the opportunist photographer. A dull misty day in autumn does not lend itself to hand-held photography. To shoot fungi you need to be equipped with a tripod to support your camera. A short macro or wideangle lens both provide an excellent means to record these subjects. The major concern with photographing in conditions where the natural light is poor is reciprocity failure (see page 40) and long time exposures need to be bracketed with an extra 1/2, 1 and 1½ stops. Another idea would be to use a burst of fill-in flash to add sparkle to what might otherwise be a dull shot.

Remember at all times that a large number of innocuous-looking mushrooms and toadstools are extremely poisonous. They are not magic, they are dangerous and contain a cocktail of potentially lethal chemicals – mycoatropine, muscarine, Ibotenic acid, mycotoxin, phalloidin, amanitine and others. There is no shortage of good identification guides available for these fascinating and mysterious lifeforms but I would urge you never to pick any for eating unless you have a specialist expertise in mycology, and do take care about handling fungi.

Flowering plants

These colourful, diverse subjects are among the most popular for photography. Naturalists and non-naturalists alike take hundreds of thousands of shots a year depicting a panoply of brightly coloured blooms. While many photographers will head for a municipal park or the grounds of a park or home that is open to the public, my preference is to seek out native species in their natural habitat. Once again, this means you can, often as not, obtain some stunning shots within a short distance of your home.

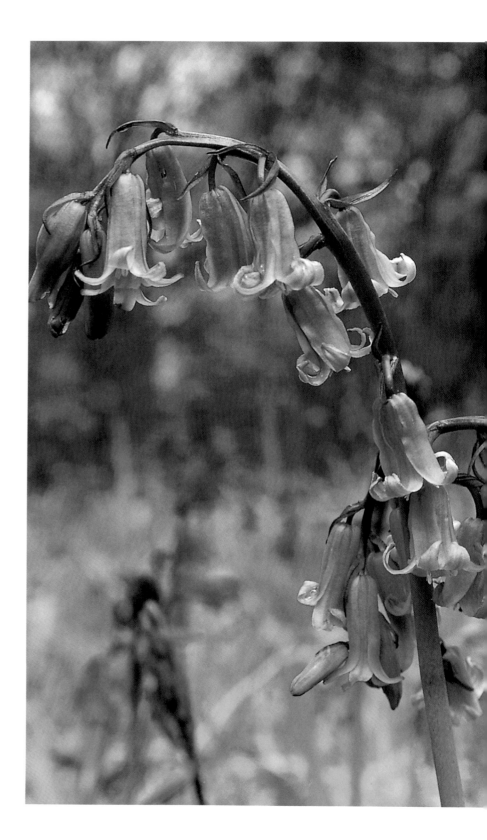

Look for the great and the small in woodland. Most people shoot bluebells en masse, so try to shoot close up. Pentax MZ5n + 28-70mm lens with a Nikon 3T dioptre, tripod.

Temperate woodland flora

In the developed world there is very little ancient woodland remaining. Farming over the millennia has modified and fragmented what was once forest so that in many places only the oldest trees in hedgerows and pockets inaccessible to the plough remain as a reminder of a formerly tree-covered landscape. That said, not all practices are detrimental to native woodland. Coppicing, for instance, a traditional form of woodland management which allows the timber crop to be harvested but not destroyed, opens up the habitat, enabling sunlight to penetrate to the forest floor, and so provides the conditions for a flush of spring flowers which photographers so love.

The photographic potential of your local woodland is almost infinite. We all retain a powerful and evocative image of warm spring sunshine shafting through an incomplete canopy of young delicate leaves. Those shafts of light create shadowy relief over a carpet of flowers – bluebells, daffodils or maybe ransoms (wild garlic) – and prompt even fair-weather photographers to dust off the winter cobwebs from their kit and to start snapping away.

Woodland nature may be at its zenith during spring, but there exists tremendous photographic potential during every season. A wood is a living mosaic of life at three levels: the dense under-storey, a lofty canopy and the ground or field layers. When the trees are in full leaf the dappled light of the shady interior is dissected by sunny woodland rides - altogether an exposure meter's nightmare.

In some ways it is easier to photograph the individual components of this living entity than it is to capture an evocative image of the entire habitat. Certainly go in close and capture bluebells, yellow archangel and other spring or early summer plants in great detail, perhaps with a butterfly or other insect in attendance. But it is undeniable that photographing these spring plants en masse provides images with the greatest impact and saleability. You might try producing bold pictures of, say, bluebells or wild daffodils close up, centre stage to a backdrop showing legions of their kind. To do this,

By using the manufacturer's depth of field tables for the lens in use, I had hoped to get sharpness that extended from the near to the far. As you can see, although this is still an excellent image in its own right, the distant trees are not completely sharp. I now use depth of field tables only as a rough guide.

This oak woodland was full of spring flowers: bluebells, yellow archangel and ransoms (wild garlic). Some subjects benefit from portrait format, some landscape format. This subject looked good in both formats. If you plan to sell your pictures, shoot both formats where ever possible – this way you stand more chance of pleasing an editor. Pentax MZ5n + 28–70mm lens. Velvia, using a heavy-duty tripod. The film was overexposed by about 1/2–1 stop.

use a wideangle lens (I would normally select a 28mm lens on my Pentax 35mm gear for shooting using hyperfocal distance, since 24mm can produce unnatural distortion) and apply the principle of focusing using hyperfocal distance to maximize depth of field. Remember that hyperfocal distance is the exact point of focus where everything from half that distance to infinity is contained within the depth of field.

To ensure a foreground flower on the woodland floor includes sharpness to the distant horizon (or the furthest oak tree, perhaps), pre-focus your lens by placing the infinity mark over the f stop mark corresponding to the aperture you have selected. The working aperture should be f/16^{1}/2 to f/22 or less if possible. The closest point of focus will be directly opposite the f stop on the other end of the lens barrel scale. Experience has taught me that for close-up work this technique is best carried out using a tripod.

You may be thinking that medium-format cameras provide the optimum quality for this kind of woodland scene photography. True, but unfortunately, you cannot reliably use the method of hyperfocal distance with medium-format lenses. In addition, you should consider the depth of field charts that come with lenses with some scepticism. I recently took both the depth of field charts for an ultra-wide medium-format lens and a fairly wide large-format lens on face value. The Velvia transparencies showed just how inaccurate the lens manufacturer calculations were. The reason for this would seem to be an error in the circle of confusion used to perform the calculation.

Despite a foggy interface between the seasons there are key times of year to shoot woodland plants and tips to make your photography more successful (see the summary of seasonal considerations opposite). Get to know an area without taking all your equipment with you. Look for good compositions, and note the position of the sun at different times of day. When you have picked three or four good sites return with your camera and tripod, but only when the lighting is at its best. It goes without saying that you should pick a day with no wind and good visibility. This approach is essential when using heavy medium-format equipment. I took several shots of my local woodland one autumn. It was a very bright sunny day, yet to retain f/16–f/22 for a good depth of field, I needed 1–2sec exposures on Fuji Provia 100 and Velvia respectively. So, a sturdy tripod and cable release was not one option, it was the only option.

Bluebells taken on a May evening. 8sec at f/32. Ebony SV45TE, Schneider 80mm Super-Symmar XL aspheric lens attached.

Getting the composition right

Composition is everything. Never cut off the base of a tree, for instance, and try to arrange the composition so that the foreground moves back to meet the base of the trees. Simplify the view as far as possible by avoiding the cluttering effects of branches and twigs, since they will distract from the overall effect which should have at least some pattern or symmetry. This sense of order is easier to achieve in coniferous woodland where dense stands of trees planted in regimental fashion exhibit an obvious geometry, although coniferous stands lack the rich ecological diversity of broad-leaved forests.

For the photographer, woodland lighting is horrendous, a mish-mash of different light intensities. Once you have a unique composition in your viewfinder, bracket your exposures extensively. I generally use a hand-held meter to take incident readings in the dominant zone of lighting and still bracket by up to 1½ stops. However, an incident reading is not always best – particularly for long exposures. Once I was shooting bluebells at around 7pm in May. My incident meter indicated 2sec at f/32 while a spot reflected meter off the grass indicated 8sec at f/32. I took the 8sec option, and was about 1/4 stop overexposed – but the image here, taken on a large-format camera, is perfect, benefiting from the very slight overexposure. With this sort of tricky metering, experience is everything. Personally, I feel slight overexposure is preferable in a woodland scene to retain all nature's magical detail. If you can overcome the technical challenge, misty woodland scenes also work very well.

Further afield

Outside of temperate regions, tropical rainforests provide the ultimate 'hunting ground' for any photographer with an interest in natural history. These dense, humid habitats are the richest ecosystems on earth and we Westerners are quick to call for their protection for the greater good of all. I suspect I am not alone in saying that the word rainforest would bring to mind Central America, particularly Costa Rica, the Amazon basin, Southeast Asia and even coastal Queensland in Australia. For most of us, getting to any of these exotic destinations requires a healthy bank balance. So it came as an unexpected surprise to me to learn that a relatively modest trip to the Indian resort of Goa would give me the opportunity to explore virgin rainforest in all its glory. I have to admit I had never fully appreciated the extent of tropical evergreen forest in this part of the world.

Summary of seasonal considerations

For photographing winter snowfall:
Overexpose your reflected meter reading by 1 or 2 stops. Look for images which contain a low winter sun and consider strong silhouettes against a snow-laden background. Remove any blue cast created by the snow with an 81 series filter.

For carpets of spring flowers:
Use a wideangle lens and a low viewpoint to keep foreground plants large and sharp as the 'carpet' recedes into the distance. Alternatively, compress the carpet around a single tree or a group of trees by using a telephoto lens.

During high summer:
This is perhaps the worst time of year for good photographs of woodland because the canopy is at its densest, producing a heavy contrast which film latitude finds almost impossible to cope with. Deep shade and fewer wild flowers make for less interesting compositions. Try to photograph open woodland and clearings, perhaps when the heather or other expanses of colourful plants are flowering.

For russet autumn foliage:
Autumn is photographically the equal of spring but the season's colours may last for only a week or two. You need to strike a balance between waiting for the leaves to turn gold and being ahead of the strong winds which liberate them from their fragile purchase. The sun remains low in the sky and dictates you use a lens hood, so try shooting *contre jour* for spectacular images of the sun through golden leaves. If the wood has an invasive ground layer of bracken which did little to enhance the woodland landscape in the summer, come autumn and coinciding with the leaves turning gold, the bracken fronds blanch before turning brown. These blanched fronds, coupled with russet foliage, provide a wonderful combination for autumn photography and a strongly three-dimensional image.

The complexity of a native woodland ecosystem is such that the photo opportunities are only limited by your ability to see the potential. Once you are satisfied with photographing the woodland context, try going in close on buds, flowers, fruits, or the patterns on leaf and bark for some more abstract results.

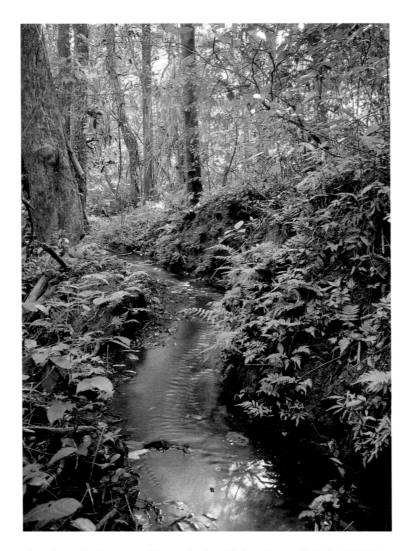

Rainforest, Western Ghats, India, f/13, 1.5sec, Fuji GA645Wi.

In a land where the overriding priority of most people is to put food on the table for themselves and their family, it is easy to see how the average local has little interest in the 'jungle'. Only in the West where subsistence no longer prevails can we afford to see the magic, mystery and symbolism of virgin rainforest. It is therefore unsurprising that as far as the local economy is concerned, mining and agriculture have always taken precedence over the virgin forest. Despite this, credit is due to the Goan authorities for establishing three wildlife sanctuaries within this small state in the 1960s. If only the government could see the potential of properly developing ecotourism, it would find that the virgin forests are more profitable to the local economy than the low-

yield ore mines, or the coconut, rubber or teak trees that are slowly replacing them. Of course this situation may also have something to do with the fact that most enlightened ecotourists are probably unaware that Goa has rainforest habitat – until recently I didn't.

An incident with a rangefinder

There is a point in relating my trip to the Goan rainforest, as it taught me another lesson. I used a 6 x 4.5cm rangefinder (Fuji GA645 Wi). It produced great results, with only one real hiccup. I followed a stream into the dense forest, set up the camera on a tripod at a particularly scenic spot and shot away. I had been told that an even more scenic spot existed a short distance upstream, so, foolishly, I left the camera on the tripod and used the whole assembly as a walking aid. It certainly helped me to negotiate the slippery stream bed, buttress roots, tangled vines and what at times seemed like aggressive vegetation. When we eventually got to the magical spot, I splayed the tripod legs and shot away. What I didn't know was that I had brushed the lens against an algal-encrusted branch or two. With this camera as with any rangefinder, you compose through a different piece of glass to that which exposes your film, so I didn't notice the algal coat on my lens until later that day. Fortunately, I used a UV filter to protect the 45mm lens, but the incident draws attention to the major failing of rangefinder systems – what you see is not always what you get. Interestingly, the outcome on this occasion was not disappointment. The effect of the algae was to catch and flare the shafts of sunlight, almost like a special effects filter.

This experience highlights how important a tripod is in the rainforest. At 2pm on a sunny tropical day, the camera required f/4 at 2sec for some shots. At best it was $1^{1}/2$sec at f/11 where the sun broke through the canopy. Add to this the humidity (even in the dry season), small omnipresent insects and fever-bearing mites, and you appreciate the camera was given a test of its ability to cope under adverse conditions.

It may surprise some people, but I don't consider the rangefinder camera's fixed lens a weakness. I find myself working to the lens' angle of view, and don't waste time making decisions about which is the most appropriate lens for a given subject (important in hostile environments). It also means lugging around less kit. Given current weight restrictions on hand luggage when flying, this compact medium-format camera provides the ideal tool for the stock natural history photographer who wants to move up one step from 35mm.

Huge buttress roots like these in tropical North Queensland, Australia symbolize rainforests. I bracketed extensively – this frame was exposed for 15sec at f/16.

Swaledale from Gunnerside, Yorkshire, England. Fuji GSW69iii, tripod and Velvia.

Grassland flora

Undisturbed grassland and hay meadows are home to a diverse range of wild flowers. Colourful meadow flowers in this verdant habitat include: hay rattle, yarrow, yellow meadow buttercups, red clover and dainty flowers like tormentil and eyebright. Hay meadows are now a very rare phenomenon in intensively farmed Britain. There are, however, a few places where they can still be found – some of the best are in Swaledale, in North Yorkshire. The meadows are enclosed by dry stone walls and cannot be grazed by sheep until after the hay crop has been reaped.

The only way to do justice to this diverse ensemble of colourful plants is to shoot them en masse using a wideangle lens and focusing using the method of hyperfocal distance. The secret to successful flower photography of this kind is to get inside the floral sward so that the nearest flowers are in close up with a carpet of flowers drawing back to the horizon. This approach was particularly successful when I photographed the wild daffodils of Farndale, also in North Yorkshire. Nothing can prepare you for the sight of millions of daffodils hugging the banks of the River Dove during April – it's an absolutely amazing sight and one which simply beckons to be caught on film. I used my Fuji GSW690iii 6 x 9cm camera with 65mm wideangle lens.

Hay meadow, Swaledale, England. The ancient hay meadows around Muker in the Yorkshire Dales are a real treat in late May and June. On my first visit I only had a Pentax 90WR compact camera with me, so the next day I returned with my Fuji 6 x 9, a round trip of 320 km (200 miles). Fuji GSW69iii, tripod and Velvia.

Wild daffodils, Farndale, Yorkshire. Fuji GSW69iii, tripod and Velvia.

Stone barn in hay meadow, Swaledale, Yorkshire. Fuji GSW69iii, tripod and Velvia.

Equally colourful grassland flowers can be found in abundance on the hay meadows of alpine Europe. This is an ideal region for photographing colourful plants and isolating individual flowers using close-up techniques which employ flash. I used this technique to isolate the beautiful blue, yellow and white flower of eyebright in the Austrian Alps one August.

When using the method of focusing using hyperfocal distance, it doesn't matter particularly if wind-blown flowers produce a blurred effect - this can even add to the impact of a shot. However, when using flash to isolate small flowers, it is important to wait until the wind drops in order to prevent ghost blurring (see page 67).

Eyebright. The colourful petals fill the frame beautifully at 1 x magnification. Pentax LX + 100mm lens, TTL flash.

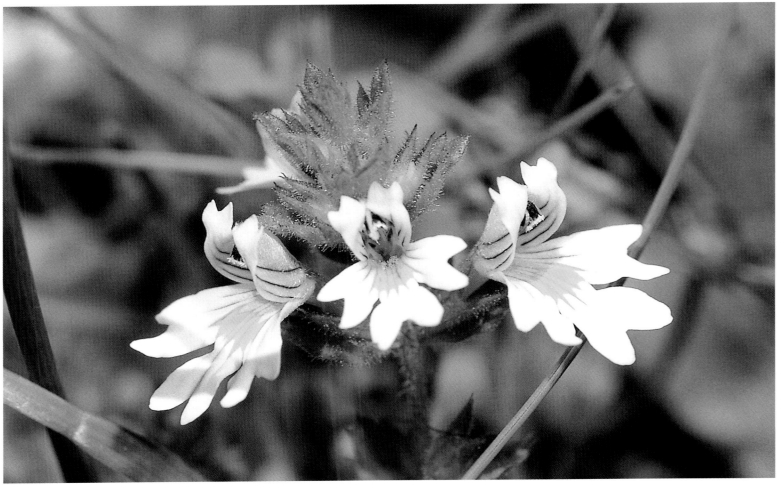

Wetlands

The principles for photographing woodland and grassland flowers extend to wetland plants – although I would add in a pair of wellington boots. Look for interesting plants such as sundews which, like the more exotic venus fly traps and pitcher plants, obtain their nutrients by trapping insects. You can choose whether to photograph close up using either flash or a tripod to isolate colourful flowers such as yellow flag and purple loosestrife or you can make them a component of a wider landscape photograph – including watery elements certainly adds significant interest to nature photographs. To my mind, waterfalls provide one of the most interesting of all photographic subjects. Try to capture plants surrounded by large or small cascades.

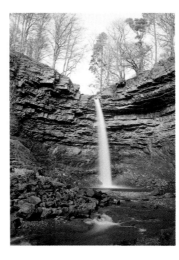

Hardraw Force in the Yorkshire Dales is the highest waterfall in all England. For this shot I erected my Unilock tripod in a depth of water that came over my boots, demonstrating the value of a sealed leg construction. I set f/22 to ensure a long exposure and added +1 stop to compensate for reciprocity failure.

Water features

Waterfalls are one of the few landscape elements that can produce unfailingly successful photographic images 365 days a year – they are truly spectacular, no matter what the season. Close to my home are the waterfalls in the wet and verdant Yorkshire Dales where streams (called becks) erode different rock strata at different rates, creating an uneven water course which results in foaming cascades of turbulent water. Wensleydale offers some of the best examples. Its most famous and grand waterfall is at Aysgarth where the River Ure negotiates river terraces stretching for a mile or more, yet there are a myriad of lesser-known, equally spectacular, and possibly even more photogenic waterfalls in the Yorkshire Dales. Take the trouble to find out about water features local to you: all you need to get you started is a 35mm SLR camera with a standard zoom lens.

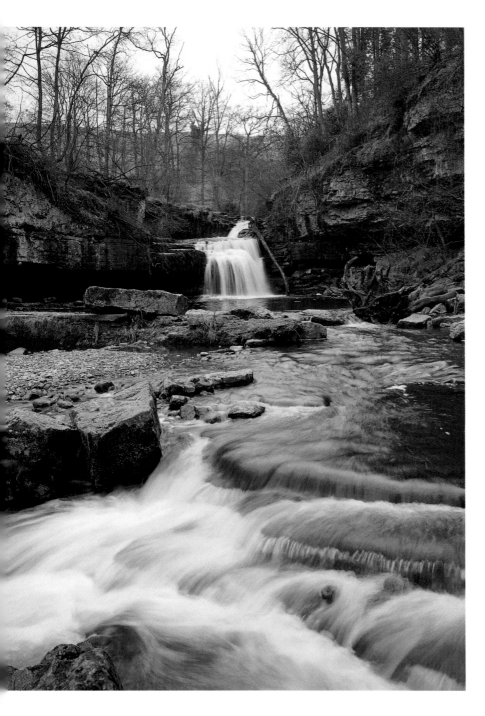

West Burton Waterfall, Wensleydale, Yorkshire. I tried to provide plenty of foreground interest in this image via the swirling motion of the turbulent water. Fuji GSW69iii, tripod and Velvia.

There is a knack to photographing a foaming white cascade, particularly if it is in a dark gorge. In such a situation, the contrast can be as high as it gets. I found that even with the matrix metering on my Pentax MZ cameras, I need two extra stops to prevent underexposure owing to the white frothy water fooling the TTL meter and reciprocity failure due to exposures on Velvia in excess of 1sec (often nearer 10sec) at f/16. So don't forget your tripod – or boots – if you want a good shot of cascading water – the rocks can be very slippery.

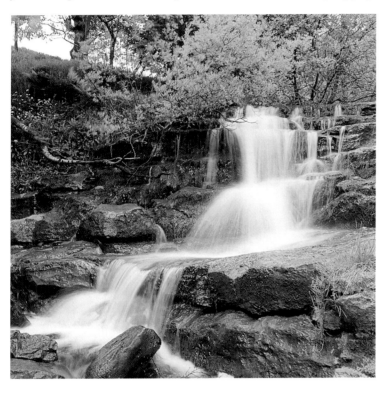

East Gill Force, Yorkshire Dales. Fuji GSW69iii, tripod and Velvia.

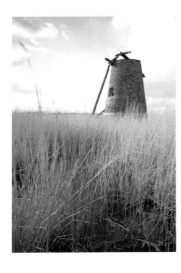

When looking for aquatic plants to photograph, why not add something unusual to focus the interest. I did this at Dingle Marshes in Suffolk, where I introduced this disused wind pump as a focal point amongst the Phragmites reed bed. Fuji GSW69iii, tripod and Velvia.

Tips for photographing moving water

- use a solid tripod with legs sealed against water penetration. Many of my successful images have required a tripod and 10sec at f/16 on Velvia.

- use slow ISO 25 or 50/64 film to blur water.

- include foreground rocks for interest. For my money the best waterfall images also have some green foliage framing them.

- use a warm up 81B or 81C filter to remove the inevitable blue cast in the white foaming water.

- wear shoes/boots which grip slippery surfaces.

- in bright light and when using fast film use an ND filter for longer shutter speeds to blur water movement.

- if white foaming water forms a significant part of the frame, overexpose by up to 2 stops, especially in dark gorges. Try $+^1/_2$, $+1$, $+1^1/_2$, and $+2$ stops the first time you shoot in this kind of environment.

- take care – plunge pools may be deep – you could easily drown (don't drop your camera in either).

Finally, don't limit yourself to spectacular cascades; even babbling brooks produce interesting flowing water patterns when long exposures are used. Impact may be improved in this context by using a 100mm macro lens.

Your own back yard

As photographers we should never overlook the obvious. You don't have to be in the midst of a rural haven to photograph plants successfully. Most of us plant our gardens for maximum colour and longevity of flowering. The blooms are therefore usually spectacular and abundant from spring right through to autumn. They are also just outside the back door. So you can both practise technique and obtain highly saleable images. If you don't have a plot yourself, head for the municipal park, public gardens or local nature reserve.

The medium-format camera
and landscape photography

Medium-format photography is definitely a step up from 35mm. The transparencies are larger and require less magnification than 35mm to achieve a certain reproduction size. This means images reproduced in magazines and books are, for a given size, sharper on medium format than 35mm. If you view 35mm slides alongside say 6 x 7cm transparencies on a light box, the difference is striking. The larger format is full of punch and vibrancy – they have impact, which is why so many people use medium format – it sells. Some picture buyers won't even look at 35mm which limits their choice, because many natural history subjects can only be shot on the smaller format for obvious practical reasons. Fortunately, plenty do still rely on a steady flow of 35mm for their publications.

The medium-format options

Medium-format cameras exist in a multitude of guises and can produce a variety of transparency sizes out of the 120 roll film format. These include 6 x 4.5, 6 x 6, 6 x 7, 6 x 8, 6 x 9, 6 x 12, 6 x 17 and 6 x 24cm. Up to 6 x 8cm, cameras tend to be SLR designs. Beyond this, a separate, non-TTL viewfinder is the norm. The variety of cameras available is wide and they come with a graded range of technical sophistication. The most technically advanced medium-format cameras known to me at the time of writing are the autofocus Pentax 645n which has auto everything and takes superb images, and the comparable Mamiya and Contax 645 cameras. Although the 6 x 4.5cm format is the smallest frame size, it does approximate to the aspect ratio of an A4 page – ideal for selling to many magazine editors. The 6 x 6cm cameras produce a larger frame size but need cropping to fit an A4 page – which seems a bit pointless. Also it is argued that 6 x 6cm, being square, is not well-suited to landscape work. Undoubtedly, the most popular image size is 6 x 7cm because this is the largest frame size obtainable with mainstream SLR

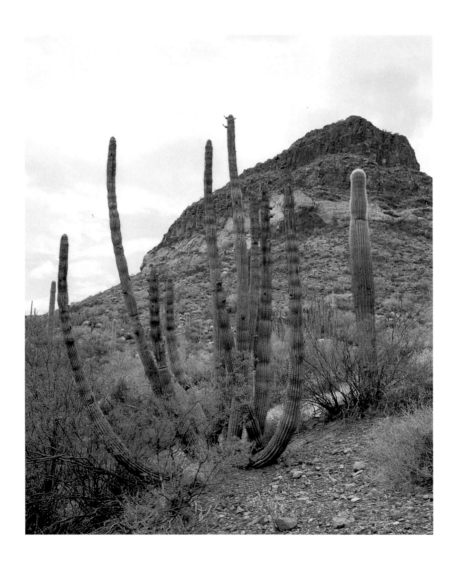

Organ Pipe Cactus, Ajo Mountains, Organ Pipe Cactus National Monument, Arizona. Mamiya 7ii + 65mm lens, f/22 on Velvia.

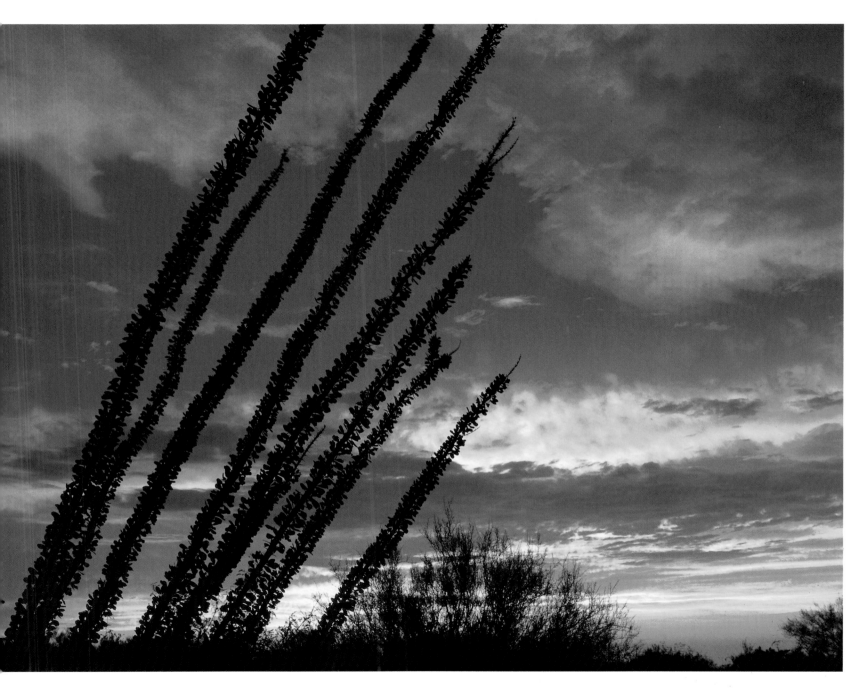

cameras that also have an array of accessories available (the exception is the Fuji 6 x 8cm). Once again the aspect ratio is broadly equivalent to A4 which means less cropping, less magnification and hence sharper reproduction. Mamiya and Pentax are the manufacturers that largely occupy this niche.

Ocotillo silhouetted at sunset, Tohono O'odham Reservation, Sonoran Desert, Arizona. Mamiya 7ii + 65mm wideangle lens.

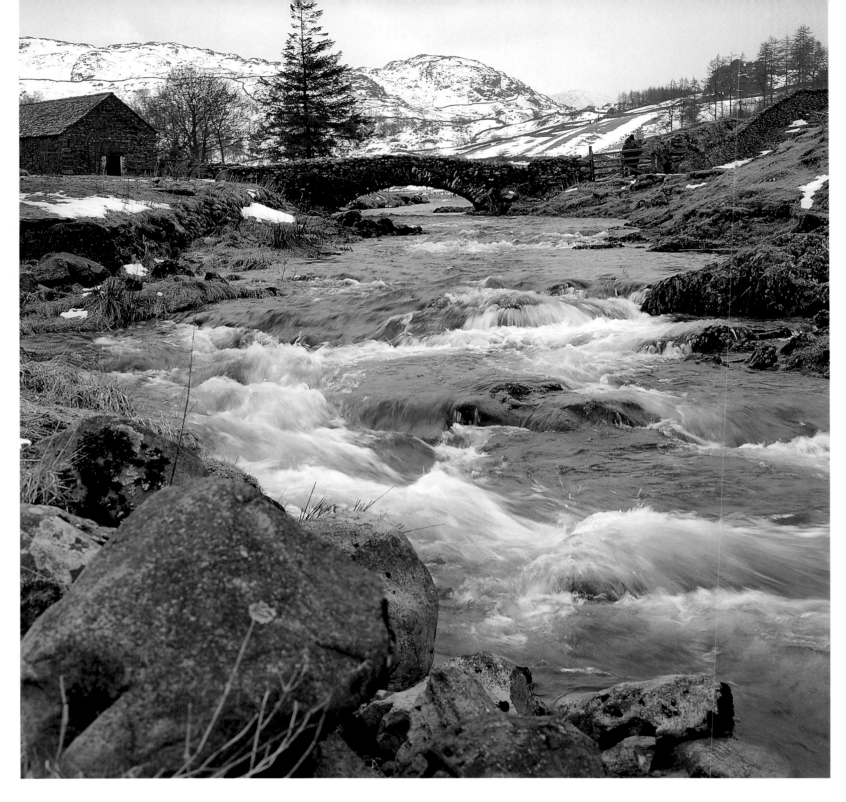

I took this picture in the Lake District on my first medium-format camera, a Hasselblad 500c/m with 80mm planar lens. It shows the hamlet of Watenlath against a backdrop of river, snowy mountains and walkers. Actually, my car nearly fell into this river (I parked it a bit too close), and I needed to enlist the help of three walkers to push me out of a potentially nasty situation.

Gategarthdale Beck, Lake District. A big format is great for a big view. Fuji GSW69iii, tripod and Velvia.

River and packhorse bridge at Grange, Lake District. The fixed 65mm lens on this camera is equivalent to 28mm on the 35mm format. Its wide angle is perfect for images requiring a good depth of field, without losing the impact of distant scenery as you might with a wider lens. Fuji GSW69iii, tripod and Velvia.

The 6 x 12, 6 x 17 and 6 x 24 beasts are panoramic cameras. These are extremely expensive and highly specialized cameras with a unique position in the market. Definitely for the professionals. Here we will content ourselves with the 6 x 9 and 6 x 7cm rangefinders because they are lightweight and cost-effective landscape cameras, capable of producing amazingly large transparencies which have the added advantage of being approximately the appropriate aspect ratio for an A4 magazine page.

Initially, when I entered the world of medium-format photography, I aspired to what is generally considered to be the best medium-format system available. I invested in a Hasselblad 500c/m, which produces 6 x 6s from a totally manual body. Several thousand Velvia transparencies later, still thrilled with the optical quality of my landscape shots, I came round to the view that the square 6 x 6cm format is less suitable for general landscapes than the rectangular perspective typical of 35mm and offered by most of the other medium-format cameras.

The pros and cons

The search soon began for an alternative. The Hasselblad is compact for its type but has considerable density (this density being directly proportional to price, I'm still frightened of it toppling off its tripod). My nature photography is as much out of a rucksack as a car, and generally in foreign lands, hence portability was an important consideration. I weighed up (quite literally) the Mamiya and Pentax 6 x 7cm reflex cameras, since they were even bulkier than my Hasselblad. In the end I settled for the Fuji GSW69iii, a camera which costs less than half the other contenders, weighs almost half (or so it seemed) and gives me an image size half as big again. No competition: its mega 6 x 9 trannies offer the perfect landscape format. A couple of years later, I invested in a Mamiya 7ii 6 x 7cm rangefinder with 43mm, 65mm and 150mm removable lenses (equivalent to 21mm, 32mm and 70mm in 35mm format). This camera has a built-in meter giving autoexposure that speeds up the picture-taking process, which my family particularly appreciate.

The Fuji camera undoubtedly represents the best-value landscape camera currently available. For anyone who doesn't know this camera, it is a rangefinder model in a robust polycarbonate shell which offers a light, portable design with a fixed Fujinon f/5.6 electron beam, coated 65mm lens and fixed back. This focal length lens is arguably the best for general landscape photography, equivalent to a 28mm lens on 35mm cameras.

Strange as it may seem, the lack of interchangeable lenses or other back-up, is for my brand of out and about photography, a plus point. My mind has become accustomed to thinking wideangle – to seeing the subject as the camera sees it, and thinking foreground interest, etc. This means I travel lighter, with fewer decisions to make regarding which lens to use. After a shoot with this camera, I nearly always end up collecting lots of very satisfying razor-sharp images from the lab, all on an awesome 6 x 9 Velvia tranny – awesome at least by 35mm standards. By 5 x 4 standards it is less spectacular but definitely more convenient. Obviously, for my landscapes I take few shots below f/8 where good-quality glass becomes important, but I can honestly say that on the light box I cannot detect the difference between Hasselblad and Fuji images whether in terms of sharpness or colour rendition. For those few occasions where my landscapes require a longer lens I have my Hasselblad, Mamiya 7ii or 35mm systems. The 6 x 9 picture of Utah's Delicate Arch at sunset was taken with the aperture at its widest setting (f/5.6) – I think this is a cracking picture and I can't see any image degradation compared with shots taken at f/22.

So what does this compact with an overactive endocrine system offer for your money? It weighs in at little more than a $1^1/2$ kg (just over 3lb), takes eight 6 x 9 images on one roll of 120 film (16 on 220 film) and has a host of extremely useful features. Those which stand out are:

- built-in spirit level
- built-in lens hood
- shutter actuation counter, which is a prompt for servicing
- 35mm ease of operation – including film loading

When you hold the camera its robust yet ergonomic construction for comfortable hand-held use is immediately apparent – should you forget your three-legged friend. Its between the lens leaf shutter and rangefinder design does away with the clunky mirrors and shutter curtains of SLR-design medium-format cameras. When you put your eye to the viewfinder in landscape orientation your index finger is led intuitively to the shutter release (which has a lock to prevent accidental triggering, another thoughtful touch). A second shutter-release button on the front of the camera makes it easy to trip the shutter in portrait format, although in this vertical orientation the spirit level cannot be used. The film wind-on lever is in the same place as on a 35mm camera and has a two-stroke advance. Also on the top plate are the frame counter and hot shoe. Strobe syncs at all shutter speeds (1–1/500sec) are possible via the hot shoe or X-sync socket, which has its own spring-loaded cover. This is an excellent refinement – I lost my Pentax LX cover to a vacuum-cleaner years ago. Loading the film on the Fuji is much simpler than on either my Hasselblad or Mamiya 7ii (the latter requires an expensive adapter to facilitate film change while mounted on a tripod). You simply press two red buttons under the takeup and film spools to disengage them. Insert film on the left-hand side, take up spool on the right, re-engage the buttons, locate the film leader in the take-up spool slot and wind on till you see the arrow. Close the back and snap away – it really is as easy as that.

Under the camera is a frame counter that registers one unit every ten films. At 10,000 shots the shutter blades seize up, even by 5,000 they become inaccurate. Fuji recommends a service at 5,000 shots (when

Sunset at Delicate Arch, Arches National Park, Utah. Fuji GSW69iii, tripod and Velvia. 2sec at f5.6–8.

Virgin River, Zion National Park, Utah. It took over an hour to shoot a handful of decent images on my Mamiya from the rickety bridge. It bounced up and down as an endless stream of tourists traversed the structure. Before the vibrations had stopped, another group would come along. A tripod definitely enhanced this shot, but I wonder whether hand-holding might not have been easier in this instance. Mamiya 7ii + 65mm wideangle. f/16 on Velvia.

the counter reaches 500). Interestingly, my camera had 2 on the dial when I bought it new indicating it had 20 films through it already, presumably due to quality control – I hope. Don't doubt that the blades will seize up: I can verify that at around 10,000 exposures, the iris blades on my Pentax 100mm macro lens seized. This was unfortunately, at the beginning of a trip abroad. If you are serious about your photography, heed the manufacturer's advice on regular servicing or get caught out.

The Fuji viewfinder has parallax correction marks and a straw-coloured double image centre spot for focusing by bringing together the two subject images. This is not that easy, particularly after using Acuttematt screens on my Hasselblad and autofocus on my 35mm gear. The Mamiya 7ii has a similar focusing setup. The superb EBC Fujinon SW 65mm f/5.6 lens has six elements in four groups and can focus down to one metre. The aperture goes down to f/32 from f/5.6. Vignetting does not occur with screw-in filters. I leave my 67mm Hoya 81B on most of the time and have experienced no problems. Since rangefinder designs do not permit TTL viewing certain filters such as grads and polarizers are difficult to use. As I'm no filter addict this isn't a drawback to me. For shutter speeds longer than 1sec you must select the T-position.

While the Super Wideangle 6 x 9 camera is ideal for landscapes, Fuji also does offer cheaper alternatives: a 90mm version and a 6 x 7 rangefinder clone. Fuji also has reasonably priced autofocus and autoexposure 6 x 4.5 rangefinders in the normal and wideangle range, plus a zoom 6 x 4.5 rangefinder. Bronica has also a 6 x 4.5 interchangeable lens rangefinder camera – the 645 RF.

In the field the 6 x 9 camera is joy to use. I must have carried the Fuji for scores of miles along backcountry trails. Even in the relentless baking sun, it presented less of a problem than my Pentax LX which, with a 28mm lens, flash and 100mm macro lens is far more cumbersome. However, this is rather a subjective assessment because, portable as the Fuji is, I'll admit to it being far less user-friendly than the Mamiya 7ii or the modern generation 35mm SLRs.

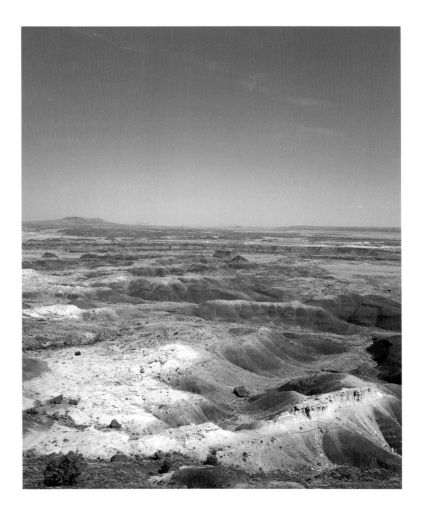

Painted Desert, Petrified Forest National Park, Arizona. All three shots using Mamiya 7ii + 65mm wideangle lens. Velvia.

Standing rocks, Chiricahua National Monument, Arizona.

Balanced rock, Chiricahua National Monument, Arizona.

When I added the portable GSW690iii to my collection I also invested in a lighter, more shoulder-friendly Unilock tripod. Up to now I haven't noticed any increase in camera shake than I found using my Hasselblad and much heavier Benbo and Unilock tripods – they all dance a bit if it gets blustery.

I have had many cameras over the past 20 years but only four have endeared themselves to me in a way that makes them special: the Pentax LX – to my mind, possibly the best piece of camera engineering ever; the Pentax MZ-5n; the Fuji GSW690iii, and the Mamiya 7ii. These four models have kept me in the business of selling pictures and, just as important to me, have been a joy to use.

Compared to my other systems, the Fuji is robust, but not to Hasselblad standard. It is easy to use and portable – more so than my Hasselblad. Most importantly its sharpness is razor-edged, and on the light box it is, to my critical eye, the equal of an 80mm Carl Zeiss Planar lens. That said, it is not nearly as versatile as the many 'system' cameras on the market with their many interchangeable lenses, finders and backs. Fortunately, to me at least, this is not particularly limiting when I'm switched into my backpack landscape photography mode. The Mamiya 7ii is a good alternative to the Fuji, but it costs far more. It is better for speed of use and low light work, since the autoexposure goes down to 4sec. Compare this to the 1sec maximum on the Fuji GSW690iii.

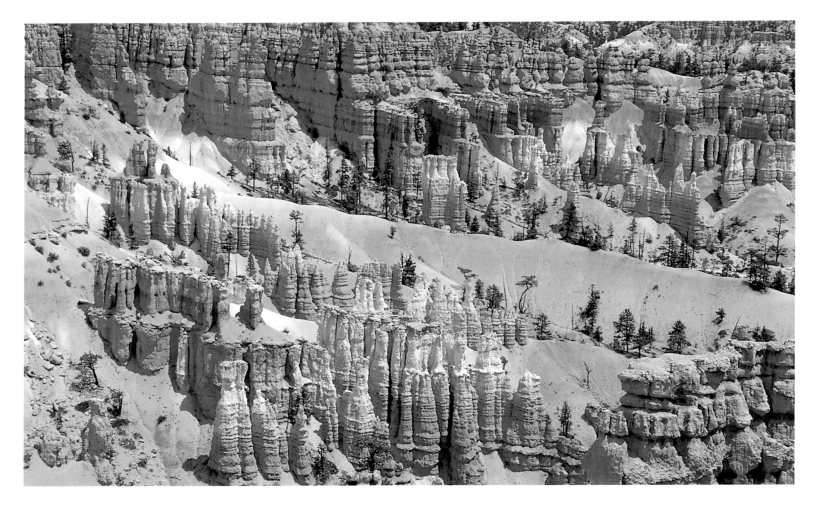

This professional camera from Fuji is relatively cheap and produces the highest quality images on an impressive 6 x 9 format which makes 35mm seem anaemic in comparison. That said, I've had fewer people distracted by the proletarian Fuji compared to the élite Hasselblad, which seems to hog the attention of other photographers who often drool at the vision of my tripod-borne shiny Swedish box. The truth is it's the final image that matters. And some of my best trannies were taken on the Fuji. I am not suggesting that the Hasselblad isn't an optical and engineering legend – it is. I just prefer my Fuji. It is portable and cheap, so it gets used and taken places where I would fear for my Hasselblad's safety even though I know it is one of the most robust cameras ever made. Despite my preference for the Fuji, I use my Mamiya 7ii more and more these days, largely because of the speed with which I can use it. The Fuji's hand-held metering requirement slows the pace down considerably, which I'd generally favour – although my family may beg to differ.

Sunset Point, Bryce Canyon, Utah. Hand-held shot on 35mm Pentax SLR. 70mm end of standard zoom.

The best of both worlds

Although this chapter concentrates on medium-format photography, neither the Fuji 6 x 9 nor the Mamiya 6 x 7 rangefinders (nor, for that matter, any other roll film camera) can provide universal photographic coverage of the nature and landscapes of an area. For blanket coverage, 35mm is certainly a more universal format. My philosophy has always been to blend the best of both formats. In other words, wildlife shots get taken on 35mm, while landscapes benefit from the breath-taking sharpness of medium format. Both formats were pressed into service on a trip to the American Southwest, where I needed to shoot quite different subjects: the immense landscape and desert light, along with an array of diminutive desert dwellers.

Joshua tree silhouetted against sky and clouds, Joshua Tree National Park, California. Mamiya 7ii + 65mm wideangle lens.

For anyone who wants to exercise both roll film and 35mm cameras, deserts must be among the most photogenic of all natural environments. The awesome scale, remarkable geological formations, the unique light, the stark vegetation and the wildlife combine to make these truly special places to experience and to record. A word of advice: take twice the film you think you will need. If you are a serious photographer take four times your initial estimate, because you will need to bracket exposures by, in some cases, an extra $1^1/_2$ x. This is particularly true if you use a hand-held meter with medium-format equipment.

There are four distinct deserts in America's Southwest: the Mojave, Chihuahuan, Great Basin and Sonoran. I set myself the task of photographically recording the natural history of the Sonoran Desert, land of poisonous serpents, spiny sentinels – and inhuman heat. An hour under an unrelenting sun led me to evolve a novel form of locomotion in which I lumbered, zig-zag fashion, between the stumpy shadows of magnificent saguaro cacti. I don't know what Messrs Eastwood and Wayne would have made of my desert prance, although in my defence, a heavy-duty tripod, film and cameras and plenty of water certainly weigh more than a couple of six shooters. In any event, with such a variety of toxic desert critters around, I think my brand of shooting can be just as dangerous as theirs.

Goosenecks of
San Juan River, Utah.

Ocotillo and cacti against brooding monsoon sky, Organ Pipe Cactus National Monument, Arizona. Both images taken using Mamiya 7ii + 65mm wideangle lens. Velvia.

Balanced rock, Arches National Park, Utah. Fuji GSW69iii,
tripod and Velvia.

The summer monsoon is a good time of year to see truly spectacular
lightning discharges over the desert landscape. Electrical storms can
be almost guaranteed to entertain late in the afternoon. Foolish as it
was, I couldn't resist doing some medium-format lightning
photography, which is actually quite easy, but dangerous – very
dangerous. A fellow photographer related to me how, just the
previous week, a lightning bolt went to ground just a few paces from
where he was photographing. He and his Canon camera survived, but
his digital watch was fried. I caught a couple of flashes on my
Mamiya 7ii with saguaro cacti as foreground interest, but didn't hang
around too long.

The Sonoran landscape is certainly photogenic and begs the use of a
medium-format camera, especially at Gates Pass Road in the Tucson
Mountains where there is a spectacular view of jumping cholla and
saguaro cacti cascading down the mountainside. For some of the best
landscapes in the US you should also visit the Great Basin Desert,
another must for medium-format photographers, with some

particularly evocatively named sites: Monument Valley, Valley of the
Gods, Goosenecks State Park (spectacular convolutions of the San
Juan river below awesome mesas), the similar Dead Horse State Park,
Mexican Hat, the Painted Desert, Canyonlands and, my personal
favourites, Bryce (which has to be the most photogenic place in the
US), Zion and Capitol Reef, along with the newly established and
very wild Grand Staircase Escalante National Monument. All of these
locations are perfect for shooting magnificent medium-format
landscapes in that very special light only really found in deserts at
the beginning and end of each day. At Arches National Park near
Moab, the agents of weathering have hewn spectacular natural stone
arches from the Colorado Plateau. On my last night here, determined
to shoot sunset at one of the most famous arches, Delicate Arch, I ran
the two-mile hike in 15 minutes, despite the temperature up in the
nineties, carrying my Benbo MK1, rucksack stuffed with Fuji 6 x 9
GSWiii and other paraphernalia. Although I just made sunset my
cable release unravelled and died on the first exposure – as indeed I
almost did, judging by my heart rate.

Clearly, serious desert photography is not for the faint-hearted. Do take every precaution. You must come to terms with daytime temperatures of 37–48°C (100–120°F), powerful blasts of sandy wind that penetrate camera mechanisms, monsoon rains which can cause flash floods within minutes, and some delightful creatures that you really would not want to offend. These organisms produce images on celluloid that are equally as fascinating as the surreal, yet photogenic world of cacti. Reptiles typify the deserts of the Southwest. The Arizona uplands around Tucson are considered to have the richest concentration of Sonoran Desert reptiles, with 21 snakes, 17 lizards and 3 turtles, most of which are dangerous and photographically challenging. Certainly none of the snakes can realistically be shot on the roll film format in a field situation. I therefore limited myself to 35mm with these noxious creatures. Indeed, I managed to shoot several species of rattler, including a sidewinder, using my Pentax kit. I did, however, also shoot a mojave rattler with my Mamiya 7ii from the safety of my car – not a tranny to submit to the BBC Wildlife Photographer of the Year competition.

Gila monsters (two species) are the only poisonous lizards in the world. They chew their venom into their victims as they salivate. Their jaws are so powerful that you can't pull them off once they get a grip. My wife actually spotted one of these rare creatures in the garden where we were staying in Tucson. What a souvenir. Again, I caught this monster on film with my 35mm Pentax kit.

Tarantulas are exceedingly commonplace here. I got fairly close to one with my 35mm camera, but backed off as it began flicking fine, fibreglass-like barbed hairs from its abdomen at me. These can cause eye, skin and respiratory distress. The upshot is, don't get too close with your macro lens or you could develop a nasty itch. They have a painful, but generally harmless bite. Far nastier are the brown recluse and black widow spiders which can cause necrotic arachnidism!

Centuroides scorpions, unlike their European cousins, can kill, and are best avoided altogether. However, even the seemingly innocuous desert millipedes can secrete an irritating cocktail of defensive chemicals that can irritate, blister or stain your skin. I have found hundreds of scorpions in southern Europe, but only a few in the deserts of the Southwest. The only Centuroides scorpion I spotted was right next to my left foot as I relieved myself behind an obliging saguaro cactus.

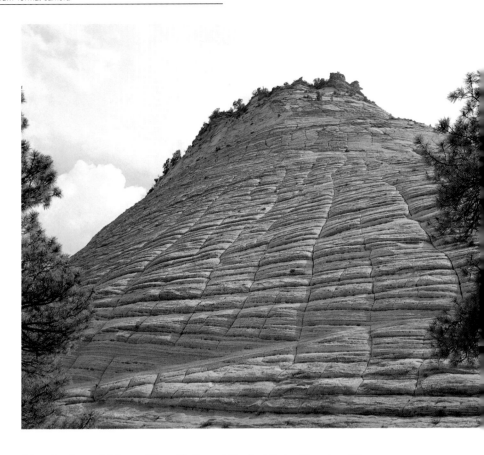

Checkerboard Mesa, Zion National Park, Utah. Mamiya 7ii + 65mm wideangle lens. f/16–22 on Velvia.

I found it almost as disconcerting encountering a group of javelinas (peccaries) in the Chiricahua Mountains. They are, I am told, harmless, but to me they looked threatening enough. I felt safer around the rattlesnakes than this large pack of wild pigs. I decided neither camera format was appropriate for these subjects, as it would mean overcoming a primal fear of wild pigs that I hitherto didn't realize I had.

The American deserts may be a medium-format photographer's paradise, but there are dangers at every turn. Apart from the heat, the dust and the wildlife, watch out for the cactus spines. I fell foul of an Engelmann prickly pear – I had a good 200 spines embedded in my leg, some of which are still there. Jumping cholla spines are even worse, and again I talk from experience. Wherever you take your camera, never put your own or others' safety at risk for the sake of your pictures: deserts are extremely inhospitable places, and you should never underestimate the dangers. However experienced in the field you are, do take great care and always carry plenty of water.

How to sell your *work* 19

Grecian copper on bramble leaf, Thassos. Simple uncluttered pictures like this sell better than messy or overly busy images.

Pentax LX + 100mm macro lens, TTL flash.

Most keen amateur wildlife and landscape photographers reach a point in their career when they would like to show the world some of their work and be justly rewarded for doing so. Unless you are extraordinarily fortunate, though, being a freelance nature photographer is unlikely to make you rich – although it certainly helps to pay for what can be a rather expensive hobby. In this final chapter I offer advice and hints on how to market your photographs successfully.

The digital question

The world is changing, there is no doubt about that. Technology is evolving at an exponential rate which means it can be hard to stay abreast of the latest advances. No serious photographer can afford to ignore the digital revolution. Although I still duplicate my slides for editorial submissions, six-colour home-produced prints from digital scans are proving to be an easier and cheaper way for me to submit my work.

For years I have been a photographic purist. My wildlife and landscape photography has been executed with a professional attitude in which I have strived to record nature on film in a way which is powerful and evocative, yet always true to life. To this end I have even avoided using filters (except an 81B warm-up to protect my lenses) which would otherwise alter the viewer's perception of the subject on film. In addition, I would almost never consider shooting captive animals, which I consider cheating. I stalk my prey in the wild as this nearly always produces superior results. So overnight, and 256MB of RAM later, what do I discover about myself? I find I am a digital-imaging freak – reworking wildlife slides which are already quite acceptable, using all manner of Photoshop techniques to bring out the original qualities of the subject that sometimes do not register on the film: light quality, colour fidelity, etc.

While I now fully accept the value of digital imaging and manipulation ('enhancement' is probably a more ethical and acceptable term), to my mind wildlife photographers in general are a breed apart, and they will be the last to succumb to bits and bytes. However, we shouldn't forget that this virtuous band of photographers already alter the truth with polarizers, warm-ups and grads, and invariably use different types of film – Velvia for instance which beefs up real-life colours quite substantially. When you think about it, fast grainy film, the perspective alteration of extreme wideangle and telephoto lenses, and even fill-in flash, all create an altered perception of life. With this in mind, is there anything wrong with enhancing post-production sunsets, as opposed to covering the lens with an 85 series filter at the point of exposure? The dividing line comes when a manipulated image is passed off as something it is not, particularly when it misleads or, worse, deliberately misinforms. Provided any deviations from reality are well cited and people enjoy looking at the image, then no harm is done.

In spite of the apparent conflict between electronic and film-based storage of images, what could be better than an affordable digital home studio/darkroom where you can scan all your favourite 35mm nature transparencies at a resolution which produces extraordinarily high-quality output on 1440dpi printers that are no more expensive than a compact camera? Digital output is definitely better than pricey Cibachromes and the like. The majority of us have access to a PC, RAM has never been cheaper and with the advent of CD-R/RW (and DVD RAM), JAZ and ZIP drives for infinite storage capacity, the technology is available to most conventional, film-based photographers. A typical 28MB file for a transparency scan exceeds the resolution required for magazine front-cover quality output. In fact, A4 output by a top-quality image setter for a magazine cover requires a typical scan of 18–24MB, depending on the colour model used. Using my PC I find that I am now actually enjoying looking at my own images much more. It is far easier to view 1440dpi inkjet prints than transparencies and they cost only a few pence each.

Finally, given the exceptional quality of the results that can be achieved by blending conventional and digital imaging, I still find myself unable to go along with the big interest in digital cameras – they cost a fortune yet produce rather poor, low-resolution images which at best (for the consumer mass market at least) are an order of magnitude below the resolution of the digital-imaging technology I have just described. Perhaps digital camera manufacturers are not aiming at committed photographers. Having said that, now that I've seen the results of image files taken with the Fuji S1 Pro, perhaps I will have to review my opinion in due course. It is a fact that increasing numbers of world-class wildlife photographers are now utilizing digital SLRs incorporated into their daily shoots, outputting their work using special software which can yield incredibly sharp images suitable for the highest quality magazine reproduction.

I have used this digital trickery to produce off the wall images for the greetings card market as well as to beef up landscapes for magazine submissions. I get the impression that there may be a vast new market out there for the *digital* nature photographer. At this stage, however, there is more than enough room for traditional film-based and digital media to co-exist, and I still prepare duplicate slides for submission.

Duplicating slides

Unlike a landscape photograph of your local terrain, a rare snake shot thousands of miles from home cannot be re-taken if your original image is lost or damaged. I only have one good head shot of the lethal mojave rattlesnake photographed in Arizona. If I lost that, I would be pretty angry. Clearly it is prudent to duplicate irreplaceable wildlife slides, and only ever submit copies to your prospective clients. It goes without saying that you should only ever submit first-class duplicates. Dupes can be produced to a very high standard – sometimes offering an improvement on the original.

The major concern with duplicating is an unwanted increase in contrast, although special slow speed duplicating film is available from Fuji and Kodak. This inevitably requires special filtration, and each film batch will require different colour filtration. Therefore, use of this purpose-designed film is best left to professional labs.

Commercial duplicators are available, such as the Bowens Illumitran, which have a built-in flash and a continuous tungsten light source for focusing. They can also reduce contrast by fogging the film slightly before or during exposure. Unsurprisingly, these duplicator systems are relatively expensive. At home I now duplicate my best slides onto Kodachrome 64 using the following setup. My Pentax LX is supported by a solid Benbo tripod. I use a 50mm macro lens with a short 12mm extension tube attached. The lens' UV filter is replaced with an 81B warm-up filter to reduce the blue component of my AF280T flash gun which is off camera and set to TTL autoflash via a 4P sync cord A. The female 81B filter thread on my 50mm macro lens is screwed into a step-up ring which attaches to a bellows slide copier. It may sound like Heath Robinson, but it works well.

With my camera set to aperture priority, I set f/8 (optimum optical resolution) and point my flash tube onto a white sheet which reflects back onto the slide through a diffuser screen. Hey presto – near-perfect dupes. Remember to use a cable release, mirror lock-up and magnification beyond life size to remove the slide mount from the field of view.

I dupe all my best 35mm close-ups using my own setup. However, my 6 x 4.5, 6 x 6, 6 x 7 and 6 x 9 original landscapes tend to be duped in camera while in the field. Landscapes don't run off and three or four dupes can usually be made before the light changes.

With close-ups of small creatures using 35mm you often only get one shot, but if you do get the chance for more, take it – originals are usually crisper than dupes.

I have found that some subjects dupe better than others. I recommend you play with 81 series filters to eradicate any blue cast in your images – you may even need an 81C. Also, consider your film. Velvia has much to commend it, but it is a poor duping film giving unnatural colours. The slow Kodachromes are absolutely neutral giving realistic colours and a sharpness equal to Velvia.

A viable alternative to duping slides yourself is to use one of the specialist duping services which exist. These will not only dupe 35mm slides as 35mm copies but will dupe a 35mm slide into a larger format such as 6 x 9cm. Results are spectacular, with some labs charging as little as 50% of the price of a roll of film for a 6 x 9cm dupe of a 35mm slide.

Presentation

Having identified your marketplace – perhaps a magazine, book or calendar publisher – you will want to send a selection of slides for consideration. Presentation is important:

- select only a small number of technically and aesthetically perfect images – I'd say no more than 20. One bad image – soft or poorly exposed – will undermine all the good pictures.

- for publication of colour images submit only slides, preferably on slow, fine-grained emulsions.

- caption your slides professionally. Various computer programmes are available for doing this which make the task less onerous. I enclose a label on the top of the slide mount giving the copyright symbol, my name, address and telephone number. On the bottom I give details of the subject, depending on the market. For a photographic magazine I would include details of the camera, lens and film etc. For a nature magazine I would give the scientific name, habitat, season and country.

- for easy viewing, put your 35mm slides in transparent file sheets. Alternatively they can be mounted in matt black masks, although I generally reserve this approach for my medium-format images.

- place the file sheet in a soft but protective binder along with a cover letter which is simple and to the point. Always include a stamped self-addressed envelope for the return of your material, not loose stamps. Do not over protect your work with yards of sticky tape and hundreds of staples. Most important: never send glass-mounted slides. If the package is badly handled and the glass breaks, your precious slides can be damaged beyond repair.

- send your packet by an insured method of transit and one where it can be tracked.

When you consider what your submission represents, and its potential selling value, these precautions are vital.

Blue-tailed damselfly. I was knee deep in an ancient Roman bath when taking this picture in Turkey. Pentax LX + 100mm macro lens.

The markets

The potential marketplace is enormous. Browse the shelves in your local store, and you'll begin to see the number of possible outlets. Most obviously, these include magazines on photography, outdoor pursuits, country life, nature and gardening, and that is before you start to consider publishers of books, calendars, diaries or greetings cards.

With magazine submissions, it is mostly the case that words and pictures together will sell better than either words or pictures alone. Busy editors with tight schedules welcome a complete package. If they like what they get, they are likely to come back for more. Also timing is important: magazines will follow the seasons in their editorial, but you have to anticipate their lead times, and appreciate that issues are planned well ahead of actual publication. Shots of autumn leaves need to be sent in mid-summer not during the autumn months; images of the first flowers for potential spring-time cover shots have to be submitted early in the New Year.

As you get to know particular markets, you will find yourself shooting prospectively. This is what I meant by pre-visualizing the shot in the field. For a photography magazine you could, for example, shoot a moth head on, at different apertures to illustrate depth of field, or grass blowing in the wind at different shutter speeds to illustrate the motion stopping principle of shutter speed. For a nature or gardening magazine, the emphasis would be different, and you might concentrate instead on a shot that clearly identified the subject or some aspect of its behaviour.

With book submissions, if you have a good idea, pictures to back it up and can package it well, identify a publisher who has used similar material in the past and submit your outline proposal. You may need to develop a thick skin and exercise patience. A book represents a far bigger investment on the part of a publisher than one article in a magazine, and the commissioning process may take some time. If several publishers reject you, you probably should rethink your idea. Rejection doesn't necessarily mean you have no future as a photographer and/or writer. Your idea simply may not fit the publisher's advance programme of titles or may not be commercially viable. Don't limit yourself to magazines and books, consider also calendar and card publishers and using an agent or one of the many slide libraries which act as agents for wildlife and nature photographers.

Organization

Turning your hobby into a business requires good organization of your material. Throw away your shoe boxes and invest in a filing cabinet for storing your slides – adopt a logical filing system. I find my PC invaluable for keeping me on top of everything. My slide index/library archive is listed in one of its databases by subject, colour, alphabetical order etc. I use its basic functions to caption slides, keep potential client addresses up to date, invoice clients as well as write articles and cover letters. Connection via the Internet and e-mail (and most importantly digital imaging), mean my work can be browsed on my website anywhere in the world. The PC is undoubtedly one of my best photo accessories, keeping me in a permanent state of good organization.

Whatever direction your nature photography takes, and whether or not it delivers a financial return, it has to be one of the most exciting, healthy and absorbing pursuits I know. It has taught me a great deal about the world on all scales, macro and micro, and the part we play in it. It has also afforded me the opportunity to travel extensively and to experience other cultures, climates and continents in a way that few other 'jobs' might do. Whether or not I sell a picture, I have it as a permanent reminder of what I've been doing over the past two decades, and what I've been doing has been immensely rewarding and satisfying. I hope the same for you, too.

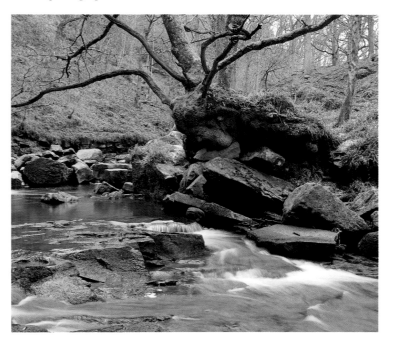

West Beck, Goathland, North Yorkshire Moors. Exposure for this shot was f/16 and about 2sec on Velvia. My Mamiya 7ii and 65mm wideangle lens were mounted on a Unilock tripod which was immersed in water – along with my feet.

Warm pre-sunset glow, Ubirr, Kakadu, Australia. Mamiya 7ii + 43mm ultrawide lens. Velvia. No filtration.

Sources of useful information

Websites

Photo Resource is the source for photographers:
http://www.photoresource.com/resource.html

Some of my favourite sites by great photographers (in alphabetical order) include:

Heather Angel
http://www.naturalvisions.co.uk

Jim Brandenburg
http://www.jimbrandenburg.com/home.html

Joe Cornish
http://www.joecornish.com

Peter Dombrovskis
http://www.view.com.au/dombrovskis/index.htm

Jack Dykinga
http://www.dykinga.com/start.html

Jeff Gnass
http://www.jeffgnass.com/jeffgnass/home/home.cfm

Michael Hardeman
http://www.michaelhardeman.com

Frans Lanting
http://www.lanting.com

Joe McDonald
http://www.hoothollow.com

Thomas D Mangelson
http://www.imagesofnature.com

David Muench
http://muenchphotography.com

Edmund Nagele
http://www.nagele.co.uk/index1.htm

William Neill
http://www.WilliamNeill.com

Graeme Peacock
http://www.graeme-peacock.com

Galen Rowell
http://www.mountainlight.com

Tom Till
http://www.tomtill.com

Charlie Waite
http://www.charliewaite.com

My apologies to all those great photographers whose sites I have yet to learn of, or which are not yet on-line.

The best source of information on the most suitable outlets for your photography in the UK is the annual *Freelance Photographers Market Handbook* (Bureau of Freelance Photographers, Focus House, 497 Green Lanes, London N13 4BP). It cross-references a variety of photographic subjects and their possible markets and gives a comprehensive listing of agents, calendar, card, book and magazine publishers. I can also recommend *The Writers' and Artists' Yearbook* (A&C Black, London) and the *Photographers' Market* (Writers Digest Books, Cincinnati, USA).

There are also regular newsletters to which you can subscribe for making money from your photography. I subscribe to the *Market Newsletter*, which is also produced by the Bureau of Freelance Photographers in London.

The professional lab I use for all my photographic requirements is Photobition Warrens, 361 Burley Rd, Leeds LS4 2SL, England. Telephone (0113) 2783614. Their service is truly excellent.

Finally, there are various computer programmes available for captioning slides. The one I use is Cradoc Caption Writer (Iris Audio Visual, telephone 0208 500 2846), which has proved to be an excellent product.

Bibliography

Identification guides

There are a number of good identification guides available.

Insects

The one book that is always packed with my camera gear on European trips is *Collins' Guide to the Insects of Britain and Western Europe* by Michael Chinery (HarperCollins, London, 1986). This is arguably the handiest guide to the European insect fauna and essential on any trip to the rich Mediterranean 'hunting grounds'.

For European butterflies I would recommend *The Butterflies of Britain and Europe* by Lionel Higgins and Brian Hargreaves, published by HarperCollins (London, 1985). For butterflies in the States I have found the *Audubon Society Field Guide to North American Butterflies* by Robert Pyle and published by Alfred A. Knopf (New York, 1990) extremely helpful.

Reptiles and amphibians

The best book for identifying European reptiles and amphibians is *Collins' Field Guide to Reptiles and Amphibians in Britain and Europe* by E. Arnold, J. Burton & D.W. Ovenden (HarperCollins, London, 1992). In the US, the best books are *Peterson Field Guides: Reptiles and Amphibians (Eastern/ Central North America)* by Roger Conant and Joseph T. Collins (Houghton-Mifflin, New York, 1991), along with *Western Reptiles and Amphibians* by Robert Stebbins (1985). Together, these two volumes comprehensively cover the entire US.

If you want to treat yourself to one of the best snake books around, with superb colour photography by Michael and Patricia Fogden, you should buy Harry Greene's book: *Snakes – The Evolution of Mystery in Nature* (University of California Press: Berkeley & Los Angeles, CA, 1997).

Birds

Identification books that I have found useful include *Collins' Pocket Guide to Birds of Britain and Europe with North Africa and the Middle East* by Hermann Heinzel, Richard Fitter and John Parslow (HarperCollins, London, 1995) and the guide I use in the US is the *National Geographic Society Field Guide to the Birds of North America* (National Geographic Society, Washington, DC, 1996).

Plants

One of the best identification guides to ferns and horsetails is *Collins' Guide to Grasses, Sedges, Rushes and Ferns of Britain and Northern Europe* by Richard & Alistair Fitter and Ann Farrer (HarperCollins, London 1987).

A good identification book, entirely illustrated by photographs, is that by Roger Phillips: *Grasses, Ferns, Mosses and Lichens of Great Britain and Ireland* (Pan, London 1980).

The book I use for identifying flowering plants is *The Wild Flowers of Britain and Northern Europe* by Richard Fitter, Alistair Fitter and Marjorie Blamey (HarperCollins, London 1985).

Style-led landscape photography books

The following recent publications are guaranteed to inspire:

Rainforest – Ancient Realm of the Pacific Northwest by Graham Osborne (Greystone Books, Douglas & McIntyre Ltd, Vancouver 1998).

Stone Canyons of the Colorado Plateau by Jack Dykinga (Harry N. Abrams, New York 2001).

Colorado – Lost Places and Forgotten Words by John Fielder (Westcliffe Publishers Inc., Englewood, 1989).

About the author

Mark Lucock is a professional biologist. After graduating from university in 1983 with a degree in applied biology, he obtained his PhD in 1991. Today, Mark carries out research at the University of Leeds, Yorkshire, and is a Fellow of the Institute of Biology and a Chartered Biologist. In his spare time he photographs the natural world, producing transparencies that reflect the broad spectrum of nature. A broad range of destinations feature in Mark's work. Areas covered include India, most Mediterranean countries, the Eastern and Western United States, Australia, and much of Britain.

Mark has had many publications in the popular press, including illustrated nature articles in magazines and books. He says he is only truly happy when he has a camera and is in the middle of a remote wilderness, either stalking an elusive creature or capturing an ephemeral vista. He is married to Jill and has a daughter, Rebecca, who is hoping to study biology herself.

Index

Note: Pages with **bold** references include a photograph.